The Getty Conservation Institute

Solvent Gels for the Cleaning of Works of Art

The Residue Question

Dusan Stulik, David Miller, Herant Khanjian, Narayan Khandekar, Richard Wolbers, Janice Carlson, and W. Christian Petersen

Edited by Valerie Dorge

2004

research in conservation

© 2004 J. Paul Getty Trust
Fourth printing

Published by the Getty Conservation Institute, Los Angeles
Getty Publications
1200 Getty Center Drive, Suite 500
Los Angeles, California 90049-1682
www.getty.edu/publications

Patrick Pardo, *Project Editor*
Sheila U. Berg, *Copy Editor*
Pamela Heath, *Production Coordinator*
Hespenheide Design, *Designer*

Distributed in the United States and Canada by the University of Chicago Press
Distributed outside the United States and Canada by Yale University Press, London

Library of Congress Cataloging-in-Publication Data
Solvent gels for the cleaning of works of art : the residue question /
Dusan Stulik ... [et al.] ; edited by Valerie Dorge.
 p. cm.
Includes bibliographical references and index.
 ISBN 0-89236-759-8 (pbk.)
 1. Art—Cleaning. 2. Art—Conservation and restoration. 3. Colloids.
4. Paint removers. I. Stulik, Dusan, 1956- II. Dorge, Valerie, 1946-
 N8560.S7 2004
 702'.8'8—dc22
 2003025849
ISBN 978-0-89236-759-7

Illustration credits: Figure 1.1, the J. Paul Getty Museum. Plates 1 and 8, the J. Paul Getty Museum, © 2003 Artists Rights Society (ARS), New York/SABAM, Brussels. Figure 6.7, the J. Paul Getty Museum, Gift of William P. Garred. Figure. 6.1, Getty Conservation Institute Study Collection. Plates 2 and 9 and figures 1.2, 6.8, 6.9, and 6.10, Courtesy, Winterthur Museum.

Contents

Foreword

I am pleased to introduce this addition to the Getty Conservation Institute's series Research in Conservation. This publication, *Solvent Gels for the Cleaning of Works of Art: The Residue Question*, presents the research methodologies and results of the Surface Cleaning–Gels Research Project undertaken to find answers to long-standing concerns regarding the use of aqueous cleaning methods.

Aqueous cleaning methods were introduced to the conservation community in the early 1980s by Richard Wolbers of the Winterthur/University of Delaware Program in Art Conservation as a tool for solving often complex and difficult cleaning tasks. Since that time, experience with aqueous cleaning methods has led—as is frequently the case—to questions regarding their use. Among these questions is the possible long-term effects of surface residues that remain after cleaning or layer removal using a gel formulation.

Although other research institutions have undertaken studies on various aspects of aqueous cleaning systems, the residue question, particularly with regard to organic solvent–based gel formulations, remained unanswered. With the Getty Conservation Institute's commitment to addressing significant concerns in the conservation field and the implementation of its broad-based Surface Cleaning–Gels Research Project, it was fitting to focus specifically on an investigation of whether residues remain after cleaning with solvent gels, and if so, whether they might contribute to future degradation of the surface or underlying layers of works of art.

The research results alleviate some of the concerns regarding residues and provide conservators with information that will allow them to make better-informed decisions in formulating a gel for a specific cleaning task. At the same time, the results of a comparative cleaning experiment using a selection of pure solvents or solvent mixtures for surface cleaning support the researchers' interest in further studies on the effects of solvents on painted or varnished surfaces. The application of analytic methods used in other science fields, such as autoradiography and profilometry, during the course of the project offers new tools for conservation research.

The dedication and enthusiasm of the entire project team, Valerie Dorge, Dusan Stulik, Herant Khanjian, and former GCI colleague Narayan Khandekar, as well as colleagues in the conservation departments of the

J. Paul Getty Museum, were instrumental to the success of the project. However, the project was a collaborative effort with a considerable number of institutions and individuals. They are acknowledged in the preface. I would like to acknowledge here the main project partners: the Department of Chemistry, California State University, Northridge; Winterthur/ University of Delaware Program in Art Conservation; and the Conservation Division of the Winterthur Museum, Garden and Library. Each institution, through its representatives—David Miller, Richard Wolbers, and Janice Carlson and W. Christian Petersen, respectively—contributed specific expertise to the various components of the project.

The GCI is committed to making the results of its work available to the cultural community. The project team has made presentations to gatherings of conservation professionals on the results of components of the research as they were completed. This publication is a compilation of all the research component methodologies, data, and results. We hope that conservators will find it informative and helpful in selecting the most appropriate cleaning tool and that it will serve as a useful reference work for conservation scientists.

Timothy P. Whalen, Director
The Getty Conservation Institute

Preface

Valerie Dorge

As I write this preface, I cannot resist reflecting on the paths that led me as an individual, and the Getty Conservation Institute (GCI) as a research institution, to the GCI Surface Cleaning–Gels Research Project. My introduction to the Wolbers cleaning methods was in 1988 during my leave from the Canadian Conservation Institute (CCI) to complete a one-year Mellon Fellowship in polychrome sculpture at the Detroit Institute of Arts. The head of the conservation services laboratory, Barbara Heller, had just returned from a workshop at the GCI entitled "New Methods in the Cleaning of Paintings." She was enthusiastic about the new cleaning methods, and the course binder quickly became the most sought after and copied document in the lab. I could not have imagined then that some ten years later these materials would become a major part of my professional activities over a four-year period at the GCI.

When I returned to the CCI, I was fortunate to participate in a Wolbers workshop it sponsored in Ottawa in 1990. The title of this course was "Workshop on New Methods in the Cleaning of Paintings and Other Decorative Surfaces," reflecting the fact that surface cleaning and layer removal are important problems in object as well as painting conservation.

Workshops on Wolbers cleaning methods continue to be in high demand among conservators, an indication of the importance of surface cleaning in all fields of conservation. It is important not only because it may well be the most common task for conservators and often presents technical difficulties but also because the degree of cleaning (i.e., removing dirt, varnish, or paint layers, or all three) affects the aesthetics of the object. And, as can be seen in the minor and major controversies that have occurred down through the centuries, and referred to in the introduction, the perception of how an object—especially a painting—should look is a very personal one that elicits strong emotions and is subject to changing taste over time.

The GCI first became involved with the Wolbers cleaning methods in the late 1980s. When I joined the GCI as a training program coordinator in 1992, it had already offered the Wolbers workshop a number of times. Thus the GCI provided the first opportunities for conservators to understand the theoretical and practical aspects of the new cleaning methods. Alberto de Tagle, then head of the GCI Science Department, had developed an interest in aqueous cleaning methods during his tenure

as senior scientist in the Scientific Research and Analysis Laboratory of the Winterthur Museum. Recognizing the continued need for definitive answers to issues related to the use of aqueous cleaning methods, he included these methods in the Surface Cleaning–Gels Research Project, which was initiated at the GCI in 1997. Over the next three years, until his departure for the Netherlands Institute for Cultural Heritage, he ensured that resources were in place to allow members of his staff—Dusan Stulik, Herant Khanjian, and Narayan Khandekar (until his departure from the GCI in 2001)—to devote considerable time to the research and dissemination phases of the project. Because of my practical experience in conservation and my previous work with Science Department colleagues on other training activities organized by the GCI, I was invited to lead the Surface Cleaning–Gels Research Project.

The aim of our research was to attempt to answer some of the questions regarding use of the aqueous cleaning methods that continued to cause concern and perhaps prevented their more widespread application to conservation. Although a number of institutions had carried out important research into some of the issues regarding materials, the residue question remained unanswered. For this reason and to keep the project within manageable parameters, we decided to apply the Getty's expertise and access to up-to-date scientific instrumentation to the organic solvent gel residue question.

This has been a truly collaborative project, and over the past four years I have been privileged to be part of a large team of professionals—both within the J. Paul Getty Trust and from other institutions—who brought their specific expertise and their dedication and enthusiasm to this project. The Getty project team was composed of the following J. Paul Getty Museum colleagues: Paintings conservators Mark Leonard and Yvonne Szafran; Decorative Arts conservators Brian Considine and Arlen Heginbotham and former Museum conservators Joe Godla and Abby Hykin; and Antiquities conservators Jeffrey Maish and Eduardo Sanchez. I would especially like to mention Mark Leonard's participation in the paintings cleaning experiment and his assistance to Narayan Khandekar in the sampling of objects from the Getty Museum collection discussed in chapter 6; Brian Considine's and Jeffrey Maish's participation in the cleaning experiment on object materials discussed in chapter 3; and Jeffrey Maish's contribution to information on early application of gelled materials in objects conservation. Tiarna Doherty, assistant paintings conservator, contributed to the decision tree test kit trial.

This research project would not have been possible without the collaboration of Richard Wolbers, associate professor in the Winterthur/University of Delaware Program in Art Conservation, and David Miller, professor of chemistry at California State University, Northridge (CSUN). Richard Wolbers's in-depth knowledge of biochemistry and the aqueous cleaning methods he introduced to the conservation field, as well as his continuing research into their potentially detrimental effects on cleaned surfaces, contributed greatly to the project. The methodology developed for our quantitative measurement of residues using radiolabeled components built on his earlier work in this area.

Even with the GCI's significant resources, our research, particularly the quantitative measurement of residues using radioisotope labeling, would not have been possible without the Department of Chemistry at CSUN, represented by David Miller, as a project partner. The department lab is fully licensed in the use and disposal of radioactive material, and David Miller's considerable expertise in the use of radioactive materials and research methodology was a crucial factor in the project's success. Initially, his role was to contribute to development of methodology and protocols and to provide the lab for the cleaning experiments involving radiolabeling; however, his enthusiasm for this "conservation field" has resulted in his contributing to most areas of our gels research project and to other GCI research projects as well.

There is a long history of collaboration between the GCI and the Conservation Division of the Winterthur Museum in scientific research and training activities, and Janice Carlson, formerly senior scientist in the Scientific Research and Analysis Laboratory, played an important role in the project, from participating in the early development meetings to define the parameters of the research to be undertaken, to participating in the November 1998 test painting cleaning experiments and being responsible for the research into aging characteristics of surfactants, a project component carried out at Winterthur. W. Christian (Chris) Petersen contributed his considerable experience and enthusiasm to the project despite his "retirement" from the DuPont Company in Wilmington, Delaware. He was especially instrumental in the surfactant studies carried out at Winterthur.

The preparation of this book also has been a collaborative effort. Although authorship of individual chapters is attributed to those team members with overall responsibility for the respective research components or for preparing the initial drafts, all authors contributed to revisions of all chapters. As project leader overseeing completion of the manuscript, I am particularly grateful for Jan Carlson's help in weaving the writing styles and content of the various chapters into a manuscript, and to Kristin Kelly and Cynthia Godlewski in the GCI's Dissemination and Research Resources Department for guiding our manuscript through all the stages involved in turning it into a publication. Thanks also go to Patrick Pardo in Getty Publications for shepherding the publication through the final phase of production and to Sheila Berg for her thoughtful copyediting of the final manuscript.

Acknowledgments

The preface mentions the individuals and institutions that played the major roles in this project. The following colleagues at the Getty and in the international conservation community made important contributions to various stages of the project.

The project team is grateful to the many GCI colleagues who contributed to the project. These are Jeanne Marie Teutonico, associate director, Field Projects and Science; in the Science Department, Gary Mattison, department coordinator; Nora Lavie, Tina Segler, and Stephanie Nuñez, staff assistants; senior scientist Michael Schilling, who assisted with some of the analyses; and Joy Keeney, research lab associate, who assisted in preparing the decision tree test kits. Colleagues in Information Resources, especially Thomas Shreves, Valerie Greathouse, and Jackie Zak, were very helpful in gathering what seemed like everything that had ever been written on surface cleaning theory and practice. In the Getty Museum, thank you to Kirsten Younger, Paintings Conservation intern, for kindly allowing us to interrupt her work on the Raoux painting in order to take samples.

The team is extremely grateful to Sandor Reichman, chair of the Department of Chemistry at California State University, Northridge, who supported the participation of David Miller in the project and the use of the radiochemistry laboratory at CSUN in developing and carrying out the cleaning experiments. We also wish to thank CSUN student assistants Pejman Javaheri, Sarkhadoun (Sam) Yadegar, and Yasmin Chaudhry.

Gregory Landrey, Winterthur Museum director of conservation, generously agreed to collaborate on this project. Joyce Hill Stoner, chair of the Winterthur/University of Delaware Program in Art Conservation (WUDPAC), supported the program's participation as a project partner through the contributions of Richard Wolbers. Subsequent chair, Debbie Hess Norris, continued that support. Alexis Miller, WUDPAC Fellow (Class of 2000), is acknowledged for the pilot study science project she carried out that created exposure and deterioration data on many of the surfactants involved in the research discussed in chapter 5. Bruce A. Lockett of the DuPont Company, Stine-Haskell Research Center, Newark, Delaware, is gratefully acknowledged for assisting Winterthur Museum with analysis of the volatile degradation products for the surfactant aging studies.

The project team also gratefully acknowledges the contributions of the following conservators and conservation scientists who took part in the experimental test cleaning discussed in chapter 3: Aviva Burnstock, Department of Conservation and Technology, Courtauld Institute of Art, London; Roberto Bellucci, Opificio delle Pietre Dure e Laboratori de Restauro, Florence; Paulo Cremonesi, Florence; Johann Koller, Doerner-Institute, Munich; Katharina Walch, Bayerisches Landesamt für Denkmalpflege, Munich; Joe Fronek, Los Angeles County Museum of Art; and Chris Stavroudis, private studio, Los Angeles. Chris Stavroudis undertook trial testing and revision of the decision tree and test kit developed by the project team and discussed in chapter 7 and is developing a database using this decision tree concept.

Introduction

Narayan Khandekar

The Surface Cleaning–Gels Research Project team focused on three main areas: quantitative measurement of surface residues of the various gel components after the cleaning process; the aging characteristics of the surfactants during both natural and artificial lighting and identification of the decomposition products that might present a long-term danger to the paint surface; and detection of residues on the surface of paintings and painted objects cleaned since 1984 using gel formulations and examination for any signs of deterioration that might be related to their use. The research reported in this book is concerned primarily with the cleaning, using aqueous solvent gels, of painted and varnished surfaces whose major components are natural resins. The research focuses on the cleaning of oil paintings, although it touches on other materials such as furniture finishes. In the field of conservation, cleaning is a much larger topic than is covered in this book, and we do not discuss all aspects of cleaning that a conservator is likely to encounter. In particular, it should be noted that we do not discuss the use of a number of aqueous gel formulations, including enzymes, chelating agents, and resin soaps.

Cleaning is one of the few conservation procedures that usually has more to do with aesthetics than with preservation of the physical object. Other activities in this category include infilling and inpainting. Although a strict definition of cleaning would be the removal of dirt, grime, or other accretions, in the conservation field "cleaning" is used in the broader sense to include removing unwanted layers of varnish, gilding, or paint from decorative surfaces and removing stains, salts, and other accretions from surfaces or substrates of objects. In a profession whose codes of ethics emphasize the principles of reversibility, it also is one of the few conservation processes that is inherently irreversible. Surface cleaning has serious implications in terms of aesthetic and physical changes to the object being cleaned, yet at times it has been undertaken almost routinely. For example, traditional easel paintings often were varnished with natural resin–based coatings; as these degraded— that is, became less transparent, yellowish or darkened, or soiled—with age, they were removed and replaced with similar materials that would in time degrade again; and the process would be repeated. Other objects, such as clear-coated pieces of furniture, suffered the same fate: French-polished furniture was refinished as a matter of routine maintenance; and architecturally engaged decorative finishes were often stripped and

redone as a matter of course or to accord with change in fashion. Because of its aesthetic implications, the cleaning of art objects has generated a number of controversies over the centuries (see Khandekar 2000). This is not to say that cleaning has only negative aspects. There are benefits as well, such as increasing the legibility and interpretability of the image.

Traditional cleaning methods for removing dirt, stains, or unwanted varnish or paint layers can be broken down broadly into three categories: mechanical, chemical (aqueous and nonaqueous), and noncontact (i.e. laser). The main mechanical means of removing the undesired layer is to use a tool such as a scalpel, usually with the aid of a magnifying loupe or a microscope. Abrasive methods—rubbing materials ranging from the fingers to powdered resins (e.g., mastic or dammar) to brick dust or ash—have also been used. Current materials for mechanical removal of dirt mainly from organic objects, textiles, and paper include dry "eraser"-type materials that act by direct transfer of soiling materials onto finely divided solids.

Air abrasives also have been used for objects, with size, hardness, and velocity of the abrasive being variables in the cleaning process. Boissonnas (1987) investigated the use of microfriction to remove varnish, fillings, and other materials from painting surfaces. He found it effective and safe within a range of surface conditions but recommended its use only when traditional methods had failed.

Over the past decade, lasers have been investigated and used as an alternative to air abrasives for small-scale cleaning of objects and for large-scale cleaning of architectural surfaces. Surface dirt deposits are usually removed with infrared (IR) visible lasers (e.g., Nd:YAG); ultraviolet (UV) excimer lasers are used for the removal of organic coatings. Lasers have been tested for cleaning paintings of dirt and varnish; however, they must be used with caution on painted surfaces until research provides a better understanding of their effects on pigments and potential changes to substrates (LACONA conference proceedings: Liverpool 1997; Florence 1999; Paris 2001).

Aqueous cleaning systems, as the name implies, make use of water in the cleaning process and usually are applied to remove soil from surfaces. As a very polar solvent, water may be used alone or to carry dissolved components such as small soluble ions, soaps, saliva, detergents, and chelating agents to the surface to be cleaned. Simple ammoniated solutions are still among the most common group of aqueous cleaning solutions. Saliva also is a ubiquitous aqueous cleaning material, largely because of its convenience but also because of its natural components that provide ionic, surfactant, buffering, and enzymatic effects. Other more "unusual" but primarily aqueous materials (now largely historical or anecdotal) have included wine, blood, milk, beer, solutions of potash and lye, and sliced foods such as potatoes, which have a high water content (Marijnissen 1967; Wolbers 2000).

Solvents essentially solubilize or dissolve the layer (e.g., varnish, retouching) that is to be removed—through the general concept "like

dissolves like." The more common solvents used to clean paintings and objects are ethanol, methanol, acetone, benzyl alcohol, xylene, toluene, mineral spirits, turpentine, and mixtures of one or more of these. Conservators involved in the pioneering design of cleaning methodologies developed empirical but effective solvent mixtures at various points. The mixtures usually varied in polarity to approximate the solubility parameters needed to solvate a particular coating and became codified, for example, Keck 1–4 (fig. 0.1) (Rabin 1978). These solvent mixtures still constitute and will continue to constitute an extended tool kit for the practicing conservator.

Solvents usually are applied with cotton-wool swabs or small brushes, but this does not provide control over capillary flow of the solvent over the surface and through the structure of the object. Methods of manipulating and/or controlling solvent action have included "solvent-restrainers" and "dilutions" (Laurie 1933; Feller, Stolow, and Jones 1959; Rees-Jones 1962) and wax-solvent pastes.

In addition to lack of control, limitations of solvent cleaning, as noted by Hedley (1993), are solvent toxicity, the difficulty of removing hard insoluble layers of overpaint, and the unknown long-term effects of leaching and swelling of the paint layer. Some traditional solvents are rarely, or no longer, used because newer cleaning methodologies provide less toxic and more effective alternatives. A number of solvent options were investigated in this research project (see chap. 4).

The introduction of gel-based aqueous cleaning methods, including organic solvent gels, by Richard Wolbers in the 1980s offered many advantages over pure organic solvents and solvent mixtures. The solvent gels advanced the initial solvent mixture strategies mentioned above. However, the new systems were emphasized as an addition to, rather than as a replacement for, organic solvents and other traditional methods.

Widespread application of aqueous cleaning systems followed their introduction. And at the same time concerns were raised regarding their use. One of the most important was that of potential residues on

Figure 0.1

Keck series of test solvents

Keck 1:	Acetone	10%
	Diacetone alcohol	5%
	Mineral spirits	85%
Keck 2:	Acetone	20%
	Diacetone alcohol	10%
	Mineral spirits	70%
Keck 3:	Acetone	30%
	Diacetone alcohol	30%
	Mineral spirits	40%
Keck 4:	Methyl alcohol	20%
	Acetone	10%
	Diacetone alcohol	20%
	Mineral spirits	50%

the surfaces of objects, particularly those cleaned with organic solvent gels. This book presents a summary of traditional cleaning methods, of the development of aqueous cleaning systems and the concerns they raised, and of the methodologies and results of the GCI Surface Cleaning–Gels Research Project, which was initiated to address the question of gel residues.

Chapter 1

Gelled Systems: Theory and Early Application

Narayan Khandekar

In the cleaning process, conservators are guided by the principle of effectively removing a layer or layers of dirt, undesired paint layers, or varnish without damaging or altering the mechanical or chemical properties of the paint layers, the surfaces to be retained, or the substrate. In objects conservation, cleaning also can involve removing salts or grime from the substrate of porous materials such as stone. For decorative surfaces, the conservator must identify the chemical difference between layers and develop a formulation that acts only on the layer or layers to be removed. The ideal cleaning agent would be single-acting; that is, it would act on one layer (or treat several as one) without affecting the layer(s) to be preserved.

What Is a Gel?

In the broadest sense, a gel is a water-based formulation thickened with a polymer or other high molecular weight material. Thickened solutions may be fairly simple in composition, such as a water gel, or they can be more complex, such as a gel containing methyl or ethyl cellulose (Heydenrich 1994), propylene glycol, fumed silica, a nonionic detergent, and triethanolamine (Grissom, Power, and West 1988). Historically, "packs," "pastes," "poultices," "gels," "compresses," and "pads" were the terms used for thickened solutions. The gel is a vehicle for carrying the "active" cleaning components to the surface to be cleaned. Organic solvents are the major active ingredients dealt with in this study. The recipe for the gel under examination is provided in the relevant chapters throughout this book.

Ingredients

A range of products constitute the "active" ingredients for conservation treatments. These act chemically, for example, aqueous reagents (e.g., alkaline glycerol, used to remove copper corrosion products [Scott 2002]), ammonia, other chelating agents (e.g., EDTA, ammonium citrates), biochemical agents such as enzymes, or organic solvents.

Along with the active ingredients, thickeners form the basics of gel systems. Thickeners are selected based on the properties that are most suited to a particular task: ease of mixing; the ability to hold the solution

to the surface of the object; the degree to which the cleaning action can be controlled; and the ability to completely remove the gel from the surface. Thickeners have included cellulose ethers such as methyl cellulose, hydroxypropylmethyl cellulose, carboxymethyl cellulose, and, more recently, the Carbopols, a series of polyacrylic acid polymers.

Additives may be incorporated for various reasons. Detergents increase the wetting capability to improve contact with the surface and remove dirt through micelle formation. Surfactants such as Ethomeen interact with gelling agents such as Carbopol to form the gel. Buffers maintain the solution at the optimum pH level for enzyme action or permanently alter the pH for a specific cleaning purpose.

Working properties

Gelled formulations are used to lengthen solvent retention time, to control the depth of penetration by limiting capillary action, to control the cleaning process on vertical or other complex surfaces, or to increase the gel's effectiveness in extracting the soiling or stain as the gel dries. Materials are selected or modified to achieve the desired working properties. Manipulation of the evaporation rate of the active cleaning agent is probably the most important property gel formulations offer.

Evaporation rate

Slowing evaporation can allow a solution to penetrate farther into a surface to solubilize material at some greater depth. Depth of penetration is essential, for example, to remove stains, salts, or inaccessible soiling embedded in porous substrates such as stone or ceramics.

Cleaning action

A gel can be thinned to allow some mechanical action during cleaning. However, thinning carries the risk of increasing absorption of the gel media into the surface layers or substrate. This is a particularly important factor for moisture-sensitive objects as they require a limited depth of penetration.

Traditional thickening methods

Thickened or paste materials such as soap mixtures have long been used for cleaning paintings in an effort to control the action of the traditional aqueous cleaning agents.

With the introduction of organic solvents as cleaning tools in the early part of the twentieth century, wax-solvent pastes were used to control solvent migration and penetration (Gridley 1991). In this cleaning process, the wax acted as a reservoir to prevent the solvent from migrating to surrounding areas and to reduce its evaporation rate. The limitations of this approach were the working properties of the wax-solvent formulation, the problem of wax residue, and the need to clear the residue with organic solvents.

Gels based on cellulosic products as thickening agents have been used as a form of poultice to remove grime and stains from the surface and substrate of objects. The range of cellulosic products includes methyl

cellulose (Goldberg 1989), ethyl cellulose (Heydenreich 1994), hydroxy methyl cellulose, sodium carboxymethylcellulose (Sumira 1990), and carboxy methyl cellulose. These formulations have shown great versatility in the cleaning of organic, inorganic, and composite objects. The high solvent to sorbent ratio of gels has contributed to their popularity (Goldberg 1989).

Aqueous Gel-based Cleaning Systems

The gel-based aqueous methods of cleaning painted surfaces introduced by Wolbers in the mid-1980s offered an optional new set of materials. More important, they offered a more comprehensive approach to selecting a system for specific cleaning problems. Although solvent gels are the focus of this research, other gel types are discussed to provide a broader context for the study.

Scientific basis

A comprehensive explanation of cleaning actions and the role of individual components of the three aqueous cleaning systems—enzymes, resin soaps, and solvent gels—is now available to the conservation community through the publication of *Cleaning Painted Surfaces: Aqueous Methods* (Wolbers 2000). Basically, the systems consist of a cleaning agent (organic solvent, enzyme, resin soap, etc.) held in an aqueous gel of a thickening agent, a surfactant, and a pH buffer. The gel reduces the capillary flow of the solvent and allows the cleaning agent to be applied with precise control so as not to dissolve all layers at once. In addition, a gel can be formulated to remove a specific layer, which offered tremendous advantages in that the layers can be selectively removed from the top down. For example, in theory, a more oxidized upper varnish layer (or layers) could be removed, leaving underlying layers untouched. It should be noted that solvent gels are different in concept from the other gels mentioned. In enzyme, resin soaps, and other dirt-removing formulations, the major component of the liquid phase is water that is thickened directly by a water soluble polymer thickener. By contrast, in solvent gels water is often present only in small proportions and the solvent is thickened indirectly by a polymer in an aqueous environment that is then mixed or emulsified into the solvent phase.

The systems are based on firstly identifying and understanding the layers or materials in the specific instance—those to be removed and those to remain. The first step in the identification process usually is examination of cross sections under normal and ultraviolet light, followed by the use of fluorescent dyes. Although the use of dyes (in the form of indicators or fluorescent markers) to identify binding media is not new in conservation (Johnson and Packard 1971; Martin 1977), Wolbers and Landrey improved the process so that the use of fluorescent dyes to characterize various layers formed a vital initial stage in tailoring a gel (Wolbers and Landrey 1987; Landrey 1990, 1993; Wolbers 2000).

The main advantages offered by the gelled systems are:

- control of the organic solvent evaporation rate and of capillary flow into surrounding areas and underlying layers
- control of the surface contact time to increase effectiveness of the cleaning agent and reduce potential effects on the surface
- minimizing human exposure to toxic organic solvents

Application to conservation

One of Wolbers's early presentations on his cleaning systems was at a Washington Conservation Guild meeting in Washington, D.C., in 1986. Another was at the Wooden Artifacts Group session of the 16th Annual Meeting of the American Institute for Conservation (AIC) (Wolbers, Reinhold, and Landrey 1988). Wolbers presented the theoretical and practical aspects of aqueous cleaning systems more fully to the conservation community through a series of workshops entitled "New Methods in the Cleaning of Paintings" and hosted annually by the Getty Conservation Institute in Marina del Rey, California, from 1987 through 1990. A workshop was also held in 1989 at the Courtauld Institute of Art, London, which was preceded by a one-day mini-conference on the topic; and in 1990, at the National Gallery of Victoria, Melbourne, cosponsored by the GCI, and at the Canadian Conservation Institute, Ottawa.

The development, application, and acceptance (or questioning) of this gel cleaning methodology by the wider conservation community has been gradual and cumulative. Various articles by conservators and scientists who had either participated in one of the workshops or had become informed and interested in this new development appeared in North American and European professional newsletters in the late 1980s. Articles by Chris Stavroudis and Sharon Blank (1989) as well as several by Anna Southall (1988, 1989) were the first in the United States and the United Kingdom, respectively, to try to explain to the conservation community the basis of the methodology and the advantages it offered.

Application to paintings conservation

Early applications of aqueous systems to the cleaning of paintings in the Winterthur Museum collection were carried out on two nineteenth-century oil on canvas works, *Winterscape: Skating on the Pond* (E. Von Liebrach) and *Venetian Canal Scene* (unattributed). The former had undergone a number of earlier treatments and was cleaned in 1988–89 using a solvent mixture to remove the resin varnish followed by a resin soap to remove residual coating. Recovery of the aesthetic presentation was undertaken on the latter in 1990 and required three steps: an abietic acid soap was used to remove the uppermost coating, a modified formulation of the soap was applied to remove an older coating layer, and a solvent gel was used to remove the original coating protected by the frame rabbet. More detailed explanations of the methodology for choosing the specific systems for these paintings, along with their application to other paintings and objects, can be found in *Cleaning Painted Surfaces* (Wolbers 2000).

Further, J. Paul Getty Museum paintings conservators Andrea Rothe and Mark Leonard applied one or more of the aqueous systems to a number of paintings in the Museum's collection during the early stages of their application to conservation, as a result of a workshop Wolbers organized during his guest scholarship in the Paintings Conservation lab in 1987. The paintings include *The Farewell of Telemachus and Eucharis* (Jacques-Louis David, 1818) (fig. 1.1) and *Christ's Entry into Brussels in 1889* (James Ensor, 1888) (Plate 1), both cleaned in 1987. Samples from these two paintings (both oil on canvas) were included in the examination of surfaces treated in the past with the aqueous system, a component of the Gels Research Project discussed in chapter 6.

Following the workshops, the aqueous systems were tested for their efficacy in specific cleaning situations in many other conservation labs. In 1987 Joe Fronek, paintings conservator at the Los Angeles County Museum of Art, reported on the use of a lipase gel to remove overpaint and a xylene emulsion used to remove both a varnish from deep impasto and an attempted thinning of an Acryloid B-67 acrylic varnish. Fronek noted that (a) his lack of experience with the new methodology may have been the cause of minimal success in these cleaning situations; and, importantly, (b) "enzymes, soaps and emulsions are not necessarily a substitute for other cleaning techniques [but] more and more we are discovering their effectiveness when other systems have failed" (Fronek 1987:10).

Other early applications in cleaning paintings were reported by Koller (1990) and Stringari (1990). Koller used resin soaps in an attempt

Figure 1.1

Jacques-Louis David (French, 1748–1825), *The Farewell of Telemachus and Eucharis*, 1818. Oil on canvas, 87.2 x 103 cm (34 1/2 x 40 1/2 in.). Los Angeles, J. Paul Getty Museum, 87.PA.27

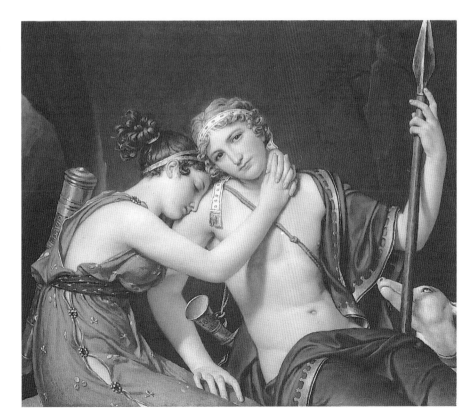

Figure 1.2
Tilt-top tea table, Philadelphia,
Pennsylvania; ca. 1765–80. Mahogany;
overall H: 71.4 cm (28 1/8 in.), diameter
of table top: 87.3 cm (34 3/8 in.).
Winterthur, Delaware, Winterthur
Museum, 60.1061. Courtesy, Winterthur
Museum.

to remove old varnishes from *Flora*, a nineteenth-century oil on canvas
by an unknown artist, on which three varnishes had been identified. This
was one of the first published accounts of concerns regarding gel
residues. Stringari used enzyme gel and solvent gel formulations to suc-
cessfully remove surface coatings and admixtures of facing and lining
residues from a triptych of van Gogh paintings that had proven very sen-
sitive to traditional solvent methods.

Application to furniture conservation
The main focus of research into the concerns of residue and leaching
from the use of aqueous cleaning methods has been in the paintings con-
servation field. But the early work at Winterthur Museum and the
Winterthur/University of Delaware Program in Art Conservation
addressed cleaning problems in objects and furniture conservation, par-
ticularly the conservation of varnished fine furniture. Furniture conserva-
tors, faced with the difficulty of removing modern synthetic varnishes
such as polyurethanes without damaging underlying shellac and other
natural resin-based layers, looked to the use of gels as a possible
solution.

 One of the first reported treatments of an object with an aqueous
cleaning system to solve a cleaning problem at the Winterthur Museum
was on a Philadelphia piecrust tilt-top tea table, ca. 1765–80 (fig. 1.2),
treated in 1988 (Landrey, Reinhold, and Wolbers 1988; Wolbers,

Sterman, and Stavroudis 1990; Wolbers 2000). Solvents alone did not sufficiently soften the polyurethane layer, applied in 1974, to allow for removal, and a two-step cleaning procedure was devised. The first step was a solvent gel to remove the bulk of the polyurethane and toning layer; the second was an enzyme/detergent gel to remove the residual polyurethane. (See Plate 9 and chap. 6.)

Additional examples of the use of solvent gels to selectively remove furniture coatings that could not be removed with traditional methods were reported by Susan Buck (1993) at the Society for the Preservation of New England Antiquities Conservation Center.

Chapter 2

Research into Potential Problems Arising from
the Use of Aqueous Cleaning Systems

Narayan Khandekar

Early difficulties with aqueous systems developed primarily as a result of incomplete understanding of their basic methodology. Because of these systems' potential to solve many previously unsolvable cleaning problems and because of the reduced health risks they offered, some conservators saw them as the ultimate cleaning tool rather than as an option to consider in a specific cleaning problem.

Gel Preparation

The sequence for adding the components is a key factor in successfully preparing the gel. Many conservators who did not participate in the early workshops and therefore did not have access to the course notes (Wolbers 1989) had difficulty mixing the gels. "Mixing guides" were provided by Southall (1989a), Stavroudis and Blank (1989), and Stavroudis (1992). Widespread dissemination of the information, step-by-step descriptions of the mixing procedures in *Cleaning Painted Surfaces* (Wolbers 2000), and greater general familiarity with the systems have addressed this problem.

Potential Problems with the Aqueous Systems

One concern that arose as the systems were being widely incorporated by conservators as an additional cleaning tool was whether they would have long-term effects on the surface and substrates of paintings and objects. A number of institutions initiated research studies in an attempt to address this concern. The 1990 IIC Brussels Congress, "Cleaning, Retouching and Coatings: Technology and Practice for Easel Paintings and Polychrome Sculpture," included seven presentations dealing with cleaning issues, four of which addressed aqueous systems (Wolbers 1990; Koller 1990; Burnstock and White 1990; Stringari 1990). In the same year, Dimond (1990) raised questions about the efficiency of the cleaning action of abietic soap in resin soap formulations.

 The main questions, and hence the focus of the research, were as follows:

- Cleaning mechanism: What is the precise role of each component in a gel formulation? What is the active ingredient? How does each component contribute to the cleaning process?
- Clearance: What is the most effective clearance method? How does clearance affect the remaining paint and/or varnish film?
- Gel residues: What are the residues? How will any residues themselves change over time? How will they react with the paint and/or varnish film over time?
- Leaching of the paint film: To what extent do the aqueous systems cause leaching? And how does this compare to leaching by traditional solvent use?

Subsequently, some of the research studies themselves raised another issue—the suitability of the substrates used in the experiments and hence the validity of conclusions drawn from certain experiments. Heated debates over this issue took place in the Correspondence section of *Studies in Conservation* (Bischoff 1995; Erhardt 1995; Erhardt and Bischoff 1994; Phenix 1995; Stavroudis 1995; Wolbers 1994). As a result of the criticism they received, some researchers have been reluctant to continue working in this area.

Because the main concern of the Gels Research Project was the question of organic solvent gel residues, this chapter focuses on the issue of residues, which includes clearance. A brief summary of the research carried out on the role played by the gel system components is provided. Summaries of additional articles reporting research on residues that are not included in the following sections, along with those addressing other concerns, can be found in an unpublished review of the literature on paint films, traditional cleaning approaches, and the Wolbers cleaning systems by Lang (1998) and in a review of relevant literature by Khandekar (2000).

Cleaning mechanism

One of the first attempts to explain the cleaning mechanism was a series of articles by Stavroudis and Blank (1989). In her 1990 study of detergents, soaps, and surfactants, Southall noted that surfactants are an integral part of the aqueous gel system, citing Triton X-100 as an example of a nonionic surfactant used in these gels. She expressed concern that surfactant residues may change the solubility parameters of the binding medium on paint films and present the potential for damage.

An investigation into the effects of alkaline cleaning agents, including solutions, pastes, and soap gels, on an artificially aged mastic varnish by Burnstock and Learner (1992) showed that cleaning effectiveness was increased with a higher pH level. Gelling the reagent, for example, ammonia, increased the rate at which it worked, possibly because the gel decreased its volatization.

The uncertainty about the nature of the active ingredient in the gel formulations was noted by Phenix (1993) as one of three main concerns regarding use of the gels. And in 1994 Erhardt and Bischoff

reported on an assessment of major components of gels and resin and bile acid soaps—TEA, abietic acid, deoxycholic acid, and hydroxypropyl-methylcellulose (HPMC)—and their effect on oil paint films individually and in combination. They noted that "gelling also tends to increase the strength of weakly active cleaning mixtures, although it has the opposite effect on strong cleaning agents" (Erhardt and Bischoff 1994:18).

The active ingredient of solvent gels has not been questioned; it is obviously the solvent. A solvent gel is typically made of Carbopol (polymer), Ethomeen (surfactant), water, and organic solvent. The dissolving power of the solvent is increased through gelling when compared to the pure liquid. This can be due to a combination of factors: the gel slows the evaporation of the solvent, creating a microenvironment of solvent and solvent vapor; and the presence of water and surfactant will alter, possibly to a significant degree, the activity of the liquid during cleaning. The activity of a solvent gel differs significantly from the free solvent, and it is these differences that can be exploited during the cleaning process.

Clearance and gel residues

Because of their volatilities, organic solvents have not generated particular concern about clearance. But clearance was one of the first concerns raised following the introduction of the gelled systems containing nonvolatile cleaning agents. Carlson (Carlson, Stavroudis, and Blank 1990) raised this issue in a letter to the editor of the WAAC Newsletter following publication of the 1989 series of articles by Stravroudis and Blank. In response, Stravroudis and Blank (1990) acknowledged that clearance was an important issue and proposed a three-step clearance procedure for the enzymes, soaps, and solvent gels. Southall (1990) also noted that clearance was a concern.

A study by Burnstock and White (1990) on a simulated painting showed that significant amounts of white spirits and water were required to remove the nonvolatile components of the soap gel and that a residue sometimes remained. They noted that the problem of undercutting during cleaning is a possibility; that is, it can remove a layer beneath the uppermost layer, which then erodes. This study raised major concerns about the long-term effect of nonvolatile components as residues and the effects of leaching by the solvents required to clear the gels.

Surfactants contain a hydrophilic end and a hydrophobic end. If the dissolved surfactant is in a low concentration in an aqueous system, it acts like any other solute. As the concentration is increased, a specific point is reached at which the surfactant molecules orient themselves into spheroidal clusters with the hydrophobic ends inward and the hydrophilic ends outward in contact with the water. These clusters are called micelles, and the point at which they form is called the critical micelle concentration (CMC). It is at the CMC that the surfactant can lower the surface tension of water. The formation of micelles is described in detail by Wolbers (2000:chap. 3).

Wolbers (1990) investigated the amount of residual surfactant as a function of pH and of CMC using three radioactively labeled surfactants—sodium deoxycholate, sodium palmitate, and Triton X-100—in the experiment on sections of an early-twentieth-century test painting (the same painting later used in the Gels Research Project experiments). The radioactive labeling allowed the residue to be accurately detected and the amount calculated as a percentage of the applied material. Considerable surfactant residues were found at high CMCs and a pH of 12.5 (higher than would normally be used to clean a painting). This was a significant finding, given the concerns put forward by Burnstock and White (1990) regarding potential peroxide formation from Triton X-100 residue. As a result, Triton X-100 generally is no longer used in resin soaps and other gel formulations. (Another reason that Triton X-100 is avoided is its ability to mimic estrogen during decomposition, making it an environmental hazard.) The study highlighted the importance of choosing the surfactant carefully so as to reduce the amount of residue (the article did not specifically address the question of clearance).

In a second series of experiments involving application of a predetermined soiling mixture on an aged test oil film, reported by Wolbers in 1992, the amount of residue was minimized by using a lower pH to control the swelling of the paint film and using surfactants below their CMC. The mechanical action of the swab removed loose surface materials, but aqueous agents were needed to remove the more tenacious material. These experiments provided a number of useful optimal parameters for tailoring the gel to a cleaning problem: adjusting the pH and selecting a surfactant based on its CMC.

Burnstock and White (1993) investigated potential solvent gel residues on the surface of a canvas used in their previous studies on the action of resin soaps. The canvas was cleaned with xylene, propan-2-ol, or white spirit/industrial mineral spirits gelled with Carbopol 934 and Ethomeen C/12 and C/25. In addition, a xylene-water emulsion with Triton X-100 as the surfactant was used. Scanning electron microscopy (SEM) examination of the canvas surface revealed no apparent residue but did reveal surface differences between areas cleaned by the emulsion and those cleaned with gels.

In 1996 Burnstock and Kieslich reported on the use of four procedures to remove Ethomeen-containing solvent gels from two substrates: an eighteenth-century painting fragment used specifically for research and a simulated canvas painting. In order, the procedures were: dry swab; saliva followed by a 25% aromatic hydrocarbon solvent mixture (xylene in Stoddard solvent, white spirit); an aromatic hydrocarbon (Shellsol A); and the same solvent mixture present in the gel (propan-2-ol/toluene; xylene/propan-2-ol; or xylene/propan-2-ol/Stoddard solvent). Analysis of the residues by gas chromatography–mass spectrometry (GC-MS) and SEM indicated abrasion of the surfaces and the presence of unbound pigment particles and possible erosion of the binding medium from both solvent gel and solvent mixture clearance and from free solvents. The

authors recommended future studies on the long-term effects of residual components of gel formulations containing Ethomeens.

Organic solvent gel residues

The project has provided quantitative data on the amount of residue that can remain after cleaning with a solvent gel. Chapter 3 discusses the methodology developed to provide these data and the subsequent results of cleaning experiments on paintings and on similar tests later carried out on four material types commonly found on objects in museum collections. (The methodology used to obtain the data built on Wolbers's earlier work with radioisotopes for measuring residues [Wolbers 1990].) This research was carried out in the laboratory of the Department of Chemistry, CSUN. It was led by GCI senior conservation scientist Dusan Stulik and CSUN Department of Chemistry professor David Miller and involved the entire project team. A group of international conservators and scientists took part in the cleaning experiment with solvent gels on sections of a study painting. (See also Stulik et al. 2000, 2002.)

Aging characteristics of surfactants

The aging component of the project was carried out by Janice Carlson and W. Christian Petersen in the Analytical Laboratory of the Winterthur Museum, Garden and Library from 1998 through 2000. Chapter 5 reports on the results of this study, which focused on the degradation rate of residues from various surfactants already in use or likely to be used on both a reference oil film and a study painting.

Detection of residues on the surface of objects previously cleaned with aqueous gels

Objects that have been cleaned with gel systems provide an opportunity to examine both the extent of residues left on the cleaned surface and their longevity and to relate the presence of gel to any negative effects. Objects from the Winterthur Museum, Garden and Library and the J. Paul Getty Museum were included in the study, which was led by Narayan Khandekar, formerly a GCI associate scientist. Chapter 6 reports on this study (see also Khandekar et al. 2002).

Additional components

Revisiting organic solvents

During the gel residues studies, it became apparent that updated comparative testing was needed on the main traditional cleaning method—organic solvents or solvent mixtures—in order to put the results of the solvent gel residues experiment into perspective. Ten commonly used organic solvents were included in a cleaning experiment similar to that carried out with the solvent gel. The methodology and results of this study are the subject of chapter 4. Also included are the results of an experiment to test the evaporation rates of the solvents and to identify any residues. This study also was carried out in the CSUN Chemistry Department laboratory; it involved most of the project team.

Parameters for designing a specific gel formulation

In discussions with conservators, it became clear that they would welcome a methodology or decision-making tool to simplify the process of developing gel formulations that would be the most effective in solving cleaning tasks with minimum risk to the surfaces. Dusan Stulik and Richard Wolbers began this daunting task with an initial methodological system of a "logic tree" and test kit of cleaning materials. The status of this work is reported in chapter 7.

Chapter 3

Research into Solvent Gel Residues

Dusan Stulik and David Miller

Our research into solvent gel residues involved two controlled cleaning experiments—one using sections of a sacrificial painting, the other using samples of varied porosity and complex surfaces of materials found in objects collections. This chapter presents the methodology, the steps of the cleaning experiments, and the results of the quantitative study of cleaning gel residues on paintings and other gel-cleaned surfaces.

Development of the Scientific Methodology

Experimental strategies

The detection and quantitative determination of small amounts of gel residues require a very sensitive analytical technique. In principle, there are several possible experimental approaches for measuring gel residues on materials such as a cleaned paint surface:

- Physical methods: mass determination; scanning electron microscopy (SEM)
- Chemical methods: direct chemical analysis; fluorescent or radioactive tracers

A direct mass measurement is not feasible, however, because the amount of gel residue after cleaning and solvent clearing is too small to be quantified using even a very sensitive analytical balance. Furthermore, the residue is deposited during the cleaning process that removes a surface layer. This does not allow an initial sample mass to be established.

Some attempts have been made to characterize and identify gel residues using SEM (Burnstock and White 2000). Surface deposits were observed in the SEM images, but it was difficult to identify the deposits as gel residue rather than a varnish layer left on the surface in the cleaning process. Alternatively, the cleaning gel could be doped with a heavy element (e.g., iodine), which would permit use of an energy dispersive spectrometer to make a semiquantitative estimate of gel residues and to map the presence of gel residue across the cleaned surface.

Gel residues can be determined by direct chemical analysis, and some experiments have been done to detect gel residues using gas chromatography–mass spectrometry (GC-MS) (Burnstock and White 1990).

Chapter 6 describes a series of experiments conducted to develop an experimental methodology to identify and analyze gel residues using pyrolysis gas chromatography and pyrolysis GC-MS techniques.

Many chemical and physical processes can be studied in detail using tracer techniques. In general, the tracer can be a chemical element, a stable or radioactive isotope, or a stable or radioactively labeled compound that can be monitored to trace the movement or change in concentration or distribution of a particular material in the chemical, biological, or physical process under study. For gel cleaning studies, it would be possible, in principle, to use fluorescent tracers. This would require labeling the individual components of a gel with fluorescent dyes and developing a suitable method to quantitatively detect the fluorescent moieties. This experimental approach was not chosen because a number of fluorescence-quenching processes can interfere with such measurements. For example, it is well known that heavy elements such as lead, which are abundant in many cleaned paint layers, can cause fluorescence quenching.

However, the use of radioactively labeled materials as tracers offers certain advantages. Foremost among these are that radioactivity can be detected with a high level of precision and accuracy and that such measurements are much less prone to the interference problems that make the use of chemical and spectroscopic methods of measuring small amounts of gel residues difficult. These features of the method stem largely from the fact that the concentration of naturally occurring radioactive isotopes and background radioactivity is very low. This, in combination with the high detection sensitivities of modern radiation counters, allows extremely small amounts of radioactivity to be measured. The experimental procedures based on the use of radiolabeled compounds are therefore relatively straightforward and the interpretation of data from such experiments relatively simple. Another major advantage is that labeled compounds behave nearly identically to their nonlabeled counterparts in both chemical and physical processes. Infinitesimal differences in the physical properties of radioactive compounds in comparison to nonradioactive analogs allow the use of labeled compounds to study many processes involving the transport of chemical compounds or the change in concentration of compounds. These advantages led us to focus our experimental methodology on the use of radioactive tracers in the form of radioactively labeled gel components. This choice was also supported by Wolbers's (1990) success in initial experiments using radiolabeled materials to study the problem of gel residues.

The radioactive tracer approach also has certain disadvantages. Among these are the need to label desired compounds with a radioactive isotope and the high cost of labeled materials. In addition, the work must be conducted in a laboratory approved for work with radioactive material and by trained and certified personnel.

Labeled materials

Natural radioactivity was discovered by Antoine-Henri Becquerel in 1896. In 1913 Georg Hevesy used radioactive tracers to determine the

solubility of lead salts in water and to follow the movement of radio-nuclides from soil into plants and the movement of food through animal systems (Ehmann and Vance 1991). Advances in the use of radioisotopes were made after 1934 when Frédéric and Irène Joliot-Curie prepared the first artificial radioisotope. The use of the radioisotopes and labeled compounds in all branches of science and medicine increased substantially after 1946 when radionuclides were first prepared on a large scale using nuclear reactors.

The vast majority of radioactively labeled materials have used beta emitters such as tritium (^3H) and carbon-14 (^{14}C) for the radiolabel. The radiation from such radionuclides is rather safe to work with and can be detected efficiently. Also, because of the long half-lives of ^3H and ^{14}C, these labels are suitable for a wide range of experiments. Radioactive tritium and ^{14}C are produced in nuclear reactors by bombardment of a suitable target material with neutrons.

Although a number of radiolabeled chemicals are commercially available, the user often has to synthesize the radioactive form of unique and complex molecules. A number of factors, in addition to feasibility and cost, that affect the use of the final radiotracer need to be considered when synthesizing the radiolabeled substance:

- decay mode
- physical half-life
- availability of a radionuclide
- chemical procedures involved in radiolabeling
- specific activity of the labeled substance
- radiology of the labeled substance

In isotopic labeling, a compound is labeled with a radioisotope of an element already present in the compound so that the resulting substance is identical, apart from the isotope, to the unlabeled substance. Two main types of labeling are possible:

- specific labeling, which yields molecules where the radioactive atoms occupy known positions; and
- random labeling, which yields molecules where the radioactive atoms are distributed in a random pattern.

Carbon-14-labeled compounds may be specifically labeled or randomly labeled and are prepared by chemical synthesis. Tritium-labeled compounds usually have general labeling and are prepared by isotope exchange reaction procedures.

The specific activity (SA) of a radiotracer preparation is the amount of radioactivity of a given radionuclide per unit amount of a radioactive compound. Typical units of specific activity are curies (Ci) per gram or per mole, or becquerels (Bq) per gram or per mole. One curie corresponds to 3.7×10^{10} disintegrations per second (dps), and 1 Bq corresponds to 1 dps. Although a substance may be associated with a very high specific activity (e.g., 50 Ci/mol), a sample with curie

amounts of radioactivity is highly radioactive and requires special shielding and handling to protect the user. Typically, millicurie (mCi) or microcurie (μCi) amounts are used in radiotracer experiments.

Radiolabeled compounds are not as stable as their nonradioactive counterparts, because of internal and external radiolysis. This does not have a great influence on short-term experiments, but it should be considered for long-term experiments. As a guide, typical rates of decomposition of some radiochemicals under optimum conditions of storage are:

^{14}C-labeled compounds: 1%–3% per year
^{3}H-labeled compounds: 1%–3% per month

Radioactively labeled materials are often stored at low temperatures to reduce the rate of radiolysis reactions.

Beta decay

Beta (β^-) decay is a nuclear process in which a neutron (n) is converted into a proton (p) as a radionuclide spontaneously transforms into a more stable form.

$$\beta^- \text{ decay:} \qquad\qquad n \rightarrow p \ + \ e^- \ + \tilde{\nu}_e$$

During β^- decay an electron (e^-) and an electron antineutrino ($\tilde{\nu}_e$) are also formed and ejected from the nucleus. This high-energy electron is the beta radiation that is typically detected for this type of nuclear decay. As noted above, both tritium and carbon-14 undergo β^- decay. When tritium (^{3}H) decays, one of the two neutrons present in its nucleus is converted to a proton and the tritium nucleus is transformed into a stable isotope of helium (^{3}He). A similar process occurs in the nucleus of ^{14}C (6 protons and 8 neutrons) as it decays to stable ^{14}N (7 protons and 7 neutrons).

The energy of the electrons emitted in the beta decay of tritium and carbon-14 is actually quite low (see table 3.1), and these electrons are rather easily absorbed by the surroundings, including the labeled sample itself. Consequently, liquid scintillation counting must be used to efficiently detect these beta emissions and to quantify the amount of radioactive label present in the sample.

Liquid scintillation counting

The process of liquid scintillation counting is relatively simple. In this technique, the sample containing the radiolabel (^{14}C or ^{3}H) is placed in a glass (or plastic) vial and covered with a counting solution (scintillation

Table 3.1

Selected properties of radiolabels for hydrogen and carbon

Element	Mass Number	Decay Mode	Half-life (yr)	Max. Decay Energy (MeV)
Hydrogen (^{3}H)	3	beta (β^-)	12.32	0.0186
carbon (^{14}C)	14	beta (β^-)	5715	0.157

cocktail). Then each vial is placed in the scintillation counter, where it is transferred to a light-tight chamber and counted.

The detection and measurement of the β^- decay events are achieved via capture of the beta emissions by a system of organic solvents and solutes (scintillation cocktail) that surrounds the sample. A basic scintillation cocktail consists of the following components:

- solvent
- fluorescing solute
- solubilizing agent
- wavelength shifter

The β^- decay electron emitted by the radioactive isotope in the sample excites solvent molecules, which in turn transfer the energy to the fluorescing solute, or fluor. The energy emission of the solute (light photons) is converted into an electrical signal by a photomultiplier tube. The basic steps in this counting process are outlined in figure 3.1.

Because of its abundance in the scintillation cocktail, the solvent is the principal substance that captures the energy of the beta particle. As a result, the solvent molecule is promoted to an energetically excited state. The solvent remains in this excited state for an extended period before either decaying to the ground state without the emission of light or transferring its energy to the solute. The excited solute quickly returns to the ground state by emitting light. If a secondary solute is used, that solute absorbs the emission of the first solute and emits a second burst of light at a longer wavelength.

Soon after the discovery of the basic principles of liquid scintillation in 1950, instruments designed for counting became available, the first commercial model in 1954. Figure 3.2 is a schematic diagram of a typical liquid scintillation counter. Most commercial scintillation counters are coincidence systems utilizing photomultiplier tubes (PMTs) in tandem to monitor beta decay events. A pulse (count) is not registered unless both PMTs detect some minimum number of the many photons produced by a given beta decay event within a predetermined time interval, usually 20 to 30 nanoseconds (nsec.). If each of the PMTs is triggered within the 20–30 nsec. window, a coincidence pulse is recorded that is a measure of the number of photons detected during the coincidence time interval. If only one of the PMTs is triggered, a coincidence pulse will not be produced.

Figure 3.1

Sequence of steps in the liquid scintillation counting process

BETA DECAY:	$X \rightarrow Y + \mathbf{e^-}$
SOLVENT EXCITATION:	$\mathbf{e^-}$ + solvent \rightarrow **solvent**
ENERGY TRANSFER:	**solvent** + solute \rightarrow **solute** + solvent
SOLUTE FLUORESCENCE:	**solute** \rightarrow solute + **light**
DETECTION:	**light** + photomultiplier tube \rightarrow **electrical signal**

Note: The successive stages involved in the transfer of energy are highlighted in boldface.

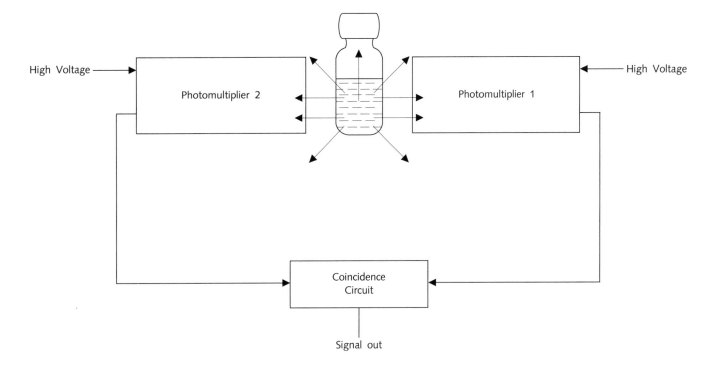

Figure 3.2

Schematic diagram of a scintillation counter

Several physical processes can interfere with the liquid scintillation counting process: chemiluminescence, photoluminescence, and other phenomena generally referred to as background. The greatest problem affecting counting efficiency is quenching. Quenching is any process that affects the energy transfer steps noted in figure 3.1 and results in a reduced observed count rate. There are several types of quenching, all of which serve to disrupt the normal chain of events in scintillation counting. Chemical quenching involves an impurity that interferes with the energy transfer between solvent and solute or the fluorescence emission of the solute. Color quenching is caused by the presence of a substance that absorbs the fluorescence emissions by the solute(s). Quenching can also result from absorption of the β^- radiation because the radionuclide is not in the same phase as the scintillation cocktail.

Both experimental and mathematical methods have been developed to deal with scintillation counting interferences and problems of quenching. The mathematical methods are usually incorporated into the software used by scintillation counters to measure the radioactivity of a given sample and to properly calculate corrected disintegration rates.

Quantitative Study of Gel Residues on Paintings

Test painting

Extensive testing of procedures using the solvent gels and measurement of gel residues required a large area of an uncleaned, well-aged painting that did not have any historical value and could be destroyed during experiments. The Gels Research Project team was fortunate because the material needed was available in the form of a large painting by the American artist Frank Linton, painted in 1911, which had been damaged,

with a major part—the face—missing. The painting, together with its still intact counterpart (Plate 2), had been donated to the Winterthur University of Delaware Program in Art Conservation for research purposes (it is the same painting used in Wolbers's 1990 study). There is no existing photograph of the painting before it was vandalized, and all judgments about its character and the execution of the painting had to be made by studying surviving painting fragments and by comparison with its counterpart, with which the vandalized painting formed a portrait set.

The painting, 2155 mm × 1230 mm, was a full figure portrait of a gentleman. It had been executed on a heavily glue-sized, plain-weave jute canvas with 15 × 15 threads per inch in both the warp and weft directions (Plate 3). A cross section was studied under the microscope to provide information about the inner structure of the painting (Plate 4), and numerous samples were removed for identification of pigments using polarized light microscopy (PLM) and binding media using Fourier transform infrared spectrophotometry (FTIR) and GC-MS. The pigment identification was confirmed using nondestructive X-ray fluorescence spectrometry (XRF).

The white ground layer on the top of the sized canvas was identified as a mixture of lead white and chalk bound in linseed oil. Paint had been applied relatively simply in two or more layers, with no intermingling of the layers. The binding medium was identified as a mixture of linseed oil and natural resin (fig. 3.3). The paint layer was covered with

Figure 3.3

GC-MS chromatogram of the paint layer showing peaks characteristic for both drying oil and natural resins

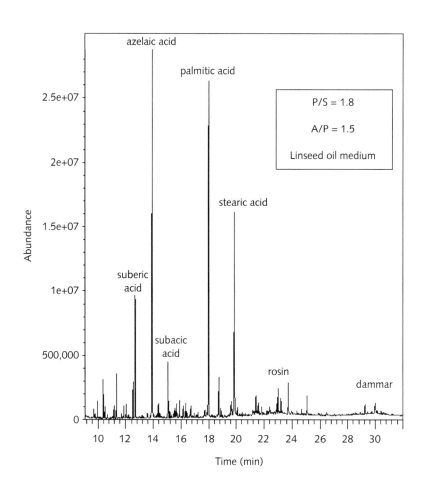

what seemed to be two layers of varnish. The thick lower varnish layer was identified as mastic varnish containing some oil. This layer was covered with a much thinner layer of another oleoresinous coating that had a larger amount of oil added to it. The results of fluorescence staining experiments supported these conclusions. The presence of oil in the lower varnish layer could be explained as the deliberate addition of a drying oil in the resin varnish or as a result of diffusion of resin into the paint layer. The top varnish was visually the most disturbing; it had substantially yellowed with aging and was the most difficult to dissolve. It was covered by a very thin layer of dirt and dust particles. It is believed that the painting had not been cleaned in its lifetime. This determination is based on the apparent presence of a soiling layer on its (original) paint surface and on the oleoresinous varnish applied to it (as indicated in the cross section). Also, none of the usual indications of prior cleaning were detected, such as staining on the reverse of the canvas, disparities in the autofluorescence of the surface coating, and abrasion of the paint surface.

Selection of the solvent gel

An initial testing or screening for solubility with three series of solvent mixtures, based on simple binary mixtures of isopropyl alcohol, acetone, and Shellsol (Shell Odorless Mineral Spirit, formerly Shell Sol 71) (fig. 3.4), indicated that only pure isopropanol or mixtures with substantial amounts of isopropanol seemed to have any effect (i.e., swelling) on the second (later) oleoresinous coating. Therefore, it was anticipated that isopropanol, coupled with a surfactant in a gelled arrangement or system, might be an effective and efficient tool at both swelling and dispersing the complicating oil fraction of the coating. In fact, oil-containing or oil-modified coatings such as those detected on the surface of the painting are often more effectively swollen or solvated with the addition of an aromatic solvent in small proportions to a more generally polar solvent (see the Appendix at the end of this chapter). In this study, a mixture of isopropanol and benzyl alcohol (10:1) was prepared in a gelled formula for this reason. Ethomeen C/25 was chosen as the surfactant based on the net polarity of the isopropanol/benzyl alcohol solvent mixture. A sufficient quantity of Carbopol 954, along with a small amount of deionized water, was added based on a typical solvent gel recipe to complete gel preparation.

Figure 3.4

The test series of solvents

Test Series 1	Test Series 2	Test Series 3
Neat Shellsol	Neat Shellsol	Neat Acetone
3:1 Shellsol: Isopropanol	3:1 Shellsol: Acetone	3:1 Acetone: Isopropanol
1:1 Shellsol: Isopropanol	1:1 Shellsol: Acetone	1:1 Acetone: Isopropanol
1:3 Shellsol: Isopropanol	1:3 Shellsol: Acetone	1:3 Acetone: Isopropanol
Neat Isopropanol	Neat Acetone	Neat Isopropanol

Preparation of radioactively labeled gels

Four cleaning gels were prepared for the experiments. All gels had the same chemical composition; the only difference between individual gels was the addition of a very small amount of a radioactively labeled gel component. The amount of this radiolabel was so minuscule (typically 100 μL) that it did not alter the properties of the gel. Each of the four gels had only one labeled component. This not only permitted quantitative determination of the gel residue on the cleaned surfaces but also provided information about the composition of the residue.

The formulation of the gel used for cleaning the test painting was based on microscopic examination of the cleaned surface, chemical analysis of paint cross sections and individual layers of the painting structure, and cleaning tests using solvents, solvent mixtures, and solvent gels. The detailed composition of the four gels is given below, with the labeled component in boldface.

GEL C
2 g Carbopol 954 + 60 μCi ^3H-labeled Carbopol
20 mL Ethomeen C/25
10 mL benzyl alcohol
100 mL isopropanol
~10 mL deionized water

GEL E
2 g Carbopol 954
20 mL Ethomeen C/25 + 60 μCi ^3H-labeled Ethomeen C/25
10 mL benzyl alcohol
100 mL isopropanol
~10 mL deionized water

GEL B
2 g Carbopol 954
20 mL Ethomeen C/25
10 mL benzyl alcohol + 60 μCi ^{14}C-labeled benzyl alcohol
100 mL isopropanol
~10 mL deionized water

GEL P
2 g Carbopol 954
20 mL Ethomeen C/25
10 mL benzyl alcohol
100 mL isopropanol + 60 μCi ^{14}C-labeled isopropanol
~10 mL deionized water

Each gel was prepared using the following procedure:

1. Measured amounts of Carbopol and Ethomeen were quickly and thoroughly mixed in a 250 mL glass beaker using a glass stirring rod to form a smooth paste free of Carbopol lumps.

2. The isopropanol and benzyl alcohol were added to the Carbopol-Ethomeen paste, and the mixture was stirred again to achieve a smooth consistency.
3. A small volume of solution containing the radiolabeled component was added to the mixture and thoroughly blended.
4. Deionized water was added to the mixture in small (mL) increments with constant stirring until a semiclear gel (viscosity approx. 20–30K centipoise [cps]) was obtained.

Each gel was placed in a wide-mouth, screw-cap jar and labeled with information about the gel composition, the radioactive component and amounts, and the date of preparation. A radioactive material label was also affixed to the jar.

The radioactively labeled gels were prepared in the Chemistry Laboratory of CSUN, because it is licensed for work with radioactive material. All procedures for handling, working with, and disposing of radioactive material, as well as all safety measures and rules required when working with radioactive material, were strictly followed.

Development of the experimental methodology

Experimental procedure
The cleaning experiments conducted were based on two assumptions: (1) that radiolabeled materials behave identically to their nonradioactive counterparts; and (2) that it is possible to achieve quantitative accountability of the radioactively labeled material. The experimental procedure can be divided into three individual steps:

STEP 1
Square openings measuring 5 cm × 5 cm were cut into 2-mm-thick sheets of dental wax (fig. 3.5). The dental wax was then heated using a laboratory heat gun and pressed onto approximately 7.5 cm × 7.5 cm

Figure 3.5

Preparing the cleaning well

fragments cut from the sacrificial test painting to delineate the working area for a gel cleaning experiment.

Each conservator participating in the cleaning experiment was given about 1.0 gram of radiolabeled gel, a fraction of which they distributed across the experimental well in the dental wax using one or more cotton swabs that each individual had prepared in his or her usual way. The total mass of gel used for each cleaning was measured.

STEP 2

After applying the gel, each conservator used his or her cleaning technique to remove surface dirt and the yellowish oleoresin coating from the painting surface within the wax well. Each was free to use any number of cotton swabs and any combination of dry and wet (typically 3:1 isopropanol:mineral spirits) swabs, including reapplication of fresh gel, to achieve the agreed level of "cleanness" of the painting surface (fig. 3.6).

The only restriction on the experimenters' freedom to proceed as though they were working in their own studios was to not put too much dirt on any individual swab since this could cause problems during the liquid scintillation counting step of the experiment (see *Self-absorption due to gel mass and swab*, below). Each swab used in cleaning and removing the gel was collected by assisting scientists and measured for radioactivity.

STEP 3

Fourteen individual 12-mm-diameter disks were punched out of the cleaned and cleared painting area using a sharp laboratory cork borer (fig. 3.7). The fourteen gel residue–containing disks accounted for more than 60% of the cleaned area and provided good experimental statistics. The number of disk samples also allowed experimenters to deal with the localized inhomogeneity of the painted surface and with the heterogeneity of the cleaning procedure itself.

Each disk and used swab was placed into a 20-mL screw-cap glass scintillation vial and prepared for scintillation counting. Several

Figure 3.6

Clearing the gel from the cleaned area of a painting sample, using an isopropanol–mineral spirits (3:1) mixture

Figure 3.7

Punching disks from the cleaned surface of a painting sample using the 12-mm-diameter cork borer

approaches were taken to ensure a quantitative determination of the gel residue on the painted surface. Some disk samples were first treated with 50 µL of a 2:1 toluene:Ethomeen C/12 mixture to disperse any gel present. Others were treated with 50 µL of Ethomeen C/12 only, and the remaining disks were left untreated. Finally, 18 mL of scintillation cocktail (Beckman Ready Solv HP) were added to the vial and thoroughly mixed. Care was taken to ensure that each disk sample was positioned in the vial with the painted surface up.

Swabs used for cleaning and clearing were prepared for counting by first adding 0.5 mL of a 1:1 toluene:Ethomeen C/12 mixture and 9 mL of scintillation cocktail. After vortexing the sample for 15 seconds, another 9 mL of scintillation cocktail was added and the vial capped.

All samples were counted with a Beckman LS1801 liquid scintillation counter. A Beckman Model 6500 liquid scintillation counter was used for subsequent experiments (fig. 3.8). Samples were counted for 1 to 5 minutes or until the uncertainty in the count rate (2δ) was less then 5%. Both quenched and unquenched ^3H and ^{14}C standards were counted in a similar way, and quench correction curves were constructed and used to convert individual sample count rates to disintegration rates. From knowledge of the gel composition and measurement of the disintegration rates for radiolabeled gel samples and swabs or gel residue–containing paint samples, it was possible to determine the amount of radiolabeled cleaning gel component present in the swab and remaining on the surface of the test painting samples (target information in this study).

Verification of experimental procedure

In developing a working methodology for the radioactivity measurements needed in these gel cleaning experiments, we experienced some problems

Figure 3.8

Beckman Model 6500 liquid scintillation
counter

in accounting for all the radioactivity distributed during the cleaning process. In theory, the amount of radioactivity applied to the surface of the painting ($A_{applied}$) should be equal to the total experimentally measured activity (A_{total}), which is a sum of the radioactivity measured on all of the swabs (A_{swab}) plus the radioactivity found on the entire paint surface of the 5 cm × 5 cm well cleaned during the experiment ($A_{painting}$).

$$A_{applied} = A_{total} = A_{swab} + A_{painting} \qquad (1)$$

In our experiments a major focus was to measure $A_{painting}$, but we were also interested in accounting for all of the radioactivity in the experiment. Initially we could not get experimental A_{total} values that agreed within counting statistics with the values for $A_{applied}$ obtained from the experimental mass of applied gel and knowledge of the concentration of the radioactive component in the prepared gel. This prompted us to conduct a series of additional experiments to try to understand the observed discrepancies and to make sure that we were not dealing with an unknown experimental artifact or error that could affect the accuracy of the quantitative measurements of gel residues and the interpretation of the experimental data.

Gel uniformity All of the above experiments assumed that the radioactively labeled gel component is uniformly distributed throughout the gel. In that case, an exact relationship exists between the measured radioactivity and the mass of gel (assuming that there are no other experimental errors). Each radiolabeled gel was prepared by introducing the radioactive label to a fluid mixture of Ethomeen, Carbopol, and alcohols before water was added and before the gelling process started. This increased the likelihood that the label was homogeneously distributed. Gel uniformity was tested by taking several samples for counting from across the gel surface and at different depths of a prepared gel stored in a wide-

neck jar. The results shown in table 3.2 are typical of the radiolabeled gels prepared for this project and indicate that the radiolabeled gel is uniform within the experimental error and statistics of the scintillation counting measurement. The results not only demonstrate that the gel radioactivity is uniformly distributed but also provide a measure of validation for the counting process. The same specific radioactivity (disintegrations per minute [dpm]/g) is measured for gel masses varying in size by nearly a factor of 10.

Self-absorption due to gel mass and swab Since the conservators involved in the cleaning experiments prepared their own cotton swabs and applied and cleared the gel according to their everyday practice, other experiments were performed to see if either the size of the cotton swab or the amount of cleaning gel on an individual swab affected the measured radioactivity for a given sample. A series of measurements were made in which a constant amount of radioactivity was placed in a scintillation cocktail with increasing amounts of the cotton used to make the cleaning swabs. The results in table 3.3 indicate that the liquid scintillation counting was not affected by the presence of a clean cotton mass typical of the size used for the cleaning swabs.

As noted above, the measured specific activity (dpm/g labeled gel) was constant for a wide range of gel masses when the gel was dispersed in the scintillation cocktail. Another experiment was done in which different amounts of ^3H-Ethomeen gel were taken on cotton swabs and the swab plus gel sample was counted. The measured specific activity decreased from that measured for the gel alone by 7% for gel samples weighing 0.1280 to 0.2532 g. It is believed that this decrease arises because the gel sample on the swab is not efficiently dispersed within the scintillation cocktail or because the gel + swab sample creates a "self-shielding effect" that reduces the counting efficiency by interfering with the detection of photons emitted by the fluorescent solute.

Table 3.2

Measurement of uniformity of ^3H-Ethomeen gel

Sample	Gel Mass (g)	dpm/g
GU-1	0.0537	1.656×10^6
GU-2	0.0920	1.674×10^6
GU-3	0.3360	1.665×10^6
GU-4	0.5267	1.640×10^6
GU-8	0.1908	1.636×10^6
GU-9	0.0613	1.616×10^6
GU-10	0.1293	1.660×10^6
GU-11	0.1081	1.631×10^6
	Average dpm/g = $(1.647 \pm 0.020) \times 10^6$	

Note: Samples GU5-7 were not counted because of uncertainties in the mass of the gel sample.

Sample	Cotton Mass (g)	Net dpm
SW-1	no swab	1.688×10^5
SW-2	no swab	1.728×10^5
SW-3	no swab	1.804×10^5
	Average dpm $= (1.740 \pm 0.059) \times 10^5$	
SW-4	0.2510	1.805×10^5
SW-5	0.1400	1.721×10^5
SW-6	0.1598	1.800×10^5
SW-7	0.1827	1.633×10^5
SW-8	0.0823	1.700×10^5
	Average dpm $= (1.732 \pm 0.072) \times 10^5$	

Note: 50 µL of ^{14}C–benzyl alcohol solution added to each sample.

This conclusion was tested further by a related experiment in which a constant amount of radioactivity was placed in a scintillation cocktail and a nonradioactive gel sample on a swab was added. Some swabs were used before taking the gel sample, whereas others were soiled from use in cleaning a paint surface. The results of these measurements are given in table 3.4.

Since the radioactivity in these samples was already dispersed in the scintillation cocktail before the sample was introduced, the observed reduction in the measured activity is associated with the self-shielding effect rather than a lack of contact between the cocktail and the radioactivity. That the more opaque soiled swab samples had the larger reduction is consistent with this explanation. Consequently, it was recommended that experimenters limit the amount of gel on any cleaning or clearing swab and limit the degree of soiling for any swab.

Sample	Gel Mass (g) + Swab Type	Net dpm
SW-9	0 + no swab	1.678×10^5
SW-10	0 + no swab	1.723×10^5
	Average dpm $= 1.700 \times 10^5$	
SW-11	0.1494 + clean swab	1.626×10^5
SW-12	0.3715 + clean swab	1.699×10^5
	Average dpm $= 1.662 \times 10^5$	
SW-13	0.1882 + soiled swab	1.636×10^5
SW-14	0.2181 + soiled swab	1.664×10^5
SW-15	0.2129 + soiled swab	1.594×10^5
	Average dpm $= 1.632 \times 10^5$	

Note: 50 µL of ^{14}C–benzyl alcohol solution added to each sample.

Loss of radioactivity Equation (1) assumes no loss of radioactivity outside the wax well and no contamination of the walls of the wax well. This condition is very difficult to achieve during cleaning experiments. Some gel is inevitably deposited on the wax well, and well walls are contaminated when an experimenter tries to clean the whole surface of the painting delineated by the wax. In some cases the dental wax did not remain fully secured to the paint layer and some radioactive gel may have been pushed under the wax.

Tests were conducted to evaluate these possible losses. Dental wax was removed from one test painting sample used in the cleaning experiment and its radioactivity measured. Also, the painting area under a poorly adhering wax well of another sample was sampled and counted. In each case, only minute and insignificant amounts of radioactivity were detected.

Light absorption The liquid scintillation counting measurement is based on conversion of the emitted radiation into visible light via the interaction of a beta particle from the radioisotope with the scintillation cocktail. For a count to be recorded, enough visible photons must reach the highly sensitive photomultiplier detectors outside the scintillation vial. Any material that absorbs this visible light in the scintillation vial would lower (quench) the actual count rate and thus introduce a systematic error into the radioactivity measurement. The self-shielding effect of soiled swabs is an example of this type of problem.

The experiments showed that dirt from highly soiled swabs can significantly discolor and darken the scintillation cocktail, which could then absorb the fluorescent photons emitted by the scintillation fluor (color quenching). To assess this effect, an experiment was conducted in which varying amounts of a colored isopropyl alcohol sample (made brown by using it to clean a painting sample) were added to discolor the scintillation cocktail in vials containing an identical amount of radioactivity. All samples were counted to determine the effect of the color quenching. The results are given in table 3.5. As expected, the count rate

Table 3.5

Effect of discolored scintillation cocktail on counting

Sample	Volume of Colored Isopropanol Solution (mL)	cpm	Net dpm
Ref1	0	9.358×10^4	2.338×10^5
Ref2	0	9.519×10^4	2.364×10^5
Average dpm = 2.351×10^5			
Color1	0.5	7.349×10^4	2.163×10^5
Color2	1.0	6.133×10^4	2.077×10^5
Color3	1.5	5.168×10^4	2.018×10^5
Color4	2.0	4.318×10^4	1.900×10^5
Average dpm = 2.039×10^5			
Note: 50 µL of ^3H-glycine solution added to each sample.			

(count per minute [cpm]) dropped as the scintillation cocktail became more discolored. In converting count rate to disintegration rate, a correction for quenching is applied; however, as can be seen in table 3.5, in the case of significant color quenching the corrected dpm value has an error of about 13%. This again indicates the importance of limiting the extent of soiling on the swabs in the cleaning experiments.

Idealized cleaning experiment Results from all the above experiments suggested that a major problem could be related to dirty swabs and absorption of light by dark or opaque media present in the vial during liquid scintillation counting. To test this hypothesis and to check if the measurement protocol could quantitatively account for all of the gel radioactivity, an idealized "cleaning experiment" was conducted. Instead of cleaning a painting surface that contained a dirt and varnish layer, a ^3H-Ethomeen gel (identical to the gels used in the formal cleaning experiments) was deposited on a large sheet of rigid, clear, nonabsorbing plastic without any wax mask attached. The 4 cm × 4 cm area to be "cleaned" was delineated on a sheet of paper under the plastic. The cleaning process was identical to that used in the formal cleaning experiments. Application, cleaning, and clearing swabs were collected and the entire area of the "cleaned" 4 cm × 4 cm square was cut into small pieces for scintillation counting. Because no soiling of the swabs occurred, the sum of the radioactivity of all swabs and plastic samples should precisely equal the radioactivity of the cleaning gel deposited on the plastic surface if the measurement method is quantitative. This same "cleaning" of a plastic surface was repeated using a ^{14}C-isopropanol-labeled gel. For comparison, a similar experiment was run with each of the four labeled gels in which a 4 cm × 4 cm piece of painting was cleaned with a gel and all swabs and the entire painting sample were counted. Care was taken to ensure that the swabs did not become too discolored during the cleaning and clearing process. The results of these measurements are shown in table 3.6.

The experimental data show that in the absence of light-absorbing material (only plastic and slightly soiled swabs), a complete accounting of all radioactivity is possible. However, in the case of the isopropanol-labeled gel, less than full recovery was found, although the plastic and painting experiments produced essentially identical results. The lower yield is attributed to the relatively high volatility of the isopropanol.

Table 3.6

Control experiments in cleaning gel measurements

Labeled Gel	% Recovery	
	Plastic	Painting
^3H-Ethomeen	99.7	90.1
^3H-Carbopol	N/A	85.1
^{14}C-benzyl alcohol	N/A	94.5
^{14}C-isopropanol	78.6	75.8

Experimental findings

Results

The information given in tables 3.7 through 3.10 provides insight into the individual approaches of the eight conservators to the cleaning experiments with the labeled solvent gels and into the amounts of the different gel components left on the cleaned surface as a residue. The **Number of Swabs** column includes the number of swabs used to apply the cleaning gel, clean the painted surface, and clear the cleaned area of cleaning gel in a given experiment. Most conservators used two applications of gel and a combination of dry and wet swabs (**Swab Type**) for gel clearing. Some used only one swab for the application, one (experimenter #8) used a fine-tipped brush, and some used only dry or only wet swabs for clearing. The **Total Applied Activity (dpm)** is directly proportional to the **Mass of Gel (g)** applied to the surface.

To help visualize the amount of residue remaining on the cleaned surfaces, the results were calculated in three ways:

(1) The **Average dpm/Disk** shows the amount of radioactivity present on the disk after cleaning. This number can be easily related to the radiation background (a combination of earth and cosmic radiation), which is approximately 40 dpm. The **low–high** values provide information on the uniformity of a given residue across the cleaned surface.

(2) The **% of Applied Activity/Disk** compares the amount of radioactivity left on the cleaned surface to that of the originally applied gel.

(3) The **Average μg/cm²** gives the average mass of residue per square centimeter area of cleaned surface. The **low–high** values again indicate the amount of residue distributed across the cleaned surface.

The tables also provide an average value in each category, so that the results for each gel component can be compared and evaluated.

Interpretation and discussion of results

The data from this study provide quantitative insight into the amount of gel residue left on the cleaned surface following cleaning and clearing with the gels. They also furnish information on the contribution of each gel component to the total amount of gel residue detected on the cleaned surface. A comparison of results from each conservator's cleaning test permits an assessment of the different cleaning methodologies and the individual approaches of conservators in terms of the amount of gel residue. Our cleaning experiments represented an extreme situation in which both the dirt and the varnish layer were completely removed during the cleaning operation and any cleaning gel residue would have direct contact with the paint layer of the cleaned object.

Table 3.7 shows that the average quantity of isopropanol (boiling point 82.4°C) in the paint layer several hours after the gel cleaning was

Experimenter	Number of Swabs	Swab Type	Mass of Gel (g) Total Applied Activity (dpm)*	Average dpm/Disk* (low–high)	% of Applied Activity/Disk	Average µg/cm^2 (low–high)
#1	8	Wet	0.4485 (542,300)	4 (nd–16)	0.0007	2 (nd–8)
#2	18	Dry	0.4774 (577,200)	1 (nd–9)	0.0002	0.5 (nd–4)
#3	16	Wet + dry	0.3423 (414,000)	3 (nd–8)	0.0007	1 (nd–4)
#4	22	Dry + wet	0.1998 (241,600)	1 (nd–6)	0.0004	0.5 (nd–3)
#5	20	Dry + wet	0.4932 (596,300)	3 (nd–18)	0.0005	1 (nd–9)
#6	7	Wet	0.3966 (479,500)	4 (nd–18)	0.0008	2 (nd–9)
#7	24	Wet	0.2923 (353,400)	0.2 (nd–3)	0.0006	0.1 (nd–1)
#8	10	Dry + wet	0.5162 (629,600)	2 (nd–10)	0.0003	1 (nd–3)
Average	**16**		**0.3958**	**2 (0.2–4)**	**0.0005**	**1 (0.1–2)**

Notes:
nd = not detected.
* All dpm values are corrected for background.

Table 3.7

Residue measured: isopropanol (propan-2-ol)

Table 3.8

Residue measured: benzyl alcohol

(phenylmethanol)

Experimenter	Number of Swabs	Swab Type	Mass of Gel (g) Total Applied Activity (dpm)*	Average dpm/Disk* (low–high)	% of Applied Activity/Disk	Average µg/cm^2 (low–high)
#1	13	Wet	0.5812 (416,000)	449 (214–707)	0.11	49 (24–78)
#2	18	Dry	0.4932 (353,000)	419 (330–608)	0.12	46 (36–67)
#3	18	Wet + dry	0.6030 (432,000)	345 (90–714)	0.08	38 (10–78)
#4	18	Wet	0.1590 (113,800)	131 (61–209)	0.12	14 (7–23)
#5	13	Dry + wet	0.4573 (327,000)	173 (80–391)	0.05	19 (9–43)
#6	13	Wet	0.2959 (211,700)	85 (52–130)	0.04	9 (6–14)
#7	21	Wet	0.4572 (327,000)	68 (34–117)	0.02	8 (4–13)
#8	10	Dry + wet	0.5472 (378,400)	33 (nd–81)	0.01	5 (nd–12)
Average	**16**		**0.4492**	**213 (33–449)**	**0.07**	**24 (5–49)**

Notes:
nd = not detected.
* All dpm values are corrected for background.

Experimenter	Number of Swabs	Swab Type	Mass of Gel (g) Total Applied Activity (dpm)*	Average dpm/Disk* (low–high)	% of Applied Activity/Disk	Average μg/cm² (low–high)
#1	10	Wet	0.6672 (1,160,000)	1941 (1493–2788)	0.17	169 (130–243)
#2	16	Dry	0.4333 (750,000)	771 (458–1279)	0.10	67 (40–111)
#3	14	Dry + wet	0.5282 (915,600)	1022 (423–1755)	0.11	89 (37–153)
#4	12	Wet	0.1324 (229,500)	552 (240–908)	0.24	48 (21–79)
#5	12	Dry + wet	0.4932 (854,900)	440 (123–902)	0.05	38 (11–79)
#6	12	Wet	0.1653 (286,500)	264 (143–494)	0.09	23 (12–43)
#7	21	Wet	0.3710 (643,000)	383 (178–665)	0.06	33 (16–58)
#8	10	Dry + wet	0.3596 (620,000)	111 (31–180)	0.02	11 (3–19)
Average	**13**		**0.3938**	**686 (111–1941)**	**0.10**	**60 (11–169)**

Notes:
nd = not detected.
* All dpm values are corrected for background.

Table 3.9

Residue measured: Ethomeen C/25

Table 3.10

Residue measured: Carbopol 954

Experimenter	Number of Swabs	Swab Type	Mass of Gel (g) Total Applied Activity (dpm)*	Average dpm/Disk* (low–high)	% of Applied Activity/Disk	Average μg/cm² (low–high)
#1	9	Wet	0.7907 (54,000)	34 (3–73)	0.06	7 (0.7–16)
#2	14	Dry	0.3371 (23,200)	45 (13–94)	0.19	10 (3–21)
#3	14	Dry	0.3626 (25,000)	36 (16–73)	0.14	8 (4–16)
#4	28	Wet	0.3013 (20,700)	12 (nd–35)	0.06	3 (nd–8)
#5	14	Dry + wet	0.4932 (33,900)	18 (nd–47)	0.05	4 (nd–10)
#6	7	Wet	0.1669 (11,500)	26 (1–62)	0.23	6 (0.2–14)
#7	34	Wet	0.9658 (66,400)	42 (17–75)	0.06	9 (4–17)
#8	10	Dry + wet	0.4942 (10,500)	7 (nd–15)	0.07	9 (nd–16)
Average	**16**		**0.4890**	**28 (7–45)**	**0.11**	**7 (3–1 0)**

Notes:
nd = not detected.
* All dpm values are corrected for background.

very small (avg = 1 µg/cm^2). The radioactivity level was so low that it was often indistinguishable from the levels of natural radioactivity background (from natural radioisotopes, cosmic radiation, etc.). There is no apparent relationship between the amount of gel applied to the surface of the painting and the amount of isopropanol in the paint layer after cleaning. These results and the control experiments discussed in the *Idealized cleaning experiment* section (p. 34) suggest that the volatility of isopropanol and perhaps its solubility in the solvent used to wet the clearing swabs greatly reduce the isopropanol residue, even though this is the major component (on a mass basis) in the cleaning gel. Because the measured quantity of isopropanol from the gel formulation on the cleaned surface did not exceed 9 µg/cm^2 just hours after cleaning, it is reasonable to assume that isopropanol is not a major component of long-term gel residue on the cleaned surface.

The benzyl alcohol radioactivity on the cleaned surface was several times that of the natural background radioactivity several hours after cleaning. Calculations showed the presence, on average, of 24 µg benzyl alcohol per square centimeter of cleaned area, reaching a maximum measured amount of 78 µg/cm^2. The quantity of benzyl alcohol (boiling point 205°C) in the gel residue was diminished somewhat by evaporation and solubility in the solvent used to wet clearing swabs; however, it remains on the surface at a level comparable to that of the less volatile gel components.

Ethomeen C/25 is an ethyoxylated (15) cocoalkylamine that is a high molecular weight liquid with a very high boiling point (300°C at 700 mm Hg). In gel formulations, it acts as a weak basic detergent, in addition to having a gel-forming function. Working together with the Carbopol (a polyacrylic acid polymer), the free base (Ethomeen) forms a salt (ionic) link with the carboxylic groups on the Carbopol. This causes the long polymer chains of Carbopol to unfold in the solution during gel formation. The experiments with the custom-labeled radioactive Ethomeen and Carbopol allowed us to quantify the amount of both nonvolatile components of the gel residues on the cleaned surface.

The experiments showed that Ethomeen is a major component of the gel residue. The measured quantity on the cleaned surfaces was, on average, about 60 µg/cm^2. However, the Ethomeen residue on the test samples of the individual conservators varied substantially. The highest average for an individual was 169 µg/cm^2, with 243 µg/cm^2 found for a single disk. The lowest average was 11 µg/cm^2, with a range of 3 to 19 µg/cm^2 across the cleaned surface. The amount of Carbopol residue measured on cleaned surfaces was much lower in comparison. The average quantity of Carbopol was 7 µg/cm^2, and the maximum quantity detected on any cleaned sample was 21 µg/cm^2. For both Ethomeen and Carbopol, the cleaning and clearing process removed an average of 99.89% of the gel applied (i.e., 0.11% remained).

Since Ethomeen and Carbopol undergo an acid-base neutralization reaction with each other during the gel-forming process, it is assumed that the gel residue from Ethomeen and Carbopol is primarily composed of this reaction product. The presence of free (nonreacted)

Ethomeen was not measured, but it is assumed that due to a high concentration of available carboxylic acid sites on the Carbopol molecule, almost all Ethomeen molecules are bound to the Carbopol chains. It is also reasonable to assume that the chemical properties of the Ethomeen-Carbopol adduct will be different from those of the free Ethomeen (we can safely predict that the Ethomeen-Carbopol adduct would have even lower vapor pressure and higher boiling point than Ethomeen alone). This is an important fact that must be considered when studying the long-term effects of gel residues on painted surfaces.

These results show that the gel residue is composed primarily of Ethomeen, Carbopol, and benzyl alcohol. The mass proportion of these components in the cleaning gel when prepared was 10:5:1 (Ethomeen:benzyl alcohol:Carbopol). The experimentally determined proportion of these components in the gel residue after cleaning and clearing is 8.5:3.5:1 (Ethomeen:benzyl alcohol:Carbopol). This suggests some slight preferential removal of Ethomeen and benzyl alcohol from the gel residue during the clearing process, probably due to differences in solubility in the clearing solvent and perhaps differences in volatility. These findings are supported by Burnstock and Kieslich (1996).

It is important to put these results on residue amounts into a correct and quantitative perspective. To give practicing conservators who do not have everyday experience with microgram quantities of materials an easy sense of what 100 µg/cm² really means, a series of experiments was conducted using a Cahn C-32 ultramicrobalance, which is able to weigh as little as 0.1 µg. In these experiments, the mass of material (mainly salts and oils after water evaporation) transferred to the surface of a small microscopy cover glass by the print of a finger was measured. A mass range of 4–92 µg was found. One person's touch consistently transferred 9–13 µg of material (one finger touch averaged approximately 10 µg). Therefore, a 100 µg mass of residue per square centimeter left on the gel-cleaned surface is equivalent to the amount of "foreign matter" transferred to the surface when touching it about ten times.

Quantitative Study of Gel Residues on Highly Porous and Topographically Complex Surfaces

Experimental methodology

Test materials
The test materials used in this study were selected by museum conservators to represent materials found in both decorative arts and antiquities collections and which, due to their porosity, might retain large amounts of gel and thus present a challenge for clearing the gel after the cleaning process. Samples of aged gilded wood, unglazed terracotta, Carrara marble, and artificially prepared gypsum plaster were used (fig. 3.9). Although these samples were not soiled as in the test painting, all of these materials were cleaned and cleared with a solvent gel in a fashion similar to that used for the test painting.

Figure 3.9

Samples of materials used in initial tests for the cleaning experiment with porous and topographically complex surfaces. Note the grooves cut into the underside of samples to facilitate separation of the individual samples.

Sample preparation and characterization of test materials

Applying the methodology developed for the quantitative measurement of gel residue on the painting samples to a similar cleaning experiment on these 3-D samples proved challenging. The particular challenge was to design the test panels so that small samples could be removed after the cleaning process and placed in vials for liquid scintillation counting without contaminating or shattering any of the cleaned surfaces. After a number of trials, we found that the solution was to cut the test materials into panels approximately 10 cm \times 10 cm \times 1 cm thick and then, using a diamond circular saw, precut a grid in the underside of each to form 1 cm^2 samples. The grooves were cut as deeply as possible to help separate the individual samples needed for scintillation counting of the residue. The porosity of each type of material was measured using a Micrometrics Pore Sizer 9320 porosimeter.

Cleaning experiments and quantitative measurement of gel residues

The previous study on the painting samples indicated that two critical gel components—Carbopol 954 and Ethomeen C/25—constitute a major part of the gel residues. Based on this information, two gels were prepared for the quantitative study of residue on the three-dimensional (3-D) surfaces using the same proportions of components as before, each with a radioactive-labeled component.

> **Gel C (3-D)** was composed of
> 1 g Carbopol 954
> 10 mL Ethomeen C/25
> 50 mL isopropanol
> 5 mL benzyl alcohol
> ~6 mL deionized water

This gel was doped with approximately 30 µCi of ^3H-labeled Carbopol. Gel E (3-D) had an identical composition but was doped with approximately 700 µCi of ^3H-labeled Ethomeen C/25.

To address the highly subjective nature of the cleaning and clearing process, as confirmed in the previous experiments, two highly experienced conservators from the J. Paul Getty Museum took part in these cleaning experiments. Each conservator chose a personal approach to the cleaning and clearing process, using as many gel applications and any combination of dry and wet swabs to clear the gel as they considered necessary. Each conservator cleaned all four types of material using both Gel C (3-D) and Gel E (3-D). The experimental procedure was divided into four individual steps:

STEP 1
The conservator applied the gel to the surface of the test panel and after waiting from two to five minutes, "cleaned" the surface.

STEP 2
The conservator cleared the gel from the panel using a combination of both dry and mineral spirits or 5% ethyl alcohol–wetted cotton swabs (fig. 3.10a).

STEP 3
The panels were broken into individual test samples (fig. 3.10b). The border sections on all four sides of the panels were discarded, and only the six individual samples from the central area of each panel were prepared for scintillation counting.

Figure 3.10a

Solvent clearing of the gel

Figure 3.10b

Separating individual samples from the
test panel

STEP 4

Each sample was placed in a scintillation vial with the cleaned surface
faceup. The gilded wood samples were secured with epoxy to the
bottom of the vial to keep them from floating in the scintillation cocktail.
The vials were filled with 18 mL of ReadySolv liquid scintillation cocktail
and placed in a Beckman 6500 scintillation counter to determine the ^3H
radioactivity of gel residue still present on the surface of the cleaned and
cleared samples.

The counting time was five minutes or until the uncertainty in the
count rate (2δ) was less then 5%. The validity of the assay methodology
had been established during the methodology development phase for the
previous cleaning experiment on the test painting.

Experimental findings

Results

Tables 3.11 through 3.14 present the results of the gel cleaning experi-
ment conducted on the four different materials. The results provide
information on the relationship between the porosity of the cleaned
material and amount of gel residues and also provide insight into the
individual cleaning and clearing procedures of the two conservators.
Each liquid scintillation counting experiment had its own sample
identification number, **Sample ID**. The **Cleaning Procedure** (see table
3.11) indicates the number of gel applications used in the experiment,
duration of cleaning action, and the number of dry and wet swabs used
to clear the gel. The radioactivity of each sample was measured as **dpm**
(disintegrations per minute). This number is directly proportional to the
amount of gel residue on the sample. The **dpm-Total** represents the sum
of the six individual samples measured in one cleaning experiment. The

Table 3.11

Quantitative measurements of gel (C) and gel (E) residues on gilded wood

Sample ID	Cleaning Procedure	dpm	dpm Total	Surface Area	dpm/ cm²	µg/cm²
BC-G-C1		164				
BC-G-C2	2 applications	238				
BC-G-C3	2.5 min.	158	1219	6.0 cm²	203	3.3 µgC/cm²
BC-G-C4	2 dry and 4 wet	255				
BC-G-C5		185				
BC-G-C6		219				
JM-G-C1		454				
JM-G-C2	1 application	226				
JM-G-C3	2.5 min.	294	2169	6.15 cm²	353	5.7 µgC/cm²
JM-G-C4	2 dry and 4 wet	349				
JM-G-C5		272				
JM-G-C6		574				
BC-G-E1		14,088				
BC-G-E2	1 application	10,440				
BC-G-E3	2.5 min.	12,382	71,883	5.85 cm²	12,168	75 µgE/cm²
BC-G-E4	1 dry and 5 wet	21,225				
BC-G-E5		4818				
BC-G-E6		8230				
JM-G-E1		9114				
JM-G-E2	1 application	9394				
JM-G-E3	2.5 min.	8363	48,082	6.00 cm²	8014	50 µgE/cm²
JM-G-E4	2 dry and 4 wet	6214				
JM-G-E5		6176				
JM-G-E6		8821				

Surface Area is the area of a cleaned panel of a given material that was separated into the six individual samples and counted. The **dpm/cm²** shows the average number of disintegrations per square centimeter of cleaned area. This number also is directly proportional to the quantity of residues per square centimeter (**µgC/cm²** or **µgE/cm²**), which can be readily calculated if one knows the radioactivity associated with a known mass of the gel. Figure 3.11 shows the results of the porosity measurements performed on each material type.

Interpretation and discussion of results

The previous study focused on quantifying the gel residues on the surface of a well-aged oil painting that had been cleaned with a gel formulation, on determining the composition of the residue, and on providing insight into a relationship between the amount of residues and the method used to clear the gel. This study expanded these experiments to other materials found in museum collections and to special problems of materials and porous surfaces found on objects in museum collections.

Tables 3.11 through 3.14, in correlation with porosimetry measurements, show that the amount of gel residues on a cleaned surface is related to the porosity of a cleaned material, suggesting that the gel is

Table 3.12

Quantitative measurements of gel (C) and gel (E) residues on plaster

Sample ID	Cleaning Procedure	dpm	dpm Total	Surface Area	dpm/ cm²	µg/cm²
BC-P-C1		4065				
BC-P-C2	1 application	3883				
BC-P-C3	(< .34 g × 2 min.)	3623	20,471	6.15 cm²	3329	53.7 µgC/cm²
BC-P-C4	3 dry and 5 wet	3705				
BC-P-C5	(Shelsolv)	2466				
BC-P-C6		2729				
JM-P-C1		4773				
JM-P-C2	1 application	4172				
JM-P-C3	(< 1.52 g × 5 min)	3421	27,451	5.75 cm²	4774	77 µgC/cm²
JM-P-C4	3 dry and 3 wet	4749				
JM-P-C5	(5% ethanol)	5692				
JM-P-C6		4644				
BC-P-E1		76,858				
BC-P-E2	1 application	71,784				
BC-P-E3	(< .40 g × 2 min.)	84,212	477,608	5.51 cm²	86,680	537 µgE/cm²
BC-P-E4	3 dry and 5 wet	76,013				
BC-P-E5	(Shelsolv)	86,908				
BC-P-E6		81,833				
JM-P-E1		111,674				
JM-P-E2	1 application	87,540				
JM-P-E3	(< 1.20 g × 5 min.)	107,068	671,130	5.85 cm²	114,723	711 µgE/cm²
JM-P-E4	3 dry and 3 wet	107,743				
JM-P-E5	(5% ethanol)	116,753				
JM-P-E6		140,262				

difficult to clear once it penetrates the pores of the material. For highly porous materials such as terracotta and plaster, the amount of residue is about five to ten times higher than for material with a lower level of porosity such as marble or gilded wood, as anticipated. Figure 3.11

Figure 3.11

Results of porosity measurements for the four types of materials

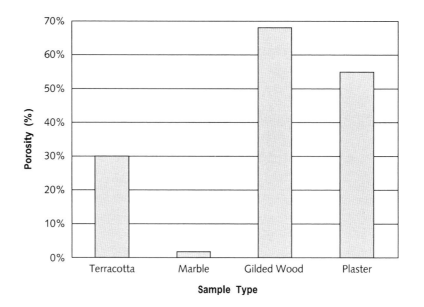

Table 3.13

Quantitative measurements of gel (C) and gel (E) residues on terracotta

Sample ID	Cleaning Procedure	dpm	dpm Total	Surface Area	dpm/cm²	µg/cm²
BC-T-C1		3711				
BC-T-C2	1 application	4224				
BC-T-C3	2 min.	3357	24,682	6.00 cm²	4114	66.3 µgC/cm²
BC-T-C4	3 dry and 5 wet	4273				
BC-T-C5	(Shelsolv) 1 dry	4531				
BC-T-C6		4586				
JM-T-C1		4122				
JM-T-C2	1 application	3747				
JM-T-C3	5 min.	3635	27,359	6.15 cm²	4449	71.7 µgC/cm²
JM-T-C4	4 dry and 4 wet	5692				
JM-T-C5	(5% ethanol)	4899				
JM-T-C6		5264				
BC-T-E1		110,353				
BC-T-E2	1 application	122,625				
BC-T-E3	2 min.	85,363	567,889	6.15 cm²	92,340	572 µgE/cm²
BC-T-E4	1 dry and 6 wet	90,880				
BC-T-E5	(Shelsolv) 1 dry	80,962				
BC-T-E6		77,436				
JM-T-E1		124,966				
JM-T-E2	1 application	121,773				
JM-T-E3	5 min.	120,687	703,042	6.4 cm²	109,850	681 µgE/cm²
JM-T-E4	4 dry and 4 wet	133,710				
JM-T-E5	(5% ethanol)	89,957				
JM-T-E6		111,949				

shows that the porosity of studied materials is, in descending order, gilded wood > plaster > terracotta > marble. However, the high porosity of gilded wood shown in the figure is due to the fact that the porosity of the sample is not isotropic. The substrate is a highly porous wood with one of its surfaces sealed with layers of animal glue, gesso, and gold leaf. In this case, the gold leaf is a very nonporous surface and the porosity of the substrate plays a role only if the gilt layer is extremely damaged or cracked. The amount of gel residue found on topographically complex surfaces can be expressed as follows: terracotta ~ plaster >> marble > gilded wood. In comparison, the surface of the aged oil painting discussed above showed an average gel retention comparable to that of the gilded wood.

Unlike the liquid scintillation counting measurements in the experiments involving the painting, the observed residue radioactivity on the highly porous and topographically complex samples was found to increase significantly when the samples were recounted after a few days. This effect was most pronounced for terracotta and plaster, and it leveled off after waiting five days to recount the samples. It is believed that this increase results from gel residue in the surface pores slowly getting dispersed in the scintillation cocktail.

Table 3.14

Quantitative measurements of gel (C) and gel (E) residues on marble

Sample ID	Cleaning Procedure	dpm	dpm Total	Surface Area	dpm/ cm²	µg/cm²
BC-M-C1		889				
BC-M-C2	1 application	1097				
BC-M-C3	(0.18 g × 2 min.)	1074	6285	6.25 cm²	1006	16.2 µgC/cm²
BC-M-C4	3 dry and 8 wet	1114				
BC-M-C5	(Shellsolv)	1107				
BC-M-C6		1004				
JM-M-C1		458				
JM-M-C2	1 application	436				
JM-M-C3	(0.63 g × 5 min.)	523	2967	6.51 cm²	456	7.4 µgC/cm²
JM-M-C4	3 dry and 3 wet	496				
JM-M-C5	(5% ethanol) 1 dry	607				
JM-M-C6		447				
BC-M-E1		21,094				
BC-M-E2	1 application	21,762				
BC-M-E3	(0.16 g × 2 min.)	18,653	118,000	6.36 cm²	18553	115 µgE/cm²
BC-M-E4	3 dry and 7 wet	19,490				
BC-M-E5	(Shellsolv)	17,618				
BC-M-E6		19,383				
JM-M-E1		13,526				
JM-M-E2	1 application	14,125				
JM-M-E3	(< 0.60 g × 5 min.)	11,679	79,408	6.00 cm²	13,235	82 µgE/cm²
JM-M-E4	3 dry and 2 wet	14,959				
JM-M-E5	1 wet (5% ethanol)	12,556				
JM-M-E6	1 dry	12,563				

The mass ratio of Ethomeen:Carbopol residue was similar to that associated with the gel formulation (10:1, Ethomeen:Carbopol), with an average of 10.2:1.

Lateral Distribution of Gel Residues

When cleaning an object, a conservator tries to achieve uniform results and to optically integrate a cleaned area, but it is almost impossible to achieve uniform cleaning action across the surface. The microtopography and porosity of the surface play an important role in the lateral distribution of gel residues. Gel might be pushed into surface pores, thus making it difficult to remove, or surface microtopography might create obstacles to achieving the good contact with a cleaning swab that is needed to clear the gel efficiently. As can be seen from the detailed results of the experiments in cleaning both paintings and the highly porous materials, the residues may not be homogeneously distributed across the cleaned surface. For example, figure 3.12 shows the bottom of a cleaning well on a painting sample from which fourteen individual disks (1–14) were removed for counting of the residue radioactivity. Table 3.15 shows the results of the liquid scintillation counting measurements and the corre-

sponding amount of residues detected on each disk. These results indicate
a typical local variation in the amount of residues across the surface of a
cleaning well.

The effect of surface porosity was studied in connection with the
cleaning of three-dimensional materials. To assess the role of surface
microtopography on the uniformity of residues, an experiment was
designed to study local variations of gel residue in relation to the micro-
topography of a cleaned surface.

Table 3.15

Measurement of ^3H-Ethomeen gel residue
across a cleaned surface

Sample	Net dpm	µg Ethomeen/cm^2
D1-E	392	34
D2-E	665	58
D3-E	397	35
D4-E	297	26
D5-E	489	43
D6-E	336	29
D7-E	484	42
D8-E	178	16
D9-E	262	23
D10-E	308	27
D11-E	292	25
D12-E	572	50
D13-E	187	16
D14-E	505	44

Experimental methodology

To measure the lateral distribution of gel residues across a cleaned painted surface, a small sample (7.5 cm × 5 cm) of the same painting used for the gel residue study was selected. The sample surface was cleaned to remove surface impurities and the varnish layer, using a gel without a radiolabeled component (Plate 5). The surface topography was then measured using noncontact surface profilometry. The cleaned and dried sample was cleaned again according to the cleaning and clearing procedure described above (pp. 27–29), using a gel containing [14]C-benzyl alcohol. The surface distribution of residues was then measured using autoradiography.

Figure 3.13

Schematic diagram of the scanning white-light profilometer

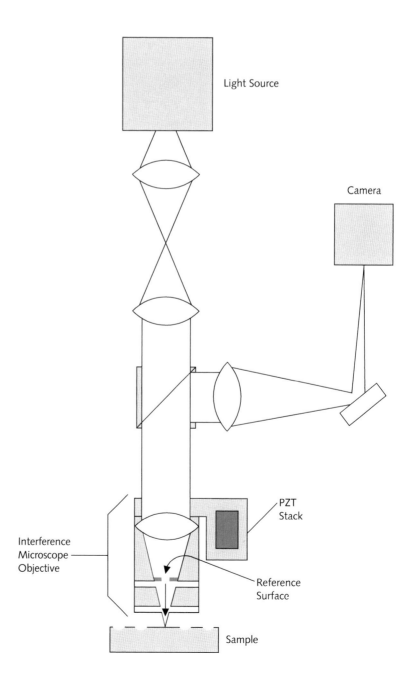

Surface profilometry measurements

Surface profilometry is based on scanning white-light interferometry (fig. 3.13). The focused light from a white-light source is split inside an interferometer into two beams; one beam reflects from the sample, and the other is reflected from an internal reference surface. After reflection, both beams recombine inside the interferometer, undergoing constructive and destructive interference and producing the light and dark fringe pattern that results from an optical path difference between the reference and sample beams. The electronic evaluation of the fringe pattern provides an accurate measurement of the distance between the lens of the profilometer and the measured point (about 10 μm in diameter) on the studied surface. A precise X-Y scan of an object in front of the objective lens of the surface profilometer generates a 3-D interferogram, which, when processed by a computer, provides a high-resolution 3-D topographic map of the object.

The test painting sample was mounted on the X-Y stage of the surface profilometer, and the sample surface was scanned (fig. 3.14). The resulting data set includes the X,Y coordinates and a Z value for each measurement point on the sample. The 3-D picture of the surface can be plotted so that different colors of the image represent different heights of the surface features (Plate 6). This image shows several ridges of paint impasto up to 2 mm high and several surface defects that are below the main plane of the painting sample. The data set can be also plotted as a

Figure 3.14

Experiment painting sample mounted on the X-Y stage of the surface profilometer

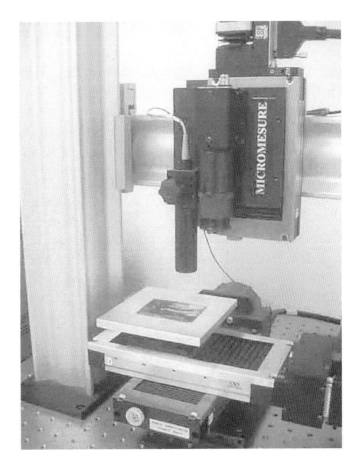

true 3-D image simulating different viewing angles (Plate 7). The profilometry images of the test painting surface were used to provide a correlation between surface features of the painting and the distribution of gel residue found in the autoradiography experiments described below.

Autoradiography experiments

In an autoradiography experiment, a sample of any given material containing a radioactive label is placed in contact with a photographic emulsion or other material sensitive to radiation. Dark areas on the film after exposure and development indicate the presence of radioactivity on the sample surface. The intensity of darkening is a function of a concentration of radionuclide within a given area on the surface. Currently, new phosphor detector screens have been introduced to replace film detection of beta radiation. After exposure to a radioactive sample, the phosphor screen is helically scanned with a laser beam in a light-tight chamber. The beam causes light emission from the phosphor screen wherever radiation exposure occurred. This emission is detected by a photomultiplier tube, producing an electrical signal that is directly proportional to the amount of radioactivity in contact with the screen. The results generate a computer image of varying intensity that represents the distribution of radioactivity associated with the sample surface. These autoradiographic methods are widely used in biological studies to show how a radiotracer is distributed within an organism. We designed the autoradiography experiments to provide information on the distribution of radioactive gel residues across the cleaned surface of the test sample of the painting (fig. 3.15).

The painting sample was cleaned using a gel formulation of

0.2 g Carbopol 954
2 mL Ethomeen C/25
10 mL isopropanol
1 mL benzyl alcohol + 250 µCi of ^{14}C-labeled benzyl alcohol
~1.2 mL deionized water

The surface was cleared using a single dry swab; the cleaned and cleared sample of painting was expected to contain a small amount of gel residue. The cleaned surface along with a strip of ^{14}C calibration standards were then placed in contact with a high-resolution ^{14}C phosphor screen (Packard, Type SR), which was exposed to radiation of gel residues in a light-tight cassette at room temperature for four days (time of exposure was tested and optimized in several preliminary experiments). The exposed phosphor screen was then attached to the cylindrical holder of a Packard Cyclone Phosphor Scanner (fig. 3.16) and scanned.

The sample was then cleared further with a swab wetted with 3:1 isopropanol:mineral spirits, exposed in the cassette for ten days, and rescanned. This wet-swab clearing process and screen exposure was repeated for an additional ten-day period before a final surface scan was made.

Figure 3.15
Schematic diagram of
the autoradiographic
experiments

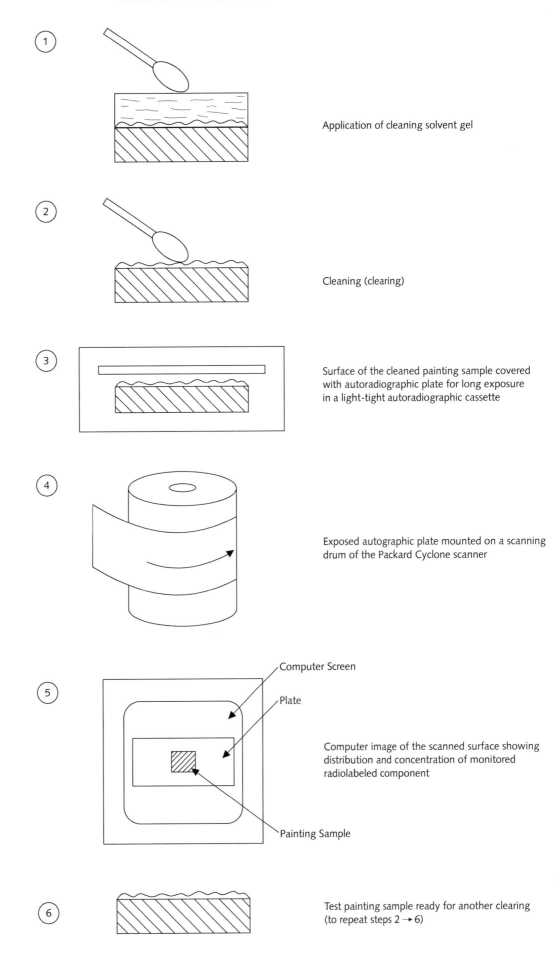

① Application of cleaning solvent gel

② Cleaning (clearing)

③ Surface of the cleaned painting sample covered
with autoradiographic plate for long exposure
in a light-tight autoradiographic cassette

④ Exposed autographic plate mounted on a scanning
drum of the Packard Cyclone scanner

⑤ Computer Screen
Plate
Computer image of the scanned surface showing
distribution and concentration of monitored
radiolabeled component
Painting Sample

⑥ Test painting sample ready for another clearing
(to repeat steps 2 → 6)

Figure 3.16

Plate being attached to the cylindrical holder of the Packard Cyclone Phosphor Scanner

Results and discussion

Figure 3.17a shows the distribution of gel residues across the test painting sample after gel cleaning followed by a simple clearing of cleaning gel using a dry swab. The level of darkness of the autoradiographic image is directly proportional to the amount of gel residues on the painting surface. It can be seen here that dry swab removal of the gel is not an adequate method of clearing the residue, and all areas of the pronounced topographical features (brushstrokes, cracks, and surface fissures) exhibit higher concentrations of residue than do flat areas. Figure 3.17b shows the same surface after the first wet clearing with the 3:1 isopropanol: mineral spirits solution. The autoradiographic scan shows a much lower concentration of gel residues in flat areas and a slight nonproportional decrease of residue concentration in areas of more complex topography. In this figure, it is possible to evaluate amounts of gel residues and their lateral distribution more quantitatively, because a calibrated radiation source strip was used to expose the phosphor screen for the same time period as the residues on the test painting. Figure 3.17c shows the extent of residues on the sample surface after the second wet cleaning. As expected, the amount of residues decreased even more in the flat areas of the painting surface, residues could not be removed from deep cracks, holes, and fissures, and solvent clearing does not wash them out from deeper cracks and fissures.

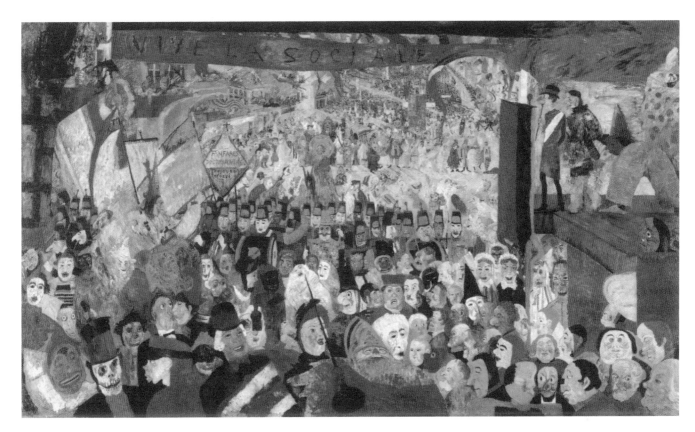

Plate 1

James Ensor (Belgian, 1860–1949), *Christ's Entry into Brussels in 1889*, 1888. Oil on canvas, 252.5 × 430.5 cm (99½ × 169½ in.). Los Angeles, J. Paul Getty Museum, 87.PA.96. © 2003 Artists Rights Society (ARS), New York/SABAM, Brussels.

Plate 2

Intact counterpart of portrait painting used as a source of painted canvas for the test procedures using solvent gels and for measuring solvent gels

Frank Linton (American, 1871–1944), *Portrait of Woman in Red and Green*, 1911. Oil on canvas, 221 × 122 cm (87 × 48 in.). Gift to the Winterthur/University of Delaware Conservation Program from the University of Pennsylvania.

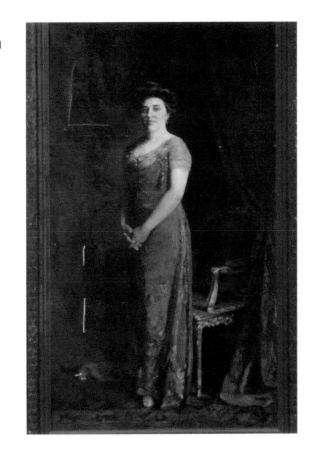

Plate 3

Detail of the Linton test painting canvas

Plate 4

Cross section of the Linton test painting
showing layers of ground, paint, and two
different oil resin varnishes

Plate 5

Cleaned sample from the Linton test
painting showing a range of topographical
features used for profilometry and
autoradiographic experiments

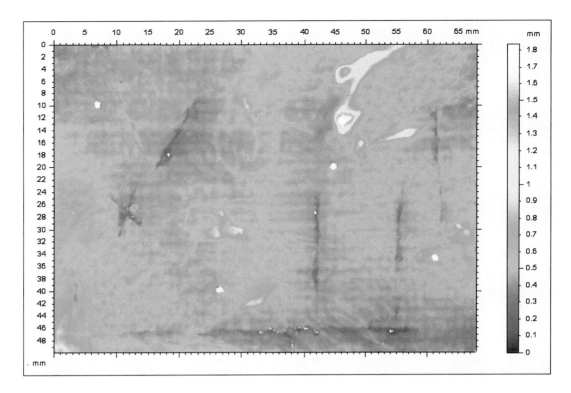

Plate 6

Surface profilometry results from the Linton test painting sample

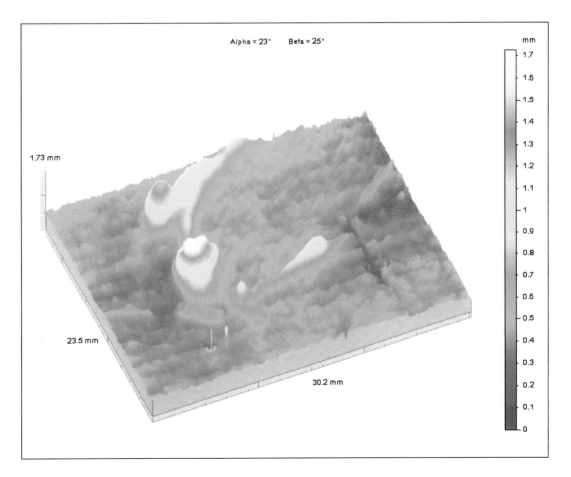

Plate 7

Computer-assisted reconstruction of the surface topography of the Linton painting sample

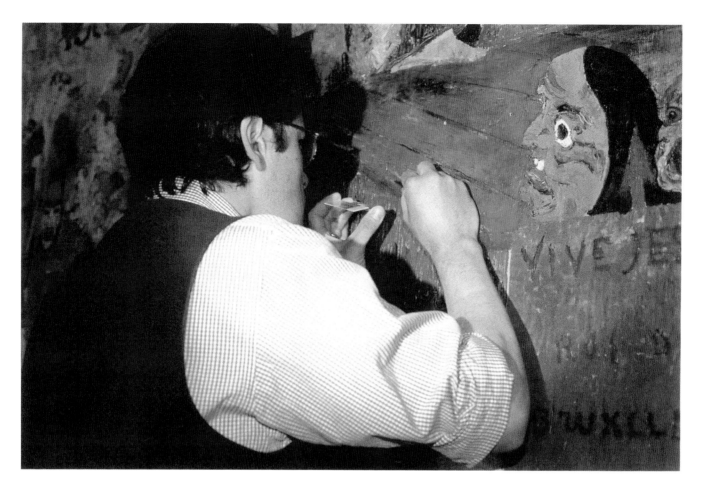

Plate 8

Sampling the green pigmented area
of *Christ's Entry into Brussels in 1889*
by James Ensor. The painting was cleaned
in the late 1980s utilizing gels, and the
sample taken here in 2000 was examined
for gels residues.

Plate 9

Detail of the surface of the tilt-top tea
table (ca. 1765–80), showing a test area
where a small portion of a solvent gel was
applied and the urethane coating
removed. The area treated was rinsed of
the gel and solubilized coating to reveal
the oleo-resinous (original) coating
beneath. Courtesy, Winterthur Museum.

Figure 3.17a

Distribution of gel residues across the surface of the test painting following gel clearing with a dry swab

Figure 3.17b

Distribution of gel residues across the painting surface following clearing with a dry swab followed by a solvent

Figure 3.17c

Distribution of gel residues following the second solvent clearing

Conclusions

Our studies showed that autoradiography is a powerful method of monitoring radiolabeled gel residues when tesing the efficacy of clearing processes. It was not surprising to find that higher gel residue concentrations occur in topographically complex features of the surface (brush strokes, holes, cracks, fissures). We also found that solvent clearing without the assistance of mechanical (swabbing) action is not sufficiently powerful to remove residues from deep cracks and fissures in the painting surface.

Appendix

A Methodological Approach to Selecting a Cleaning System

Richard Wolbers

Early Cleaning Strategies

At a point in the cleaning of a painting or decorative object, the aesthetic question, Should I clean this? becomes a technical one, How will I clean this? In the case of a natural resin varnish such as dammar or mastic, the paradigm generally followed for many years was to begin with a solvent or solvent blend that more or less coincided with a solubility parameter sufficient to swell and solvate the *bulk* of the material in the coating and, one hoped, not swell or disrupt the underlying oil paint materials. These solvent mixtures were often codified (e.g., Keck 1, Keck 2, etc.) and usually varied by slight increments in polarity to approximate the necessary strength or net solubility parameter. Most of these mixtures would fall in the lower right corner on a Teas diagram (see fig. 3A.1), nearly perfectly coincident with the general solubility region or parameters for dissolving soft resins (darker dotted line), and not with the solubility region for drying oils (lighter dotted line).

The Keck mixtures (fig. 3A.2), for instance, were numbered 1 through 4 and contained three components: acetone, mineral spirits, and diacetone alcohol (except for Keck 4, which also contained methanol). The relative proportion of acetone/diacetone alcohol to mineral spirits varied; in each higher-numbered mixture, the more polar solvents (acetone/diacetone alcohol) increased in proportion to the amount of mineral spirits, generating increasingly more polar—and essentially higher dipole moment—mixtures to match the solubility requirements of a soft resin coating. Depending on the degree of oxidation (aging, exposure, treatment, restorations, etc.), the bulk of the materials in these films would require only slight adjustments in polarity to be effectively resolubilized. The Ruhemann (fig. 3A.3, formulas 1 and 2), Rabin (fig. 3A.4), and Pomerantz (fig. 3A.5) mixtures also followed this paradigm.

The pattern that emerges from the work of these and many other conservators is that in order to more closely approximate the solubility parameter requirements of a particular varnish or coating material, a series of "steps" or mixtures of slightly varying polarity was often formulated to define a heuristic or methodological approach to finding a mixture of solvents appropriate for a given coating or situation. These "steps" often took the form of mixtures of aliphatic hydrocarbons (low

Figure 3A.1

Traditional soft resin cleaning mixtures
plotted in relation to solubility range or
area for soft resins (darker dotted line) and
drying oil mixtures (lighter dotted line) on
the Teas diagram

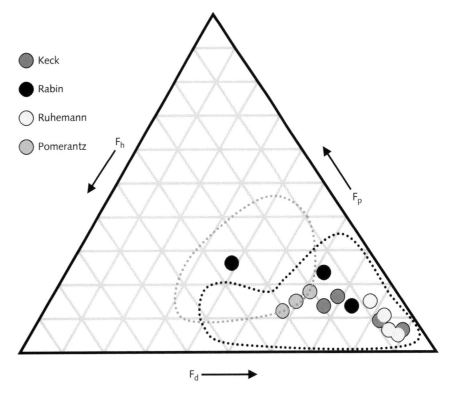

○ Keck
● Rabin
○ Ruhemann
○ Pomerantz

F_d = dispersion fractional parameter
F_h = hydrogen bonding fractional parameter
F_p = polar fractional parameter

Figure 3A.2

The Keck codified series of solvent
mixtures

Keck 1:	Acetone	10%	
	Diacetone alcohol	5%	
	Mineral spirits	85%	
Keck 2:	Acetone	20%	
	Diacetone alcohol	10%	
	Mineral spirits	70%	
Keck 3:	Acetone	30%	
	Diacetone alcohol	10%	
	Mineral spirits	40%	
Keck 4:	Methyl alcohol	20%	
	Acetone	10%	
	Diacetone alcohol	20%	
	Mineral spirits	50%	

Figure 3A.3

The Ruhemann series of codified solvent
mixtures

Ruhemann 1:	Acetone	25%
	VM&P naphtha	75%
Ruhemann 2:	Acetone	33%
	VM&P naphtha	67%
Ruhemann 3:	Ethanol	7.7%
	VM&P naphtha	92.3%
Ruhemann 4:	Ethanol	11%
	VM&P naphtha	89%

Figure 3A.4

The Rabin series of codified solvent

mixtures

Rabin 1:	Acetone	25%
	Toluene	75%
Rabin 2:	Acetone	50%
	Diacetone alcohol	20%
	Mineral spirits	30%
Rabin 3:	Methanol	50%
	Acetone	25%
	Dimethylformamide	12.5%
	Morpholine	12.5%

Figure 3A.5

The Pomerantz series of codified solvent

mixtures

Pomerantz 1:	Acetone	10%
	Shellsol	10%
	Cellosolve	80%
Pomerantz 2:	Acetone	15%
	Shellsol	15%
	Cellosolve	70%
Pomerantz 3:	Acetone	20%
	Shellsol	20%
	Cellosolve	60%
Pomerantz 4:	(etc.)	

boiling point, zero aromatic content solvents or fractions) blended in varying proportions with a more polar solvent, often incorporating either acetone or an alcohol (isopropanol, ethanol) as the polar solvent.

These solvent binary mixtures were effective for removing a material such as a soft resin (e.g., dammar or mastic) varnish that could be expected to change on aging to include substantial fractions of material that were more oxidized than the original resin but that would remain largely unpolymerized and low in molecular weight (as well as soft resin varnishes that contained no additional additives such as gums, oils, etc.).

A Cleaning Methodology

Cleaning (or the separation of one material from another, i.e., a degraded varnish from a paint film) is a *process* or series of steps, and a real cleaning process begins by first meeting the conservation needs of the painting (e.g., consolidation). It also begins with the best technical information on the composition and knowledge of the arrangement of materials (e.g., binder-to-pigment ratio, prior treatments, etc.), because some situations preclude the use of solvents or any other cleaning method. Ideally, the "arrangement" information is obtained through some form of applied microscopy (e.g., cross sections of small samples); compositional information is obtained through analytical means such as FTIR spectroscopy, gas chromatography, and mass spectrometry. Simple characterization techniques (e.g., UV light examination), historical references, personal

experience, and even anecdotal references about likely materials can help the process of finding a solvent or cleaning system appropriate for a given varnish layer.

There has also been a long-standing protocol of initial cleaning (removing accumulated soils) from a varnish surface prior to attempting to clean or resolubilize it; and in this context, this makes perfect sense as well. The more we unpack a surface (divest it of accumulated additional materials) before removing the coating, the more straightforward the actual removal process is likely to be.

Removing Surface Layers

A "shopping list" of solvents

Should the identification process become empirical, as it often does, how do we start? It often helps to begin with a finite or basic shopping list of solvents to test with, such as those suggested in figure 3A.6. The inclusion of an appropriate aliphatic hydrocarbon solvent (of relatively low boiling point and zero aromatic content), along with higher polarity solvents such as isopropanol and acetone, allows us to quickly design two series of solvent test mixtures (Series 1 and 2; see fig. 3A.7) that might help us to establish a relative solubility sense for an unknown natural resin coating. Series 1, for instance, is essentially five preparations that span from neat or pure mineral spirits to neat or pure isopropanol. On a Teas diagram, figure 3A.9, these mixtures would all lie on a line between the two individual solvents. The proportion of isopropanol increases

Figure 3A.6

Basic or working list of test solvents

Basic Solvent Kit
Shellsol T (bp: 120°F; 0% aromatic content)
Xylene
Benzyl alcohol
Isopropanol
Ethanol
Acetone
1 methyl 2 pyrrolidinone

Figure 3A.7

Three series of binary solvent mixtures for a basic test kit

Test Series 1	Test Series 2	Test Series 3
Neat Shellsol	Neat Shellsol	Neat Acetone
3:1 Shellsol: Isopropanol	3:1 Shellsol: Acetone	3:1 Acetone: Isopropanol
1:1 Shellsol: Isopropanol	1:1 Shellsol: Acetone	1:1 Acetone: Isopropanol
1:3 Shellsol: Isopropanol	1:3 Shellsol: Acetone	1:3 Acetone: Isopropanol
Neat Isopropanol	Neat Acetone	Neat Isopropanol

along with the polarity hydrogen bonding aspect of any given mixture as it moves long the line toward isopropanol. Series 2 is essentially the same arrangement of test mixtures from mineral spirits to acetone; the amount of acetone increases along with the net dipole moment.

Binary test mixtures: soft resin varnishes
Blending a polar solvent such as acetone or isopropanol in varying proportions with an aliphatic or nonpolar solvent is a simple first step in evaluating the potential solubility of resinous coatings. These particular test mixtures (fig. 3A.7) have been selected because they incorporate relatively low toxicity solvents. At some point, ideally, the amount of polar solvent added is sufficient to solvate the *bulk* material but has little effect on the underlying oil paint. The word *bulk* is repeated because some materials or fractions of the coating (or materials associated with it) may be so oxidized or chemically modified on aging that they would never be soluble in a simple binary solvent mixture that is sufficient for most less oxidized fractions.

Without the addition of a slower drying component (a solvent of substantially lower vapor pressure), fractions of unsolubilized materials (soils, resins, other coating ingredients, extracted paint film materials, etc.) often appear to settle back onto the cleaned painting surface on evaporation to form a hazy whitish accumulation of residual material. It is a salient feature that the Keck mixtures incorporated diacetone alcohol along with the acetone and mineral spirits; the Pomerantz mixtures include a material trade-named Cellosolve (methyl butyl ethylene glycol). Both are slow evaporating solvents and presumably remain on a cleaned paint surface longer than faster evaporating solvents to help re-form or redissolve residual materials onto, and into, the cleaned paint surface. But there may be other cleaning strategies that would avoid a re-forming need or aspect of solvent selection and in the long run help to deal with wide solubility demands often required for these types of *natural resin-containing films.*

> **Conservators' Note:** "Built" varnishes: *Paintings varnishes usually are not single materials but are "built" from several ingredients so as to be effective for their intended tasks. Additions can include drying oils, gums, carbohydrates, and proteins (emulsified into resin solutions). Solvent blends with a substantial hydrogen bonding aspect may be required. Others, composed of substantially natural resins mixtures to achieve the same ends (e.g., dammar or mastic mixed with the so-called beta-resene materials, such as Vibert's varnish), might age and oxidize in another fashion and require increasingly dipolar aspects to solvent mixtures for resolublization.*

The Keck, Rabin, Pomerantz, and Ruhemann mixtures are paradigms for using simple binary mixtures for solubilizing resinous coatings. At their core is a still useful, initial approach or strategy for estimating

the solubility of a particular resinous coating. But rather than incorporate other effects (e.g., re-forming), we can take from them the first and most important aspect they convey: by varying the polarity (in terms of either hydrogen bonding aspect or dipole moment) we can quickly estimate the type of solvent mixture necessary to solvate a particular coating, creating test mixtures with just three simple solvents.

> **Conservators' Note:** *Some natural resin varnishes are blends of various natural resin fractions (low and high molecular weight) as tailored or "built" coatings, and as they age and oxidize, they will inevitably require solvents of increasing dipole moment to resolvate them, and we might have more success at doing so with one of the acetone–mineral spirit mixtures. Conversely, if we are faced with a natural resin varnish with relatively small amounts of additional plasticizing or fortifying materials such as gums, carbohydrates, or proteins, we may find that solvent mixtures that increasingly incorporate higher hydrogen bonding aspects to them (e.g., the isopropanol–mineral spirit series) might prove the more successful route for resolvating the bulk of a given soft resin coating.*

More complicated coatings

The strategy of starting with a weak (aliphatic) mixture and progressively moving to more polar mixtures (with acetone or isopropanol) may work often and well for *natural "soft" resin varnishes* that are only slightly modified with minor amounts of other ingredients or have not been subjected to extreme or unusual conditions. However, there are occasions when this is not the case: natural resin varnishes blended with other materials often are found on oil paint surfaces as clear coatings; "coach" varnishes, sign makers' varnishes, and the like, pose a special challenge in this regard. The empirical usefulness of mixtures such as Pomerantz 1, 2, and 3 and Rabin 2 and 3 probably lies in the fact that they intrinsically are very close to, or within, the normal solubility region of natural soft resinous materials (figs. 3A.1, 3A.8; darker dotted line).

Situations undoubtedly arise in which more complicated or difficult materials are incorporated in resinous coatings—for example, a coating with a substantial drying oil content that requires both a high hydrogen bonding aspect and a high dipole moment to solvate the material, or in other words, that require a "stronger" solvent mixture. Some of the solvents (e.g., morpholine, dimethylformamide) used traditionally to meet this need are quite toxic. Using them to solvate drying oils, in particular, gives a very narrow margin for safety and efficacy in separating an oil-containing coating with minimal effect on the oil film beneath. However, a less toxic series of simple binary mixtures that coincidentally spans this region of the Teas diagram (see fig. 3A.9) can be formulated by mixing isopropanol and acetone in varying proportions. These could now be part of a general solvent "test" evaluation or strategy as well.

Figure 3A.8

Location of natural soft resinous materials
(darker dotted line) and drying oil mate-
rials (lighter dotted line) in relation to
traditional "strong" solvents

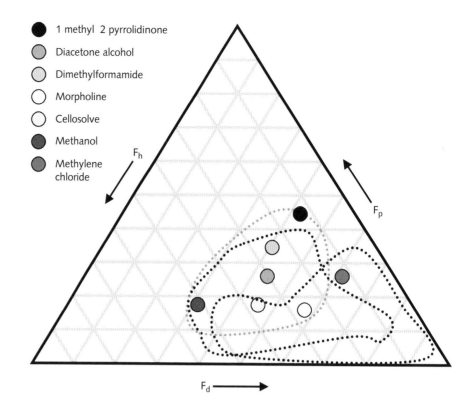

Figure 3A.9

Location of test series of binary solvent
mixtures from figure 3A.7

Additional strategies

While all of the test series of solvent mixtures in figure 3A.7 can easily
be prepared in advance and made available to evaluate the solubility
needs of a particular varnish or coating, they may not be *sufficient* by

themselves to actually fully clean or remove a coating. For instance, it might quickly become apparent that a 1:1 mixture of Shellsol: isopropanol is able to solvate the *bulk* of a particular coating in a reasonable amount of time and with minimal physical effort. "Bulk" is again used here deliberately to suggest that the wide range of material in a degraded natural resin–based varnish may be dissolved, but it is unlikely that a simple binary solvent mixture will solvate *all* materials present. Small amounts of coating materials may remain on the surface. The earlier strategy to deal with this residual material was to add a slow evaporating or re-forming solvent such as diacetone alcohol. However, another cleaning strategy might be applied at this point: for example; if the residual material represents the most polar (e.g., the most oxidized and acidic) fraction of the degraded natural resin coating, an additional aqueous cleaning step might be a gentler and more effective removal strategy. *Removal* of the residual material is preferred to re-forming it onto or into the paint surface, or the even less desirable step of eventually just saturating, or "masking over," this kind of material at a later stage with a reapplied varnish. If, on the other hand, residual materials include a higher molecular weight fraction (fossil resins, polymerized oils, etc., of a built coating or varnish material), removal is still the preferred strategy; but residues of relatively high molecular weight materials (polymers) or solid materials are probably more efficiently solubilized with preparations containing solvents *and* surfactants, rather than by other means involving solvents alone.

Whatever the exact nature or composition, small amounts of residual material can probably be anticipated and dealt with separately as necessary. The earlier strategy of building mixtures of solvents that incrementally increase in polarity is still viable for testing and designing a general solvent-based cleaning system removing predominantly soft natural resins. In any event, it makes sense to design as well for solubilizing the *bulk* material of a film or coating with the least polar mixture possible. If fractions or portions of a coating remain, tailor an additional step or material to clean or solubilize these materials separately.

Testing with the solvent mixtures described in figure 3A.7 may indicate (at least by negative results or observations) the presence of some of the more complex arrangements that coating materials can take on. Solubility tests, of course, can still serve as a basis for a logical "branching" point to evaluate and reasonably build alternative methods of solubilization or cleaning. For instance, if any of the simple binary test mixtures containing acetone and isopropanol (the Series 3 mixtures), or even the Series 1, 2 mixtures containing substantial amounts of isopropanol or acetone, appear to, at best, slowly solvate or swell a coating, then the cleaning strategy may be additionally modified to adjust for this. When a coating contains a *high* relative concentration of a drying oil, for instance, blended with a natural resin (e.g., as in furniture and coach varnishes), it is likely that we would make just such a (negative or limited) "solubility" observation. It may be the case that *none* of the simple test mixtures might appear to even to begin to swell or affect certain *substantially* "oil-modified" or highly cross-linked synthetic coating

materials (alkyds, urethanes). Coatings composed mainly of higher molecular weight polymers, or polymer-forming materials (e.g., drying oils, shellac), can very slowly, at best, be resolubilized, due to the size of the molecules. Further, these materials may behave very differently on aging and exposure than do natural (soft) resin-based coating materials. Size, rather than state of oxidation, may be the complicating factor. Therefore, the tried-and-true strategy of simply incrementally increasing the polarity of solvent test mixtures to find the right "strength" to resolubilize one of these more difficult coating materials may not be effective because these large polymer molecules do not oxidize on aging and therefore do not become more polar.

Some materials that might be encountered on paintings as coatings (e.g., butyl methacrylates) may *never* appreciably change in oxidation state and yet appear to become intractable with age as they simply cross-link to form higher and higher molecular weight materials. At this point we might want to draw again on the basic list of solvents proposed in figure 3A.6 to deal with these more problematic coating materials. Even higher dipole moment solvents (e.g., 1-methyl 2-pyrrolidinone), or higher hydrogen bonding solvents (e.g., ethanol, methanol), are available for use separately or as blends with aliphatic or aromatic solvents to create or expand the number of simple binary solvent mixtures. But in addition, solvent/surfactant blends might be explored to add an additional cleaning approach or tool.

> **Conservators' Note:** Urethanes *and* some alkyds *tend not to dissolve but appear to soften and swell in aromatic solvents; high oil content resin varnishes tend to swell in alcohol and aromatic solvent mixtures.*

Branching point: Solvent gels

If higher molecular weight material is the complicating aspect of a coating and there is an indicated "swelling" solvent or solvent mixture in the basic solvent list or simple binary test mixtures for a given material, we may be able to incorporate another material—a surfactant— alongside these swelling solvent or solvent mixtures to disperse if not outright dissolve this material. This usually can be done with generally lower polarity or solubility parameters than initial testing might indicate. This is the "branching point" in our solvent cleaning strategy: If we observe that test mixtures containing substantial amounts of isopropanol and acetone, or both, are required to begin to solvate a coating, we may want to look more closely at what is the complicating factor of the coating. If a coating contains a high percentage of high molecular weight material, it may be more advantageous to couple a lower solubility parameter solvent or solvent mixture with a surfactant to disperse—rather than dissolve—the problematic material.

Solvents can be blended with surfactants in a variety of ways to increase their ability to solubilize a wide ranges of materials. The so-called solvent gels in the Gels Research Project represent a particular arrangement of materials where a low aggregation number surfactant

(cationic) is bound through a salt-type linkage to a generic anionic polymer (polyacrylic acid) or "scaffolding." The polymer presence helps to control viscosity and penetration (diffusion) into underlying (paint) materials but can help to hold a surfactant in place to facilitate effective application and removal. Figures 3A.10 and 3A.11 are schematized renderings of the common polymer surfactant arrangements. Typically, two surfactants of slightly different polarity (trade-named Ethomeen C/12 and Ethomeen C/25) have been used. Selection generally depends on the net polarity of the solvents that surround the polymer-surfactant complex. Figure 3A.12 describes this difference; mixtures that fall to the left of the gray diagonal line are made with Ethomeen C/25; those to the right are made with Ethomeen C/12. Generic recipes are presented in

Figure 3A.10

Schematic rendering of Ethomeen C/12–Carbopol gelling system

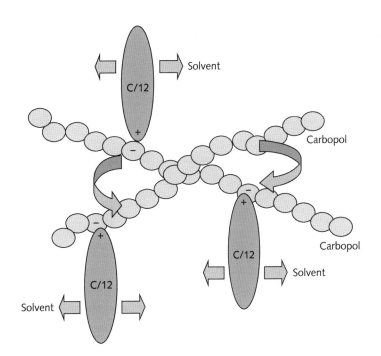

Figure 3A.11

Schematic rendering of Ethomeen C/25–Carbopol gelling system

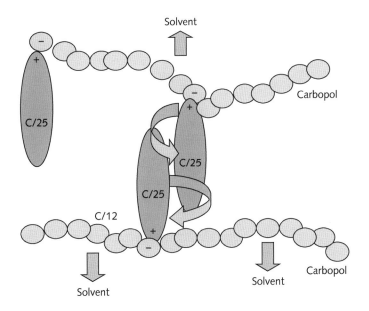

Figure 3A.12

Regions of solubility for Ethomeen C/12
and C/25 (and the gels that incorporate
them) on the Teas diagram

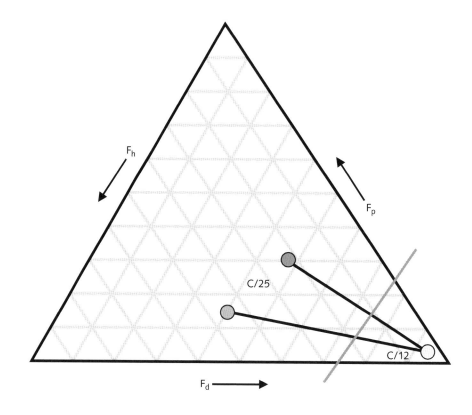

figures 3A.13 and 3A.14 to indicate the general proportions of solvent-
polymer-surfactant used in constructing these types of gels.

As a general procedure, all seven solvents listed in the basic sol-
vent kit (see figs. 3A.6, 3A.15) are premade in gel form as stock prepara-
tions and can easily be modified by adding more free solvents to each
stock gel. For instance, if the pure isopropanol gel proved too strong, its
overall solubility parameter could be adjusted downward by adding
another less polar solvent (xylene, for instance) as a free solvent.

Figure 3A.13

Generic recipe for preparing gels with
polar solvents using Ethomeen C/25

Solvent Gel General Recipe: Polar Solvents	
100ml	Solvent/solvent blend
20ml	Ethomeen C/25
2g	Carbopol 934 (943, 954, 984)
10–15ml	deionized water

Figure 3A.14

Generic recipe for preparing aromatic and
aliphatic solvent gels using Ethomeen C/12

Solvent Gel General Recipe: Aromatics, Aliphatics	
100ml	Solvent/solvent blend
20ml	Ethomeen C/12
2g	Carbopol 934 (943, 954, 984)
1.5 ml	deionized water

Figure 3A.15

Basic test kit solvents and the concomitant
Ethomeens needed to make and gel them
using the generic recipes

Basic Solvent Gel Kit
Mineral spirits gel (C/12)
Xylene gel (C/12)
Acetone gel (C/25)
Isopropanol gel (C/25)
1 methyl 2 pyrrolidinone gel (C/25)

Combinations of alcohols and aromatic solvents tend to be very effective
in gel form, with oleoresinous films, for instance. High dipole moment
solvents—for example, acetone or 1-methyl-2-pyrrolidinone (n-Pyrrole)
—can be gelled with the same basic recipe in figure 3A.13 and tailored or
modified with the addition of less polar, free solvents (e.g., xylene or
Shelsolv) to fit a given situation or cleaning need. Gelled solvents with
relatively high dipolar aspects to their overall character have been quite
useful in resolubilizing coatings that contain substantial amounts of nat-
ural resins of a higher polymeric character (e.g., "fossil resin"–containing
coatings and varnishes).

Some coating materials—for example, synthetic polymers such as
urethanes and phthalate anhydride–based alkyds—tend to at least swell
in aromatic solvents. Gels made from this class of solvents (xylene, ben-
zyl alcohol, or combinations following the recipe in figure 3A.14) are
effective at solubilizing and dispersing these types of materials.

An empirical "discovery" is inevitable in the search for suitable
solvent mixtures or systems for resolubilizing coating on paintings; and
the current "logic" simply builds on work done to date. A basis of the
stepwise process of discovery, however, is the initial testing with a
defined series of free solvent mixtures, followed by more complicated
mixtures and coupling surfactants with solvents if necessary in "gel"
preparations.

Chapter 4

Research into Solvent Residues

Herant Khanjian, Dusan Stulik, and David Miller

The reliable use of organic solvents for cleaning paintings has been based largely on research in the conservation field during the latter half of the twentieth century. The first systematic objective studies regarding the effects of solvents on oil paint films were conducted in the 1950s and 1960s (Feller, Stolow, and Jones 1959; Ruhemann 1968; Stolow 1955, 1963). The initial work by Stolow concentrated on understanding solvent effects on the swelling of organic binders in paint films during the cleaning process, as well as determining the extent of extraction of low molecular weight species. The practical work by Ruhemann dealt with the solubility of varnish and the swelling of paint, whereas Feller concentrated on understanding the swelling of aged and unaged natural resins. During the 1980s, Hedley focused on describing solvent power and the dangers of paint swelling during solvent removal of varnish (Hedley 1990). Considerable research has been undertaken at the Smithsonian Center for Materials Research and Education on the effects of solvents and other cleaning methods on paint film (e.g., Erhardt and Tsang 1990; Tsang and Erhardt 1992; Tumosa et al. 1999). In a series of 1998 presentations, Phenix (1998) explored some of the issues regarding organic solvents and their effects on paintings, and more recently, Phenix and Sutherland (2001) reviewed research to date on this topic.

Based on the important work of these scientists and others, the use of organic solvents has been generally accepted as a reliable approach to cleaning. One obvious advantage of organic solvents is their inherently volatile nature and their tendency to subsequently evaporate from the surface of treated objects. The availability of a large selection of solvent types with different physical and chemical properties has contributed to preferential use of solvents on surface cleaning or removal of varnish and unwanted paint layers. In addition, over years of training and use, many conservators have become accustomed to, and confident in, using specific solvents or solvent mixtures in their cleaning protocols. As mentioned in the introduction, solvent mixtures of varying polarities became codified and entered the paintings conservator's standard test kit (fig. 4.1; see also fig. 0.1).

However, studies have detected changes in the properties of paints as a result of solvent treatment (Stolow 1955; Hedley et al. 1990; Phenix 1998a; Tumosa et al. 1999). Depending on the length of exposure

Figure 4.1

Rabin, Ruhemann, and Pomerantz
"coded" test solvents

Rabin 1:	Acetone	25%
	Toluene	75%
Rabin 2:	Acetone	50%
	Diacetone alcohol	20%
	Mineral spirits	30%
Rabin 3:	Methanol	50%
	Acetone	25%
	Dimethylformamide	12.5%
	Morpholine	12.5%

Ruhemann 1:	Acetone	25%
	VM&P naphtha	75%
Ruhemann 2:	Acetone	33%
	VM&P naphtha	67%
Ruhemann 3:	Ethanol	7.7%
	VM&P naphtha	92.3%
Ruhemann 4:	Ethanol	11%
	VM&P naphtha	89%

Pomerantz 1:	Acetone	10%
	Shellsol	10%
	Cellosolve	80%
Pomerantz 2:	Acetone	15%
	Shellsol	15%
	Cellosolve	70%
Pomerantz 3:	Acetone	20%
	Shellsol	20%
	Cellosolve	60%
Pomerantz 4:	(etc.)	

and the type of solvent used, physical changes in softening, stiffness, and elasticity were detected. In addition, low molecular weight species such as glycerol, low molecular weight fatty acids and mono-, di-, and triglycerides were extracted and characterized using modern analytical instruments (Stolow 1985; Erhardt and Tsang 1990).

It is well known that most reagent-grade solvents used in conservation laboratories are not completely pure. Natural as well as synthetic chemical processes associated with production of reagent-grade solvents produce minor quantities of impurities. Further, small concentrations of other solvents are deliberately mixed with some reagent-grade organic solvents as denaturants. The impurities, both organic and inorganic, are usually listed on solvent bottle labels but frequently are not taken into consideration in the cleaning process because of their low concentrations relative to the main solvent. However, our solvent residue studies, described in this chapter, indicate that several solvents left behind detectable and measurable amounts of residue after evaporation. These

low concentrations of organic and inorganic acids and their salt residues could potentially harm painting surfaces through the initiation or promotion of secondary chemical reactions over extended periods of time. This is especially important because often paintings are varnished soon after being cleaned with solvents. The varnishing can slow the evaporation of solvents and increase their residency time in the paint layers. One study at the Institut Royale de Patrimoine Artistique (IRPA), Brussels, indicated that trace quantities of certain solvents, such as methanol, remained in the painting structure for up to 120 days (Dauchot-Dehon 1973–74; Masschelein-Kleiner and Deneyer 1981).

The study of solvent evaporation in the surface cleaning process was conducted as part of the Gels Research Project to detect any potential residues from solvent cleaning and compare these data with that obtained from the solvent gel cleaning experiment discussed in chapter 3. The primary objective of the study was to determine quantitatively the amount of solvent remaining on the surface of the painting after cleaning and to continuously monitor the concentration over time to determine how long it remains in the structure of the cleaned object. In a parallel study, evaporation rates of pure solvents in open containers were recorded to compare them with evaporation rates from painting surfaces.

Relationship between Solvent Parameters and Solvent Evaporation

Previous publications dealing with solvent retention, mainly from the industrial sector, have highlighted various physical and chemical effects on the rate of evaporation (Yoshida 1972; Newman 1975). Parameters such as paint film type and the differences between solvent mixtures and their relative volatility are important factors that require consideration. In addition, the effect of mixture composition during evaporation, specifically, the compositional effects of alcohol-containing solvents, has been described (Yoshida 1972). These hydroxyl-containing solvents behave irregularly when compared to individually tested components. This can be attributed to azeotropic effects as well as preferential interaction with paint.

Solvent-Paint Interaction and Evaporation

Two forms of solvent penetration—diffusion and capillary penetration—are the basis of interaction with paint films. Capillary penetration is the transport of bulk liquid solvent into the cracks and pores in the paint and ground; diffusion is the transport on a molecular level of solvent through the solid organic phase of the paint (Michalski 1990). The first effect takes place rapidly and is influenced largely by paint porosity and solvent surface tension. Diffusion, on the other hand, is influenced by the increased surface access created by the first effect.

Quantitative Investigation of Solvent Residues

Experimental methodology and procedures

Solvent selection

The experimental testing protocol using radioactively labeled materials for identifying gel residues described in chapter 3 was a valuable model in developing the methodology for studying solvent residues (see also Stulik et al. 2000). Ten common solvents were chosen for study based on their historical use, their solvent parameters, and an international survey of practicing conservators. The majority of these solvents were commercially available as [14]C-labeled material. The solvent solubility parameters, as indicated on a Teas diagram (fig. 4.2), encompass a wide range of dispersion, dipolar, and hydrogen bonding properties. Table 4.1 lists the

Figure 4.2

Teas diagram showing solubility parameters of solvents selected for study

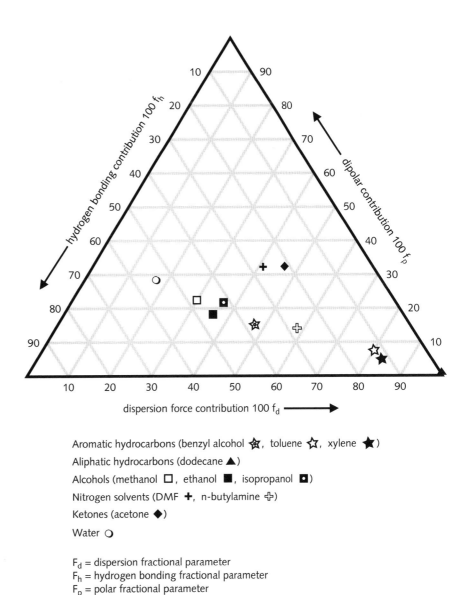

Aromatic hydrocarbons (benzyl alcohol ✮, toluene ☆, xylene ★)

Aliphatic hydrocarbons (dodecane ▲)

Alcohols (methanol ☐, ethanol ■, isopropanol ▣)

Nitrogen solvents (DMF ✚, n-butylamine ✛)

Ketones (acetone ◆)

Water ◐

F_d = dispersion fractional parameter
F_h = hydrogen bonding fractional parameter
F_p = polar fractional parameter

Table 4.1

Physical properties of solvents selected for study

Solvent	Formula	MW	B.P. (°C)
Acetone	$H_3C-\overset{\overset{O}{\|\|}}{C}-CH_3$	58.08	56.5
Methanol	CH_3OH	32.04	64.7
n-butylamine	$CH_3(CH_2)_3NH_2$	73.14	78.0
Ethanol	CH_3CH_2OH	46.07	78.5
Isopropanol	$CH_3-\overset{\overset{OH}{\|}}{CH}-CH_3$	60.10	82.5
Toluene	(benzene ring)$-CH_3$	92.14	111
Xylene(s)	(benzene ring with CH_3, $-CH_3$)	106.07	139
Dimethylformamide	$H\overset{\overset{O}{\|\|}}{C}N(CH_3)_2$	73.09	153
Shellsol (petroleum distillate)	$CH_3(CH_2)_nCH_3$ n = 4–10		177.8–198.9
Benzyl alcohol	(benzene ring)$-CH_2OH$	108.14	205
Dodecane	$CH_3(CH_2)_{10}CH_3$	170.34	216

solvents selected for this study. Because of its desired use by conservators for cleaning paintings, Shellsol was added to the list. However, the availability of several types of Shellsol used in the treatment of objects made the selection and potential radioactive labeling more difficult. As a result, ^{14}C-labeled dodecane was used to spike the unlabeled Shellsol during preparation of solvent mixtures.

Preparation of radioactively labeled solvents and solvent mixtures
To prepare "hot" cleaning solvents for our experiments, 50 to 100 µL of radiolabeled pure solvent stock was added to several mL of "cold" solvent to achieve a desirable range of specific activity (0.2–20 µCi/mL).

To study the effect of solvent–solvent interaction during a cleaning procedure and on evaporation from a painting layer, a series of acetone-Shellsol, ethanol-Shellsol, and isopropanol-Shellsol binary mixtures were included in the study. The binary solvent mixtures were prepared by mixing "cold" and "hot" solvents in proportions that covered the whole range of concentrations from pure solvent to its 1:5 dilution (table 4.2).

Evaporation rate of free solvents
To provide a convenient reference point for evaluating evaporation rates and residency of solvents during and after cleaning of painted surfaces, a

Table 4.2

Preparation and annotation of binary
solvent mixtures

Set I – Acetone:Shellsol	Set II – Shellsol:Acetone
*AS1 – Pure acetone	*SA1 – Pure Shellsol
AS2 – 5:1 ratio (v/v)	SA2 – 5:1 ratio (v/v)
AS3 – 3:1 ratio (v/v)	SA3 – 3:1 ratio (v/v)
AS4 – 1:1 ratio (v/v)	SA4 – 1:1 ratio (v/v)
AS5 – 1:3 ratio (v/v)	SA5 – 1:3 ratio (v/v)
AS6 – 1:5 ratio (v/v)	SA6 – 1:5 ratio (v/v)
Set I – Ethanol:Shellsol	**Set II – Shellsol:Ethanol**
*ES1 – Pure Ethanol	*SE1 – Pure Shellsol
ES2 – 5:1 ratio (v/v)	SE2 – 5:1 ratio (v/v)
ES3 – 3:1 ratio (v/v)	SE3 – 3:1 ratio (v/v)
ES4 – 1:1 ratio (v/v)	SE4 – 1:1 ratio (v/v)
ES5 – 1:3 ratio (v/v)	SE5 – 1:3 ratio (v/v)
ES6 – 1:5 ratio (v/v)	SE6 – 1:5 ratio (v/v)
Set I – Isopropanol:Shellsol	**Set II – Shellsol:Isopropanol**
*PS1 – Pure acetone	*SP1 – Pure Shellsol
PS2 – 5:1 ratio (v/v)	SP2 – 5:1 ratio (v/v)
PS3 – 3:1 ratio (v/v)	SP3 – 3:1 ratio (v/v)
PS4 – 1:1 ratio (v/v)	SP4 – 1:1 ratio (v/v)
PS5 – 1:3 ratio (v/v)	SP5 – 1:3 ratio (v/v)
PS6 – 1:5 ratio (v/v)	SP6 – 1:5 ratio (v/v)
* First letter of designation denotes labeled ("hot") component in the mixture.	

series of simple experiments was conducted to measure evaporation rates of free solvents under conditions identical to those of the solvent cleaning experiments (e.g., fume hood temperature, pressure, airflow). Small amounts (5 mL) of pure solvent were pipetted into 20 mL glass beakers (2.9 cm in diameter and 4.0 cm in height). The large (6.6 cm^2) opening of these beakers closely approximated a free solvent surface with a minimum of capillarity and container wall effects. The beakers were placed inside a fume hood. The mass changes of individual solvents were monitored in time periods adjusted to the evaporation rates of the different solvents, and the evaporation rates for all solvents, expressed as μg of solvent per cm^2 of solvent surface per second, were calculated.

Evaluation of higher molecular weight impurities
present in solvent samples

The same experiment was used to measure total amounts of higher molecular weight (higher boiling point) impurities present in solvent samples

that might potentially remain on the surface of a cleaned object as solvent impurity residues. The difference between the mass of the beaker after evaporation of all its solvent content and the mass of the well-cleaned and dried beaker (established before introduction of the solvent) provided information on the total amount of solvent impurity residue. A clean Kaydry wiper was placed above the beakers to ensure proper evaporation without any dust settling inside.

Identification of solvent impurity residues

To identify the type and chemical character of solvent impurity residues present in solvent samples, small amounts of solvents were spotted and repeatedly evaporated onto barium fluoride windows using a 0.2 µm capillary. A total of one µL of each solvent was deposited and evaporated to dryness. Analysis of the solvent impurity residues was conducted using a 15× Reflechromat objective attached to a Nicolet Nic–Plan FTIR microscope purged with dry air. The resultant spectra were obtained as a sum of 200 scans at a resolution of 4cm^{-1} and spectral range of 4,000–750 cm^{-1}.

Solvent residence time in solvent-cleaned painting samples

The analytical methodology used in this study was based on the approach used previously for the quantitative determination of amounts of gel residues in solvent gel cleaning studies, described in the previous chapter. Two highly experienced conservators conducted all the cleaning procedures, assisted by a team of scientists who prepared radiolabeled materials and timed and recorded all relevant experiments details. (See fig. 4.3.)

Test painting

Experimental painting samples were obtained from the same painting used in the gel cleaning studies. Both radioactively labeled pure solvents and solvent mixtures (see above) were used in the cleaning experiments.

Figure 4.3

Conservator Mark Leonard cleaning samples with one of the solvent mixtures

STEP 1

The radioactively labeled solvents were applied to the painting samples using prerolled cotton swabs, and the starting time was recorded. A cleaning time of 2.5 minutes was determined using "cold" solvents and this time was kept uniform in all cleaning experiments (fig. 4.4). The cleaning time was kept constant based on the effectiveness of initial test

Figure 4.4

Schematic of the experiment steps

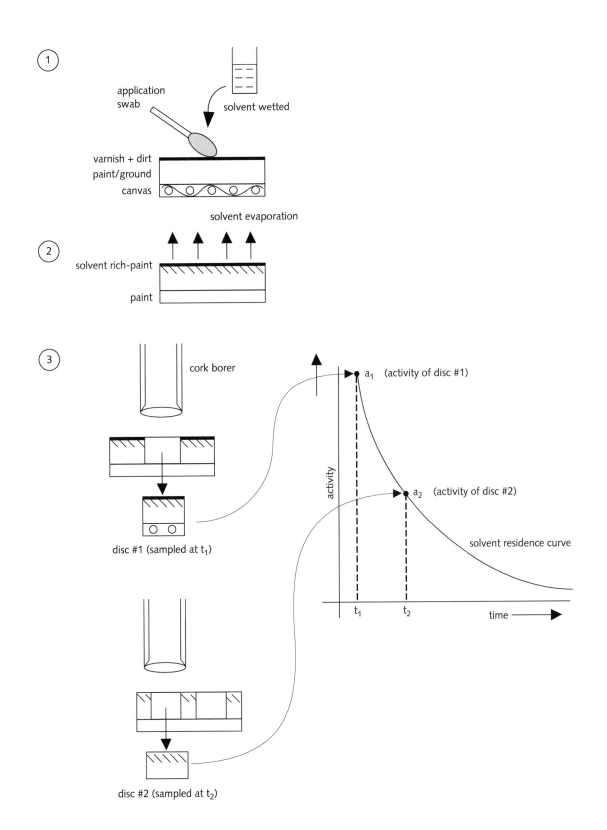

experiments and to minimize excess evaporation of low-boiling solvents. For logistical reasons and because of time limitations, only two experienced conservators conducted the cleaning process.

STEP 2

After the cleaning was completed, the initial concentration of solvent residue in and on the cleaned surface was rapidly assayed by punching three 12-mm disks from random areas of the cleaned sample. The disks were placed into 20 mL scintillation vials, and 18 mL of Beckman Ready Solv liquid scintillation cocktail was added.

The radioactivity in the painting samples (which corresponds directly to concentration of solvent present in the disk) was measured using a Beckman 6500 liquid scintillation counter. All samples were counted for five minutes or until the uncertainty in the count rate was less than 5%.

STEP 3

Step 2 was then repeated at predetermined times for up to fourteen weeks. The measured activity of the painting samples dropped to less than 5% of the initial level during this time. The measured radioactivity for each sample was converted into an equivalent volume of solvent using the known specific activity of the labeled solvent. This result was then expressed as µg solvent/cm² of the cleaned surface.

Long-term experiments (fourteen weeks) for high boiling point solvents and short-term experiments (fifty days) for lower boiling point solvents were both conducted. As mentioned previously, the evaporation rate studies of free solvents were also conducted during this period. The results of the free solvent measurements served to fix the sampling period for the painting studies. Because of the rapid evaporation of low-boiling free solvents, the experiments were limited to fifty days.

All the cleaning tests were conducted in a fume hood of a research laboratory certified for the use of radioactive material. All safety rules for work, handling, and disposal of radioactive material were strictly observed, and the laboratory was regularly monitored for any possible spills of radioactive material.

Results

Evaporation rates of free solvents

Mass difference measurements during several time periods allowed us to measure the evaporation rates of free solvents. Figures 4.5 and 4.6 show the experimental results for high boiling point and lower boiling point solvents, respectively. Table 4.3 shows calculated evaporation rates from a simulated free solvent surface expressed in µg/cm²/s (for 26°C and average air pressure range of 740 to 750 mm Hg). Calculated rates were based on the slope of fitted data from the linear region of figures 4.5 and 4.6. As expected, the results show that the evaporation rates are constant during

Table 4.3

Evaporation rates from free solvent surface in glass beaker

Solvent	Evaporation Rate ($\mu g/cm^2/s$)
Acetone	143
Methanol	65
n-butylamine	98
Ethanol	40
Isopropanol	41
Toluene	39
Xylene	14
DMF	0.13
Shellsol	0.08
Benzyl alcohol	0.2
Dodecane	0.03

Figure 4.5

Evaporation of pure high boiling point unlabeled solvents

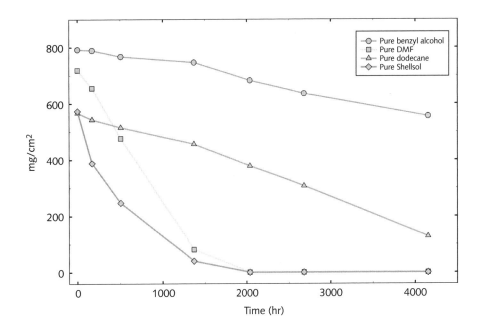

Figure 4.6

Evaporation of pure low boiling point unlabeled solvents

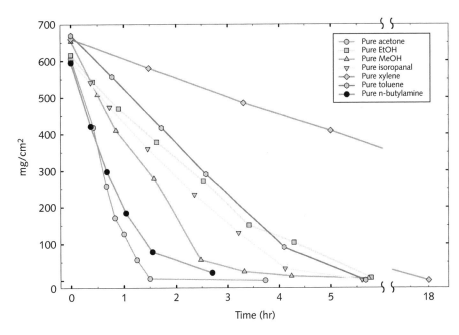

almost the entire time. Only at the end of the experiments, when the amount of solvent in a beaker was nearly depleted, was there a noticeable change in the evaporation rate due to container wall interactions. Initially, the clean and dried beakers were allowed to equilibrate to laboratory conditions before the evaporation experiments started to assist in eliminating any influences from ambient moisture. The final weight of beakers, after complete evaporation of solvents, was stable.

Identification of solvent impurities

Evaporation of free solvents to dryness showed that most solvents in the study left measurable amounts of higher boiling point impurities. Amounts of these residues are shown in table 4.4. During the period of this experiment, benzyl alcohol and dodecane did not completely evaporate. This demonstrates that certain organic solvents contain some impurities that do not evaporate from a cleaned surface and remain as solvent-deposited residues. Solvent impurities are clearly a concern, and attention should be given to the purity level of the cleaning solvent used. We can expect the level of impurities to decrease in the following sequence:

technical-grade material > reagent-grade material > "pro analysis"
and spectroscopic-grade solvents

There is a very good chance that the quantity of solvent impurities might vary from one product to another based on the manufacturer and manufacturing process and the materials (plastics, grease, sealants, etc.) that come in contact with the solvent during manufacture, storage, transportation, or packaging. The age or shelf life of solvents should also be taken into consideration as solvent degradation, due to exposure to atmospheric contamination or light, may produce additional impurities. To evaluate the potential danger that solvent impurities will remain on the treated surface of a valuable art object, it is important to consider not only the amount of residue but also its chemical nature. The FTIR spectrum of the acetone impurity residues obtained during our studies

Table 4.4

Residues present in glass beakers after complete evaporation of the solvent

Solvent	Residue Mass (μg)	Residue Mass (μg)/mL Solvent
Acetone	100	20
Methanol	300	60
n-butylamine	1200	240
Ethanol	100	20
Isopropanol	200	40
Toluene	300	60
Xylene	300	60
DMF	400	80
Shellsol	600	120

(fig. 4.7) shows peaks consistent with a spectral signature of an ester bond containing waxlike material that might be rather harmless to a paint surface rich in fatty oil and natural resin. On the other hand, the FTIR spectrum of the methanol residues (fig. 4.8) shows the presence of both an ester containing wax-type material and salts of carboxylic acids.

The situation can be even more complicated, as suggested by the FTIR spectrum of the impurity residues from dimethyl formamide (DMF) in figure 4.9. The interpretation of this spectrum indicates a presence of inorganic nitrate salts. In such cases, it is important to evaluate the impact of these residues and to consider changing the cleaning procedure or selecting a higher purity solvent. It is also important to consider the

Figure 4.7

Infrared spectra of acetone impurity residues and reference ester-containing wax

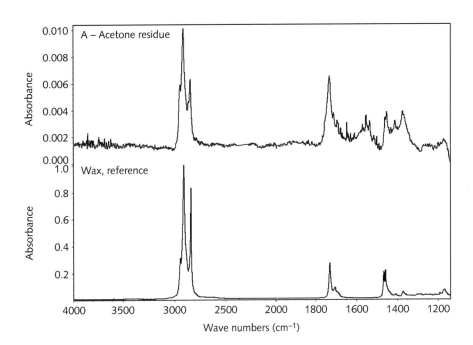

Figure 4.8

Infrared spectra of methanol impurity residues and reference ester-containing wax and salts of carboxylic acids

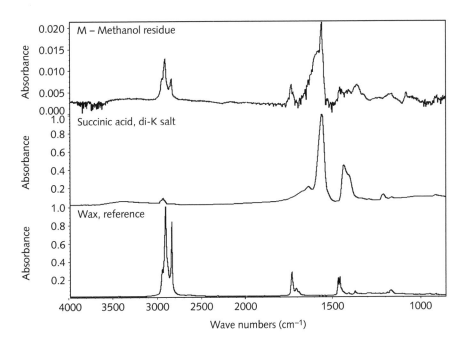

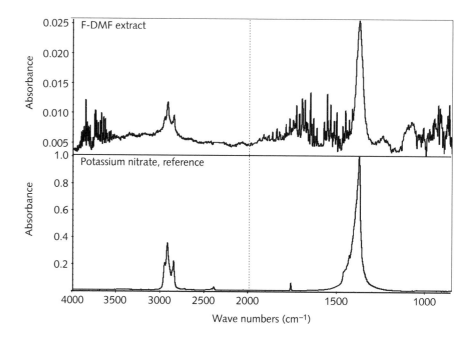

age or shelf life of certain more reactive solvents (such as chlorinated solvents). The issue of solvent degradation from exposure to atmospheric contamination also needs to be examined.

Solvent evaporation kinetics and solvent residence time in solvent-cleaned painting samples using radiolabeled solvents and solvent mixtures

Pure solvents

Two sets of experiments were conducted to obtain results for both lower and higher boiling point solvents. Figure 4.10 shows concentration

Figure 4.10

Residual solvent concentration in test
painting samples: lower boiling point
solvents

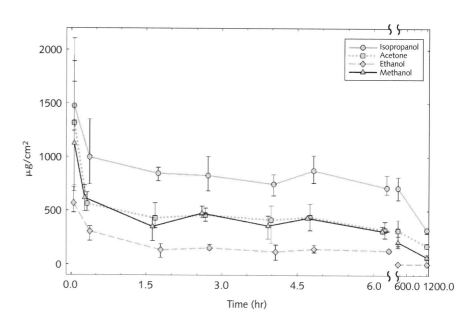

changes of individual solvents (acetone, methanol, ethanol, and isopropanol) in the solvent-cleaned painting samples from first sampling (about 3.5 minutes after the solvent cleaning procedure was completed) to 1,200 hours (50 days). Each concentration point represents the calculated mean of three measurements; the error bar shows the data range. Figure 4.11 shows similar results for higher-boiling solvents (benzyl alcohol, n-butylamine, toluene, xylene, and DMF). In this case, the experiment was extended to 2,279 hours (95 days) from initial sampling. The dodecane was not included in residual solvent concentration figures due to lack of consistent data.

Both experiments show a steep decline in solvent concentration in the painting samples during the first hours after solvent cleaning. Solvent evaporation leveled off after about 30 minutes for the more volatile solvents (acetone, methanol, ethanol, and isopropanol) and after about 50 hours for the less volatile solvents (benzyl alcohol, n-butylamine, toluene, xylene, and DMF). Further decreases of solvent concentration were very slow. The concentrations of all solvents measured in the test paintings after 1.7 hours, 24 hours, one week, and two weeks, as well as the terminal concentrations of solvents, are shown in table 4.5. The initial solvent evaporation rates for painting samples (see table 4.6) were estimated on the basis of change in concentration (μg /cm^2) per unit time (sec.) for the first two data points. In table 4.7, solvent residue concentrations are compared with gel residue concentration on a cleaned test painting.

Solvent mixtures

We also conducted a series of experiments to investigate the differences in solvent residence time in a painting cleaned with solvent mixtures. Three solvent mixtures were investigated: acetone-Shellsol, ethanol-

Figure 4.11

Residual solvent concentration in test painting samples: higher boiling point solvents

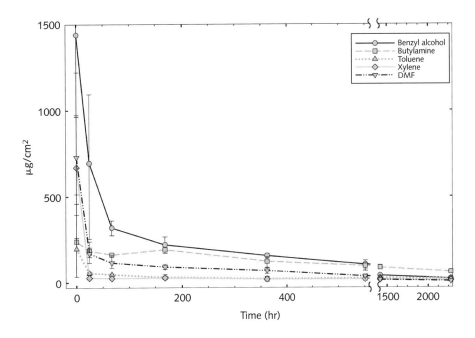

Table 4.5

Concentration (μg/cm²) of solvents in test painting samples after solvent cleaning

Solvent	1.7 Hours	24 Hours	1 Week	2 Weeks	7 Weeks
Acetone	431	320	320	318	175
Methanol	136	122	69	5	3
n-butylamine	235	186	192	132	89
Ethanol	352	305	262	211	70
Isopropanol	847	715	713	712	322
Toluene	188	56	31	22	25
Xylene	628	28	28	20	16
DMF	694	170	92	72	20
Benzyl alcohol	1392	649	220	164	57
Dodecane	2384	295	222	137	82

Table 4.6

Comparison of evaporation rates (μg/cm²/s) of free solvents and solvents from solvent-cleaned test painting samples

Solvent	Evaporation Rate Free Solvent	Evaporation (initial) Rate on Painting
Acetone	143	0.78
Methanol	65	0.22
n-butylamine	98	6.2×10^{-4}
Ethanol	40	0.65
Isopropanol	41	0.42
Toluene	39	1.6×10^{-3}
Xylene	14	7.5×10^{-3}
DMF	0.13	6.5×10^{-3}
Benzyl alcohol	0.2	8.7×10^{-3}

Shellsol, and isopropanol-Shellsol. The mixtures covered a range of concentrations from pure solvent to its 1:5 dilution (see table 4.2). These mixtures represent totally miscible binary solvent systems when in the liquid phase. The goal was to determine whether the presence of another solvent promotes or diminishes evaporation of a given solvent from a paint layer after cleaning (solvent drying process). The concentration of ethanol residue in the samples cleaned using a series of ethanol-Shellsol mixtures and the result of an identical experiment in which the amount of Shellsol residues was measured are shown in figures 4.12 and 4.13, respectively.

These results suggest that there might be a difference in the evaporation rate of pure ethanol and ethanol mixed with solvents of different polarity (Shellsol), but such an interpretation is highly speculative because the scatter in the individual measurements is too wide to provide

Table 4.7

Comparison of average concentration of surface residues from gel cleaning with those from solvent cleaning

	Average Concentration (µg/cm^2)		
	20 minutes	7 days	50 days
Gel component			
Isopropanol	2	NA	NA
Benzyl alcohol	24	NA	NA
Ethomeen	60	NA	NA
Carbopol	7	NA	NA
Solvents			
Acetone	563	320	175
Methanol	306	69	3
n-butylamine	186	192	89
Ethanol	617	262	70
Isopropanol	997	713	322
Toluene	56	31	25
Xylene	28	28	16
DMF	170	92	20
Benzyl alcohol	694	220	57
Dodecane	4179	222	82

much confidence. Our work schedule did not allow us to repeat the measurements or to improve the quality of the data by, for example, increasing the number of sampling disks removed from each sample. For

Figure 4.12

Concentration of ethanol residues in test painting samples cleaned using ethanol–Shellsol mixtures (^4C-labeled ethanol)

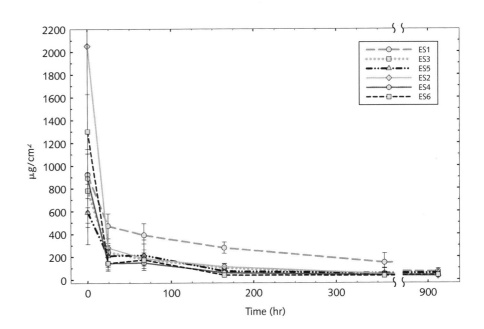

Figure 4.13

Concentration of Shellsol residues in test
painting samples cleaned using Shellsol–
ethanol mixtures (^{14}C-labeled dodecane in
Shellsol)

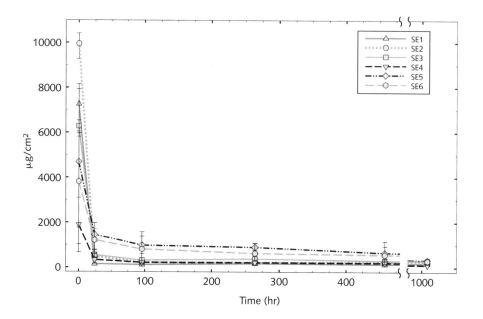

this reason, we show only one set of results; we hope that these experiments will be revisited later by other researchers.

Conclusions

Our analytical methodology for studying solvent evaporation and solvent residence time in solvent-cleaned test painting samples using a combination of radiolabeled solvents and scintillation counting works very well and is sufficiently sensitive to monitor the presence of traces of solvent residues in the painting many weeks after the solvent cleaning process is completed. Even many days and weeks after solvent cleaning, a relatively large amount of solvent was still present in the painting structure.

The important difference between gel cleaning and solvent cleaning is the apparent higher concentration of solvent residue of isopropanol and benzyl alcohol. The concentration of isopropanol is 500 times higher in the solvent residues study compared to the gel residues, while the benzyl alcohol concentration is 29 times higher. The specific solvent residues in the gel study represent the average concentration of solvent left on the surface of the painting after cleaning (see chap. 3). The higher solvent residue concentration can be attributed to the larger amount of free solvent that is applied to the painting surface during the cleaning process. This allows the capillary penetration of the bulk solvent into the cracks and pores of the paint and also enhances the diffusion of solvent into the organic medium. On the other hand, gels that contain a lower concentration of solvent are applied to the surface during the cleaning process and removed after a short time. As a result, gel residues remain primarily on the surface and penetrate much less into the paint layers. The amount of infiltration of solvent residues is apparent, as the concentrations of the isopropanol and benzyl alcohol remain high after two weeks. Therefore,

the control afforded by gel cleaning becomes an important factor in considering solvent residues left on the painting surface.

Our study demonstrates that solvents reside in the cleaned paint layer much longer than might be expected based on our everyday experience with evaporation of free solvents. Therefore, there may be a need to review current conservation practice involving solvent cleaning. Specifically, when solvents present in the painting layer can change its chemistry or physical properties, it might be necessary to extend the period between solvent cleaning and application of a new varnish over the cleaned paint layer. A varnish layer applied too soon would present an additional layer that would further slow the solvent evaporation process. (The study of these factors was beyond the scope of our investigation. A comprehensive scientific investigation of these factors is needed to complement our findings and to formulate broad recommendations for conservators.)

It is important to realize that there is a major difference between the location of gel and of solvent residues in the paint layer. Our study of solvent gel cleaning showed that gel residues are distributed over the top surface of the cleaned paint layer and concentrated in any surface cracks and fissures and in surface (brush stroke) topography of the paint layer. On the other hand, the main "reservoir" of solvent residues is in the paint layer, and the driving force for diffusion of solvent from inside the paint layer to its surface is the difference between the chemical potentials for the given solvent in and on top of the paint layer.

Although the number of conservators who carried out the solvent cleaning experiments was fewer than that in the solvent gel residue experiments (chap. 3), the conservators in our study were free to use their personal or subjective techniques in cleaning the painting samples. Despite this difference, comparison of solvent and gel residue data is important for understanding some of the differences and to establish an important link between the two methodologies.

In addition to the solvent residues described above, solvent cleaning can introduce another type of residue, which we term "solvent impurity residue." These usually higher molecular weight and higher boiling point impurities might be present in the solvents. Because of their higher boiling point, these impurities are deposited on the cleaned surface and remain there even after the solvent itself has fully evaporated. Most of these solvent impurities are not harmful to the paint surface, but our analytical studies have shown that some of these solvent residues might contain more reactive organic and inorganic acids and their salts which might be harmful to the paint binders or to more reactive and sensitive pigments. As a result, the use of fresh high-purity solvents will likely reduce the deposition of solvent residues on the surface of the painting.

Chapter 5
Aging Characteristics of Surfactants

Janice Carlson and W. Christian Petersen

The purpose of the aging study was to determine the possible presence and degradation patterns of selected surfactants under accelerated aging conditions that simulate years of normal exposure of paintings to controlled environmental conditions in museum settings. Experiments were conducted on the surfactants alone and on the surfactants in contact with three different substrates: slightly aged (24 hours) linseed oil film, slightly aged paint film (red lead in linseed oil), and the surface of a nineteenth-century oil painting. We were particularly concerned with detecting substrate-dependent interactions.

Background

Previous work
Previous studies at the Winterthur Museum addressed the degradation of a series of surfactants in the absence and in the presence of an oil paint medium (Miller 1998). The aging time intervals in those studies (minimum of 72 hours up to a total of 216 hours) were found to be too long and the surfactant too unstable to show the anticipated progression of degradation; all degradation occurred in the first exposure period of 72 hours at 18 W/m^2 and no further changes were seen.

The purpose of this current project, then, was to more closely examine the aging process and its effects. The aging time intervals (12-hour intervals up to a total of 48 to 72 hours, depending on the surfactant) in these experiments as well as the samples were chosen to allow changes in the materials under study to be followed through to termination.

Surfactants and "paint" samples
Seven surfactants, five nonionic (Ethomeen C/12, Ethomeen C/25, Triton X-100, Triton XL-80N, Brij 700) and two anionic (sodium lauryl sulfate, sodium laureth sulfate) were chosen for investigation. Their formulas are given in figure 5.1.

The Ethomeens, which chemically are ethoxylated amines, are currently the most common surfactants used in gel cleaning formulations. Triton X-100, with a polyethoxy group attached to an aromatic ring, has been widely used in the past as a surfactant in gel cleaning formulations

Figure 5.1

Structures for the surfactants included in the tests

Ethomeen C/12	$H-(CH_2)_nN(CH_2CH_2OH)_2$	$n = 8, 10, 12, 14, 16$
Ethomeen C/25	$H-(CH_2)_nN{<}^{(CH_2CH_2O)_xH}_{(CH_2CH_2O)_yH}$	$n = 8, 10, 12, 14, 16$ $x + y = 15$
Triton X – 100	$(CH_3)_3CCH_2(CH_3)_2C-\bigcirc-O(CH_2CH_2O)_nH$	$n = 9.5$
Triton XL – 80N	$H-(CH_2)_nO(CH_2CH_2O)_mH$	$n = 12$ $m = 10$
Sodium Lauryl Sulfate	$H-(CH_2)_{12}OSO_3Na$	
Sodium Laureth Sulfate	$H-(CH_2)_{12}OCH_2CH_2OSO_3Na$	
Brij 700	$H-(CH_2)_{18}O(CH_2CH_2O)_{100}H$	

but has fallen out of favor because of potential health hazards as well as because of the possible generation of peroxides. Triton XL-80N is an aliphatic polyethoxy molecule, as is Brij 700. The primary difference between them is the length of the polyethoxy chains. Each of these non-ionic surfactants differs in its surfactant properties but should degrade in about the same way with the formation of volatile smaller compounds such as acetaldehyde, leaving little or no residue. The long C18 chain of Brij 700 may result in longer residence of this fragment on the surface of the paint film.

In contrast, the two anionic surfactants, sodium lauryl sulfate and sodium laureth sulfate, would be expected either to remain intact or to degrade and leave sulfates behind on the cleaned paint surface. They provide an important and interesting comparison for the examination of the nonionic surfactants.

Accelerated aging

Although many accelerated aging experiments have been carried out using xenon arc lamps to investigate degradation of materials, there is no consensus as to a correlation of xenon-arc light exposure to days, months, or years of light exposure under normal museum conditions. The most solid information seems to be found in the automotive industry (Society of Automotive Engineers 1989) where high-intensity xenon arc irradiation is used to simulate sunlight exposure. Full sun exposure is the end use condition for their products.

In a typical museum setting, however, the UV component of the light to which a painting is exposed will be quite minimal, certainly far lower than that produced by xenon arc lighting. For example, Thomson (1967) suggested that the average proportion of daylight reaching representative walls in the National Gallery, London, was about 1.5% of the annual exposure outdoors. The exposures used in the experiments described here, and the time frame in which they took place, may not bear a direct relationship to what might be expected if the surfactants were present on the surface of a painting in a museum that follows

modern lighting standards. Feller (1994) has discussed the problems inherent to artificial aging experiments at some length. Nevertheless, to investigate long-term changes in materials within a reasonable time frame, some sort of accelerated process must be used. While the xenon arc output of the Atlas SunChex Weather-o-meter may not, in fact cannot, exactly mimic natural aging in a controlled museum environment, it nevertheless provided a controllable and reproducible means of conducting accelerated aging experiments.

"Paint" samples

Ideally, one would like to have had samples of naturally aged linseed oil and films, with and without pigment, for experimentation. Such films would of course more closely resemble the surfaces of actual museum paintings that might be cleaned with solvent gels. However, such aged test films, particularly applied to transparent infrared (IR) supports that permit convenient monitoring of surfactant–film interactions by FTIR and GC-MS, were not available. As an alternative, samples of cold-pressed linseed oil were applied to the sampling area of IR supports and allowed to dry for at least 24 hours. Similarly, a second set of samples was prepared by applying a mixture of red lead and linseed oil to IR supports. Red lead was chosen as the pigment for this paint because it does not absorb in the mid-IR region, thus eliminating the possibility of spectral interference with oil and/or surfactant bands. These surrogate "paints" served well for preliminary investigation of the degradation behavior of both surfactant and oil substrate and provided a background against which the final experiments of surfactants in contact with an actual hundred-year-old paint film were conducted.

Materials and Methods

Surfactants

The surfactants chosen for use in this project were

> Ethomeen C/12
> Ethomeen C/25
> Triton X-100
> Triton XL-80N
> Brij 700
> sodium lauryl sulfate
> sodium laureth sulfate

Two sets of surrogate "paint" samples were used in this study. The first was prepared by applying cold-pressed linseed oil diluted with toluene (1:4) by capillary pipette to the sampling area of the IR supports (3M Type 61 [polyethylene] IR cards). These samples were allowed to dry for at least 24 hours before use. The second set was prepared by applying red lead oxide pigment in cold-pressed linseed oil (64:36 pigment:oil) diluted with toluene (1:4) by capillary pipette to the sampling

area of the IR supports. These samples were allowed to air-dry for twenty days at room temperature before use.

The third sample material was the hundred-year-old painting described in Miller (1998). It will simply be referred to as "painting." An easily removed varnish coating was identified as dammar by an exact GC-MS pattern match for seven components with standards (van der Doelen 1999) (fig. 5.2). A glaze layer beneath the varnish may contain some pine resin, as dehydroabietic acid (Miller 1998) was always found to be one component in the samples. This varnish coating was removed with solvents before the painting samples were used in the surfactant studies.

Aging conditions

Samples were aged in an Atlas SunChex Weather-o-meter for twelve-hour (18 W/m^2 at irradiation surface) or eighteen-hour (12 W/m^2 at irradiation surface) periods of exposure to a xenon arc lamp at (295–400 nm) at 45°C. The lower-intensity irradiation conditions were used when a dark surface was being aged to reduce local heat buildup, even though the overall temperature in the Weather-o-meter remained at 45°C.

FTIR analysis

The aging and subsequent infrared spectroscopic analysis of the individual surfactants alone and in the presence of oil paint media was performed on 3M Type 61 (polyethylene) IR cards. These cards have a 19-mm circular aperture containing a thin microporous polyethylene film for sample application. The polyethylene film support was chosen for several reasons: the films were unchanged by irradiation under the experiment conditions; no sample preparation was necessary for FTIR analysis; and multiple samples could be obtained for GC-MS from each aged card after the FTIR spectrum was taken, thus allowing direct correlation of the FTIR changes with the GC-MS pattern. FTIR analysis was not performed on samples from the painting.

Figure 5.2

GC-MS (TIC) of dammar varnish analysis

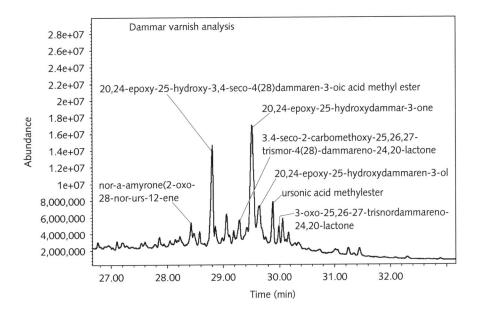

The infrared spectrum of each sample was recorded before aging and after each interval up to 48 (or 72) hours, using a Nicolet 560 FTIR spectrometer (32 scans, resolution 4cm^{-1}, range 400–4,000 cm^{-1}).

Gas chromatography–mass spectrometry analysis

On completion of the infrared analysis, two 4 mm × 6 mm samples were cut from the sample FTIR cards by scalpel for analysis by GC-MS. MethPrep II (100 μL, 0.2 N methanolic solution of m-trifluoromethyl-phenyltrimethyl-ammonium hydroxide) was added to each sample in a 0.3 mL heavy walled vial; the vials were tightly screw-capped and heated at 60°C for one hour. After cooling, the supernatant was transferred to a sample vial for GC-MS analysis. All analyses were run in duplicate. MethPrep II is designed to esterify and transesterify mixtures of fatty acids and their glycerides for the analysis of typical drying oils used in oil paintings.

GC-MS conditions were as follows: Hewlett-Packard (HP) 6890 gas chromatograph equipped with a 5973 mass selective detector (MSD) and a 7683 automatic liquid injector. The inlet temperature was 300°C, and the transfer line temperature to the MSD (SCAN mode) was 300°C. A sample of 1μL (splitless) was injected onto a 30 m × 250 μm × 0.25 μm film thickness HP-5MS column (5% phenyl methyl siloxane at a helium flow rate of 1.5 mL/min.). The oven temperature was held at 50°C for 2.0 minutes, then programmed at 10°/min. to 325°C where it was held for 10.5 minutes for a total run time of 40.0 minutes.

Aging and analysis of surfactants alone

Each surfactant was applied to the sampling area of a 3M Type 61 (polyethylene) IR support, and each sample card was then placed in the Atlas SunChex Weather-o-meter for successive periods of twelve hours (18 W/m^2 at irradiation surface) or eighteen hours (12 W/m^2 at irradiation surface) of exposure to a xenon arc lamp at 45°C. FTIR analyses were performed on these samples after each interval of the aging process. As a control, GC-MS analysis was performed on each surfactant sample using the MethPrepII procedure so as to elucidate any reagent-generated artifacts.

Aging and analysis of surfactants in the presence of linseed oil

Samples of the nonionic surfactants (Ethomeen C/12, Ethomeen C/25, Triton X-100, Triton XL-80N, and Brij 700) were applied to the dried linseed oil surface by capillary pipette from toluene (4:1) solution; samples of anionic surfactants (sodium lauryl sulfate and sodium laureth sulfate) were applied in the same manner from water solution. A sample of the dried linseed oil without any surfactant served as a control. Aging conditions, sample preparation, FTIR, and GC-MS analyses conditions were the same as those for the surfactants alone.

FTIR analyses of unaged and aged samples were performed as the samples were prepared or immediately on removal from the Weather-o-meter. Samples used in the GC-MS study were stored in the dark but in

the presence of air until all aging experiments were complete. The samples were then treated with MethPrepII and processed as a group. This allowed all the samples in the GC-MS study to have thirty days at ambient conditions in addition to their exposure time in the Weather-o-meter.

Aging and analysis of surfactants in the presence of red lead in linseed oil

Surfactants were applied to red lead in linseed oil films in the same manner as described above for linseed oil samples. A sample of the red lead in linseed oil with no surfactant served as a control. Sample preparation, FTIR, and GC-MS analysis were completed as described above. Because of the dark color of the red lead on the sample cards, the heat buildup from the high-intensity light (18 W/m^2) melted the polyethylene sample supports; therefore, a 12-watt output was used and the eighteen-hour time factor was adjusted to achieve comparable results.

Aging and analysis of surfactants on an oil painting

A section of the oil painting from which the varnish had been removed was sectioned by scalpel into 4 mm \times 6 mm segments. Each segment was placed in 9-well Pyrex spot test plates and one drop of each nonionic surfactant solution (1:4 in toluene) was applied to the painting samples by dropper pipettes. Sodium lauryl sulfate and sodium laureth sulfate were similarly applied from water solution. This application rate amounted to approximately 4 mg/cm^2 of painting sample. The surfactant application fully wetted the surface of the painting sample, as well as saturating the entire sample structure including the canvas. The dried samples were then exposed for the desired time intervals in the Weather-o-meter (18-hour intervals up to 72 hours at 12 W/m^2) and sampled for GC-MS analysis. All samples were run in duplicate.

Sampling: Solvent extraction

Samples of the painting were treated with 100 μL of a solvent mixture (1:1 toluene: methanol) at 60°C for one hour in 0.3-mL mini-vials. The solvent mixture was then separated from the painting sample and allowed to evaporate to dryness in a mini-vial labeled "extract." After being washed further with solvent, the paint sample was dried and placed in a mini-vial labeled "residue." The dried "extracts" and "residues" were then treated with the MethPrepII reagent as described above and analyzed by GC-MS.

Sampling: Water extraction

In the case of Ethomeen C/12 only, water was used to extract the aged oil painting–surfactant combinations to determine if a significantly different pattern of extracts could be seen in this manner. Treatment of samples with 200 μL of water at 60°C for one hour turned the painting samples into a suspension of fine particles and fibers. These samples were centrifuged, and the supernatant was dried, treated with MethPrep II, and chromatographed as above.

Sampling: Painting support

To assess the contributions of the canvas painting support, samples of this material were separated by scalpel and treated directly with MethPrep II for GC-MS. Other samples were water extracted, dried, and treated with MethPrep II.

Results

Experiments with controls

Linseed oil and red lead in linseed oil

FTIR studies The characteristic FTIR spectrum of fresh linseed oil showed the expected absence of hydroxyl at 3450 cm^{-1}, the presence of vinyl CH stretch at 3010 cm^{-1} (fig. 5.3), and sharp ester carbonyl at 1745 cm^{-1} (fig. 5.4). After only 12 hours of exposure, formation of hydroxyl functionality at 3450 cm^{-1} was seen, the vinyl stretching at 3010 cm^{-1} had disappeared, and the carbonyl region broadened with the formation of shoulder bands at approximately 1770 and 1715 cm^{-1}. The shoulder bands caused the peak maximum to shift to 1741 cm^{-1}. These spectral shifts are consistent with the known chemistry of the aging of linseed oil—oxidation and cleavage of the vinyl linkages in linolenic, linoleic, and oleic esters to produce hydroxy groups and shorter chain unesterified dicarboxylic acids. No significant spectral changes were observed after twelve hours of aging.

The presence of red lead added two major peaks at 540 and 470 cm^{-1} to the FTIR spectrum of the unaged oil sample, but the spectrum was otherwise identical to linseed oil alone. Aging of the pigment-oil mixture produced a series of spectra identical to those of aged linseed oil with the addition of the red lead peaks.

Figure 5.3

FTIR of linseed oil control: 0–48 hours of exposure

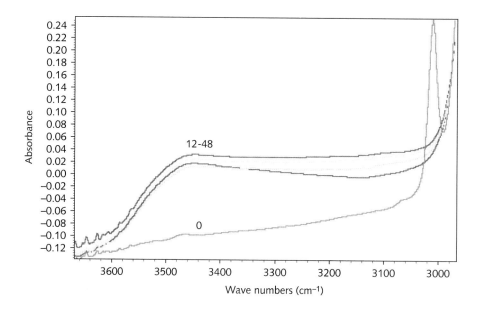

Figure 5.4

FTIR of linseed oil control: 0–48 hours of exposure

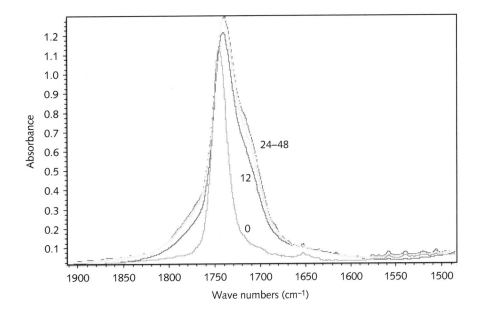

GC-MS studies To verify the ability to detect and identify the expected unsaturated methyl esters of oleic, linoleic, and linolenic acids, a very fresh sample of linseed oil was derivatized by MethPrepII treatment and analyzed using the standard GC-MS procedure. These esters constituted the bulk of the sample, with lesser amounts of the expected stable markers of stearic and palmitic esters. The degradation pattern of the linseed oil control on aging was as expected: gradual loss of oleic acid (linoleic and linolenic gone after 20 days at ambient conditions) and an almost immediate emergence of *cis*-9,10-epoxystearic and C_9-acid/aldehyde, with subsequent conversion to the C_8 and C_9 dicarboxylic acids as the end result of aging of the unsaturated lipids. Palmitic and stearic acids remained as stable markers throughout the experiment. The degradation pattern for red lead in linseed oil was the same as with the linseed oil control.

Aged oil painting

GC-MS studies The GC-MS analysis of the painting was divided into three phases: analysis of a solvent extract of the oil painting, analysis of the residue remaining from the solvent extraction, and analysis of the canvas support.

(1) *Extract Analysis.* The solvent extract of a sample of the oil painting with the dammar varnish layer intact showed the expected aged linseed oil residues of palmitic, stearic, azelaic, and C_8-dioic acids (fig. 5.5). Lesser amounts of most of the even-numbered straight chain monocarboxylic acids up to C_{22} and dioic acids up to C_{12} were seen. A glaze layer identified beneath the varnish (Miller 1998) may contain some pine resin components since dehydroabietic acid was always found in the samples.

Figure 5.5

GC-MS (TIC) of oil painting control: solvent extract and residue analysis

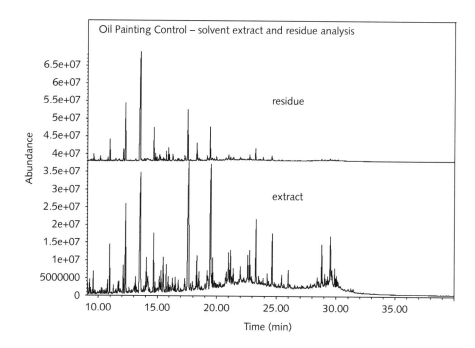

Figure 5.5

GC-MS (TIC) of oil painting control: solvent extract and residue analysis

(2) *Residue Analysis*. Azelaic and C_8-dioic acids dominated in the residue samples; the less polar palmitic and stearic acids were major components of the extracts. Several compounds from the oxidized lignin in the painting support (linen canvas) were seen.

(3) *Support Analysis*. Samples of the oil painting canvas support were separated by scalpel and treated with MethPrepII. All samples showed the polyhydroxybenzoic acid derivatives from oxidized lignin as the main peaks (fig. 5.6).

Studies with surfactants

Ethomeen C/12

FTIR studies The major changes in neat Ethomeen C/12 from unaged through to 48 hours of irradiation are shown in figure 5.7. The 1046 cm^{-1} band (primary alcohol) steadily decreased to a minimum after 36 hours as hydroxyethyl groups were lost, and a weak carbonyl band developed at 1653 cm^{-1}, indicating the formation of an amide from the oxidation of the amine functional group.

The spectrum of a sample of Ethomeen C/12 applied to a linseed oil film after 48 hours of aging was compared to the computer-generated composite (sum) spectrum of the 48-hour aged linseed oil and the 48-hour aged Ethomeen C/12. They were found to be substantially the same (figure 5.8), suggesting that the surfactant and the oil degrade independently under these conditions.

The infrared spectral pattern of the aged Ethomeen C/12 and red lead in linseed oil on aging was the same as that for Ethomeen C/12 and linseed oil. Again, the primary alcohol 1046 cm^{-1} band

Figure 5.6

GC-MS of extract of painting support

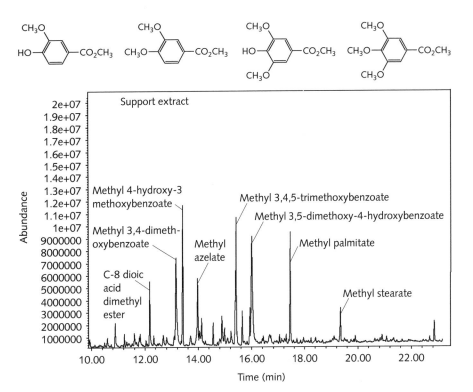

steadily decreased while a weak carbonyl band (Amide I) developed at 1653 cm^{-1}.

GC-MS analysis On direct injection (without MethPrep II treatment) of neat Ethomeen C/12, the main peak in the total ion chromatogram (TIC) was identified as the expected major component, the dodecylamine/2-

Figure 5.7

FTIR of Ethomeen C/12: 0–48 hours of exposure

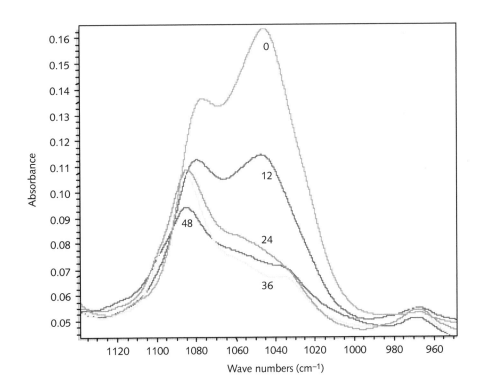

Figure 5.8

FTIR of Ethomeen C/12 and linseed oil: 48-hour exposure. Actual compared to simulated by addition of individual linseed oil and Ethomeen C/12 spectra.

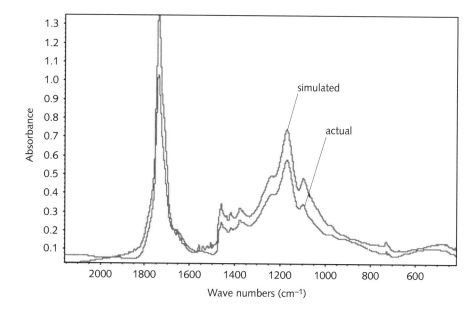

ethylene oxide adduct. Other major peaks had similar and very simple MS patterns as expected for a product of cocoamine with ethylene oxide (see chap. 6). For example; the molecule represented below by $n = 12$ with retention time 19.6 minutes has a base peak in the mass spectrum 242 representing an ion fragment generated by loss of the unit CH_2OH.

$$H–(CH_2)_n N(CH_2CH_2OH)_2$$
$$n = 8, 10, 12, 14, 16$$

After treatment with MethPrep II, a new series of peaks replaced those of Ethomeen C/12. For example, the molecule $n = 12$ discussed above now gives three major peaks at retention times 19.12, 22.85, and 26.33 min. (See the Appendix at the end of this chapter for a discussion of the interaction between several of the surfactants in this study and the MethPrep II reagent.) These MethPrep II derivitized peaks then serve to identify the Ethomeen C/12 remaining as the surfactant degrades during aging (fig. 5.9). Samples of Ethomeen C/12–linseed oil samples treated with MethPrep II showed a reduction over time of the characteristic derivitized surfactant peaks, while small amounts of palmitic and stearic esters from the oil remained constant as markers for the presence of linseed oil in all samples.

GC-MS analysis of Ethomeen C/12 and red lead in linseed oil produced the same pattern of degradation products as was observed with Ethomeen C/12 and linseed oil.

The aged Ethomeen C/12–oil painting solvent extracts (1:1 toluene/methanol, 1 hr., 60°C) samples showed the same surfactant degradation patterns as seen in the surfactant alone and in the surfactant–linseed oil experiments. The accompanying oil painting components, palmitic and stearic acids, remained constant through the aging process, as might be expected since the painting was already more than one hundred years old, while the intensity of the Ethomeen C/12 (surfactant) peaks decreased. Similar analysis of the residue remaining after

Figure 5.9

GC-MS (TIC) of Ethomeen C/12: 0–48 hours of exposure

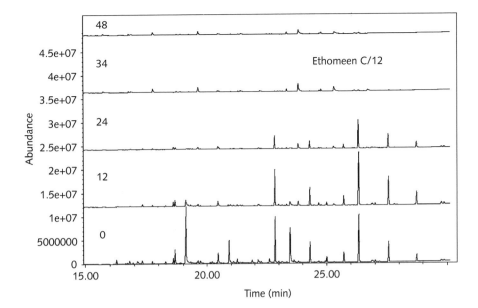

solvent extraction showed a consistent pattern of aged linseed oil (and lignin oxidation) products regardless of the surfactant used or the exposure time.

The same linseed oil residues seen in the solvent extracts were detected in the water extracts of the Ethomeen C/12–oil painting sample, except that the polar dioic acids were more readily extracted by water, whereas the less polar palmitic and stearic acids predominated in the residue. Several compounds from the oxidized lignin of the painting canvas support were more readily extracted with water.

Conclusions FTIR and GC-MS studies indicate that the presence of Ethomeen C/12 on artificially aged surfaces of a relatively new surrogate "paint" film or on a hundred-year-old oil painting did not alter the pattern of peaks related to the oil itself or to the oil painting. Conversely, there was no change in the degradation pattern of the surfactant Ethomeen C/12 when it was in direct contact with new or old oil paints. Ethomeen C/12 appears to behave independently of the surface to which it is applied. Furthermore, it is detected on linseed oil surfaces before aging but breaks down over time into smaller and smaller volatile molecules. After 36 hours of aging, little or no surfactant remains on the linseed oil surface or paint surfaces.

Ethomeen C/25

FTIR studies In samples of neat Ethomeen C/25, the strong infrared band at 1130 cm⁻¹ associated with ethoxy C-O linkages reduced to approximately 60% of its initial intensity after 48 hours of exposure (fig. 5.10). The carbonyl region, from about 1650 to 1750 cm⁻¹ showed a corresponding increase in an apparently linked series of bands (fig. 5.11). Rapid formation (after only 12 hours) of a 1670 cm⁻¹ band—possible amide formation—decreased with further aging as two other

Figure 5.10

FTIR of Ethomeen C/25: 0–48 hours of exposure (950–1270 cm⁻¹ range)

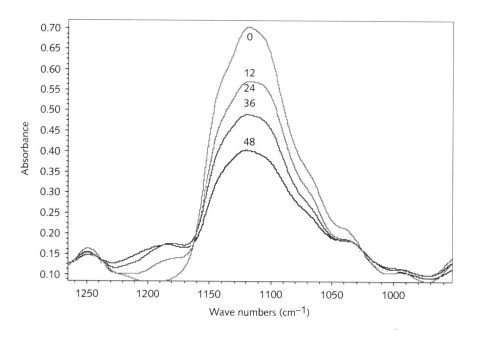

Figure 5.11

FTIR of Ethomeen C/25: 0–48 hours of exposure (1400–1900 cm⁻¹ range)

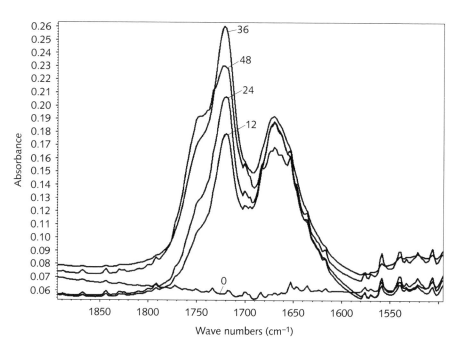

carbonyl bands increased (1720 cm⁻¹ and 1750 cm⁻¹). On further aging, the 1720 cm⁻¹ band decreased as the 1750 cm⁻¹ band continued to increase. This pattern parallels the FTIR results of the Ethomeen C/12 aging experiments.

After 48 hours of aging, the spectrum of the Ethomeen C/25–linseed oil sample was found to be substantially the same (fig. 5.12) as the computer-generated sum or composite spectrum of 48-hour aged linseed oil and 48-hour aged Ethomeen C/25. The surfactant and the oil appear to degrade independently under these conditions. Similar results were obtained with Ethomeen C/25 applied to a red lead–linseed oil film.

Figure 5.12

FTIR of Ethomeen C/25 and linseed oil: 48 hours of exposure. Actual compared to spectrum simulated by addition of individual linseed oil and Ethomeen C/25 spectra.

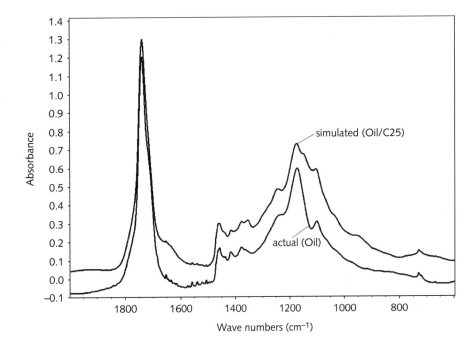

GC-MS studies Due to its high molecular weight and lack of volatility, unaged samples of Ethomeen C/25 showed minimal gas chromatographic response. The total ion chromatograms (TIC) of aged samples of Ethomeen C/25, however, showed the development of a multitude of lower molecular weight degradation products with increasingly shorter retention times as the exposure time increased to 48 hours (fig. 5.13).

A control sample of linseed oil plus Ethomeen C/25 showed that Ethomeen C/25 has apparent antioxidant properties; linolenic and linoleic esters did not decrease in concentration during 30 days at ambient conditions prior to GC-MS analysis. Normally, these esters would oxidize and degrade to their saturated analogs or to smaller dioic acids. On accelerated aging, however, both linolenic and linoleic esters

Figure 5.13

GC-MS (TIC) of Ethomeen C/25: 0–48 hours of exposure

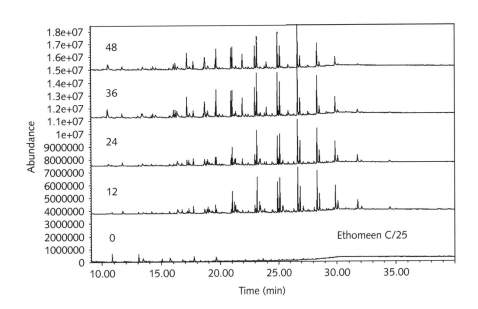

degraded rapidly. All traces of unsaturated acids disappeared after 12 hours of aging, and the final oxidation products of linseed oil—azelaic, palmitic, and stearic acids—dominate the spectrum. In samples in which Ethomeen C/25 was applied to linseed oil and to red lead in linseed oil, the same pattern was observed.

Solvent extracts of Ethomeen C/25 on the oil painting showed the same surfactant degradation patterns as found in Ethomeen C/25 itself and Ethomeen C/25–"paint" surrogates. Analysis of the residue after solvent extraction showed a constant pattern of aged linseed oil (and lignin oxidation) products, regardless of surfactant used or exposure time.

Conclusions Again, the presence of a surfactant—Ethomeen C/25 in this case—during the aging process did not appear to alter the pattern of oil film or oil painting–related peaks in the GC-MS. Intact Ethomeen C/25 is not detectable by GC-MS. When peaks due to degradation products became detectable, after 12 hours of aging, they showed normal degradation patterns independent of the surface to which they were applied. These in turn continued to degrade to lower molecular weight (shorter retention time) products and decrease in concentration over time. However, at the end of 48 hours of aging, many of these smaller products still remained.

Triton X-100 and Triton XL-80N

FTIR studies Most of the prominent bands in the infrared spectra of unaged samples of both Triton surfactants decreased substantially after 48 hours of aging. Most notable were decreases in bands at about 1120 cm^{-1}—the largest peak in each case (due to the ethoxy functional group)—and the hydroxyl band at 3500 cm^{-1} (figs. 5.14, 5.15). Carbonyl

Figure 5.14

FTIR of Triton X-100: 0–48 hours of exposure

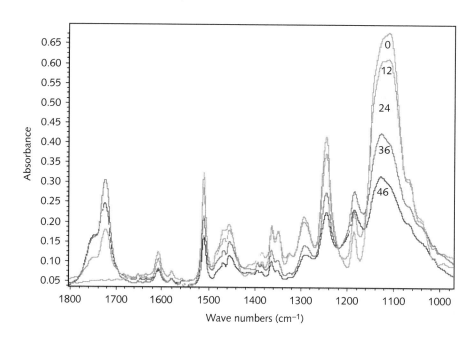

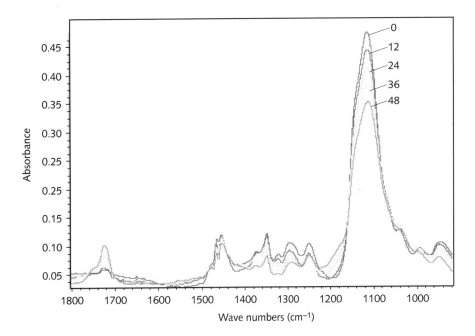

Figure 5.15

FTIR of Triton XL-80N: 0–48 hours of exposure

bands at about 1720 cm^{-1}, with shoulders at 1760 cm^{-1} typical of polyethylene oxidation products, appeared and increased on aging (fig. 5.14). These spectral changes are very similar to those observed for other ethoxylated surfactants such as the Ethomeens.

The spectrum of each of the Triton surfactants after 48 hours of aging in contact with linseed oil and red lead–linseed oil film samples, the "paint" surrogates, was found to be substantially the same as the computer-generated composite spectra of each Triton with a 48-hour aged "paint" surrogate (fig. 5.15). Each component—oil or surfactant— degrades in its own characteristic way, as described above, but the degradation of one does not appear to affect the degradation of the other. That is, surfactant and the oil appear to degrade independently under these conditions.

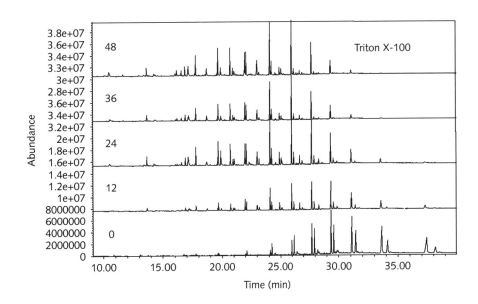

Figure 5.16

GC-MS (TIC) of Triton X-100: 0–48 hours of exposure

GC-MS studies The GC-MS patterns (TIC) for Triton X-100 and Triton XL-80N alone show a Gaussian (bell-shaped) distribution of peaks progressing with increased exposure time to shorter retention times and less intensity (figs. 5.16, 5.17). Differences were observed between the direct analysis of the two Triton surfactants and the Triton–MethPrep II treated samples. (See the Appendix at the end of this chapter.) The observed peaks served well as markers to follow the degradation of Triton X-100 (fig. 5.16) and Triton XL-80N (fig. 5.17). For example, the Triton X-100 peak at a retention time of 28.1 minutes (untreated with MethPrep II) becomes two peaks at 27.6 and 27.9 minutes when treated with MethPrep II.

GC-MS analysis of the Triton surfactants in contact with both "paint" surrogates showed that "paints" and the Triton surfactants degrade independently.

Solvent extracts of the aged Triton–oil painting samples showed the same surfactant degradation patterns as seen previously in the Ethomeen and Ethomeen–"paint" surrogate experiments. Analysis of the residues after solvent extraction showed a consistent pattern of aged linseed oil (and lignin oxidation) products regardless of surfactant used or exposure time.

Conclusions The presence of Triton X-100 or Triton XL-80N during the aging process did not appear to alter the pattern of oil painting–related peaks in the GC-MS. The surfactant peaks showed normal degradation patterns independent of the surface to which they were applied. Triton X-100 appears to degrade to volatile small molecules more rapidly than does Triton XL-80N as indicated by the total ion chromatograms of each. After 24 hours of aging, the two highest molecular weight components of Triton X-100 have disappeared, while Triton XL-80N does not reach this point until 36 hours of aging have occurred.

Figure 5.17

GC-MS (TIC) of Triton XL-80N: 0–48 hours of exposure

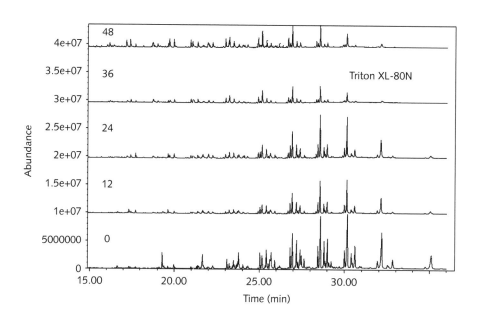

Brij 700

FTIR studies The sharp spectral bands of the solid crystalline Brij 700 were immediately broadened on aging and the dominant C-O band (1115 cm^{-1}) of the poly(ethylene oxide) units steadily decreased (fig. 5.18). Two carbonyl bands formed at 1723 and 1750 cm^{-1} (typical poly[ethylene oxide] oxidation pattern) and then declined with aging. The initial formation and subsequent decline of carbonyl bands suggest that steady state intermediates are formed and then lost through volatilization. Some Brij 700 samples were aged for 144 hours, well beyond the usual end of the experiments in order to investigate the end product of a C-18 based surfactant. The result seems to be an almost total loss of material due to the volatility of the degradation components. Since the majority of the molecular weight of Brij 700 is in its ethylene oxide tail, the C-18 portion represents a minimal residue if it remains after degradation.

With aging, the initial sharp peaks of Brij 700 on the linseed oil film and the red lead in linseed oil films vanished into the dominant linseed oil spectrum. The spectrum of the aged samples after 72 hours at

Figure 5.18

FTIR of Brij 700: 0–144 hours of exposure

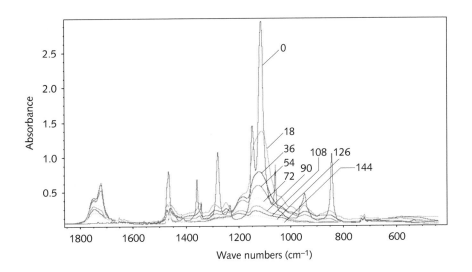

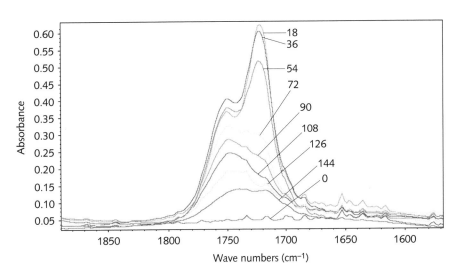

12 W/m² were substantially the same as the computer-generated composite spectrum of the 48-hour aged linseed oil (at 18 W/m²) and the 72-hour aged Brij 700. Again, the surfactant and the oil appear to degrade independently under these conditions.

GC-MS analysis Brij 700 is a high molecular weight nonvolatile material. Therefore, the unaged sample produced minimal elution on injection into the gas chromatograph. After aging, volatile fragments with increasingly shorter retention times were detected; peaks due to these fragments declined in intensity over time (fig. 5.19) as they evaporated.

On aging, GC-MS of samples of Brij 700 applied to the paint surrogates and to the oil painting showed the expected pattern of linseed oil degradation as well as an initial increase and then decrease in peaks associated with Brij 700. Solvent extracts of aged Brij 700–oil painting samples showed the same surfactant degradation seen previously in Ethomeen and Triton surfactant and linseed oil experiments, that is, rapid formation and then disappearance of smaller, more volatile fragments.

Conclusions The presence of Brij 700 during the aging process did not appear to alter the pattern of oil painting–related peaks in the GC-MS. The surfactant peaks showed normal degradation patterns independent of the surface to which they were applied. In addition, even degradation products had virtually disappeared from the samples after 54 hours of aging.

Sodium lauryl sulfate

FTIR studies There was virtually no change in the infrared spectrum of sodium lauryl sulfate as a result of aging. Similarly, the FTIR spectrum of sodium lauryl sulfate–linseed oil and on red lead–linseed oil showed only the spectral features of the sum of sodium lauryl sulfate–linseed oil spec-

Figure 5.19

GC-MS (TIC) of Brij 700: 0–72 hours of exposure

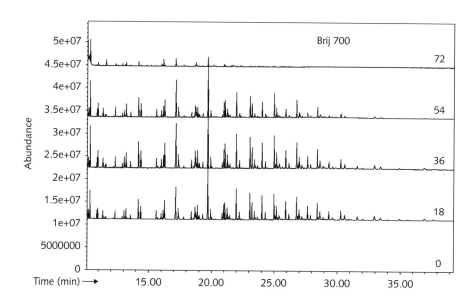

tra or that of sodium lauryl sulfate–red lead–linseed oil, respectively, even after aging.

GC-MS analysis As a salt, sodium lauryl sulfate is not volatile and would not be expected to produce chromatographic results. Instead, only small amounts of dodecanol (identified by co-injection), as well as probable tetradecanol and hexadecanol, were detected. These impurities are found in both natural and synthetic lauryl esters.

Aged samples of sodium lauryl sulfate in contact with linseed oil, red lead in linseed oil, and oil painting showed the expected pattern of linseed oil degradation, with a very slight increase in dodecanol, consistent with limited hydrolysis of the surfactant. Unlike Ethomeen C/25, no antioxidant properties were seen for sodium lauryl sulfate as the oleic ester was the only unsaturated material detected in the control sample of sodium lauryl sulfate on linseed oil after 30 days at ambient conditions. No effect of sodium lauryl sulfate on paint surrogates or on the oil painting was detected as only the degradation pattern of linseed oil was detected in each case.

Conclusions The presence of sodium lauryl sulfate during the aging process did not appear to alter the degradation pattern of linseed oil, linseed oil in red lead, and oil painting–related peaks as measured by FTIR or GC-MS. No surfactant peaks were detected, and only the normal degradation patterns of linseed oil were seen in each case.

Sodium laureth sulfate

FTIR studies There was little evidence of degradation during the first 72 hours of aging (12 W/m^2) of neat sodium laureth sulfate (fig. 5.20).

Figure 5.20

FTIR of sodium laureth sulfate: 0–72 hours of exposure

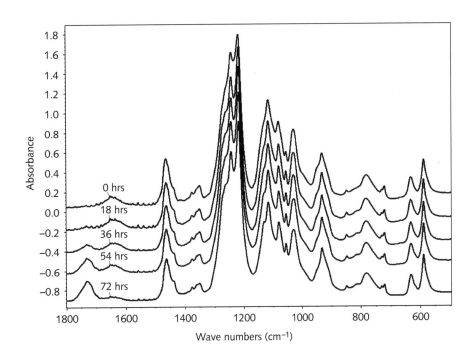

However, when aging was extended beyond the normal 72-hour terminus of the experiment, a sudden and dramatic change began at 108 hours and ended at 126 hours (fig. 5.21), with no further changes up to 162 hours. The bands attributable to ethoxy functionality between about 1000 and 1200 cm^{-1} virtually disappeared and were replaced with a broad rise due to an alcohol C-O stretch. Such behavior is consistent with a second-order autocatalytic hydrolysis of the ethoxylated alcohol mono sulfate to produce the free alcohol and sodium hydrogen sulfate. (An autocatalytic reaction occurs when a product of a reaction acts as a catalyst and thus accelerates the reaction ever more rapidly as the catalyst concentration continues to increase. In this case, little acid catalyst was present in the sodium laureth sulfate initially, but as aging continued, the ethoxy link degraded slowly, as the designers of these surfactants expect, and released some of the acidic sodium hydrogen sulfate. This material then triggered the autocatalytic stage of the experiment with the results seen.) A simulated spectrum created by combining reference spectra of lauryl alcohol and sodium hydrogen sulfate ($NaHSO_4$) was found to have many similarities to the 126-hour aged spectrum of sodium laureth sulfate (fig. 5.22). A sample of sodium laureth sulfate was then intentionally hydrolyzed, the alcohol portion isolated, and its spectrum combined with a reference spectrum of NaHSO4 to give a similar spectrum (fig. 5.23).

The FTIR spectra of sodium laureth sulfate–paint surrogate samples looked very much like those of the sum of the spectra of sodium lauryl sulfate and each paint surrogate during every step of the aging process, as sodium laureth sulfate remains quite stable until after the 126-hour aging period that the acid-catalyzed hydrolysis described above begins.

GC-MS studies Unlike sodium lauryl sulfate, sodium laureth sulfate has a less precise formulation and contained a considerable amount of volatile material; its TIC exhibits a virtual forest of peaks, even though

Figure 5.21

FTIR of sodium laureth sulfate: T = 72 hours (a); T = 126 hours (b)

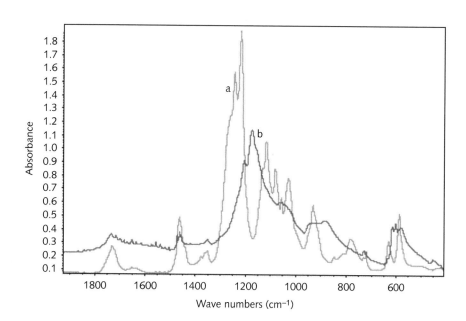

Figure 5.22

FTIR of sodium laureth sulfate: T= 126 hours (a); lauryl alcohol + NaHSO4 additive spectra (b)

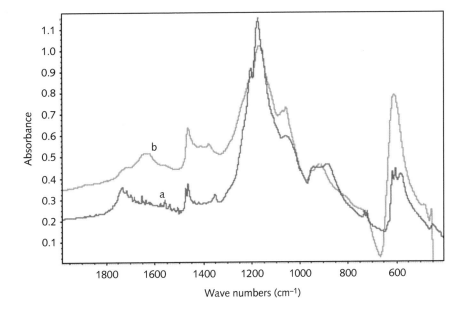

Figure 5.23

FTIR of sodium laureth sulfate: T = 126 hours (a); lauryloxyethanol (from hydrolyzed sodium laureth sulfate) + NaHSO$_4$ additive spectra (b)

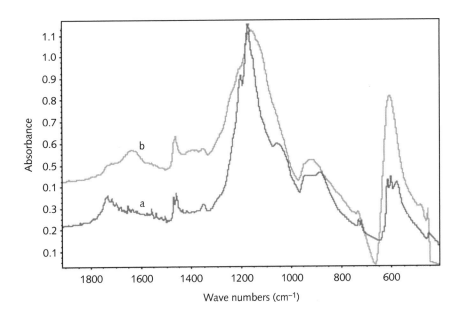

sodium laureth sulfate itself would not be expected to give any GC-MS response. These volatile materials disappeared as they degraded and evaporated over the 72-hour (fig. 5.24) aging period.

The volatile impurities in the sodium laureth sulfate solution were examined by GC-MS after chromatographic separation from the surfactant ionic salts (preparatory TLC). The pattern was the same as that in figure 5.24. A variety of phthalates—plasticizers from the plastic container—and long-chain alcohols and olefins were seen. Hydrolysis of samples of purified sodium laureth sulfate and sodium lauryl sulfate showed the main components of each to be made up of a limited number of alkylethoxylates and alcohols, respectively (fig. 5.25).

The finding that sodium laureth sulfate degrades on extended aging prompted the examination of sodium lauryl sulfate under similar conditions, but no breakdown was seen on irradiation after 162 hours.

Figure 5.24

GC-MS of sodium laureth sulfate: 0–72 hours of exposure

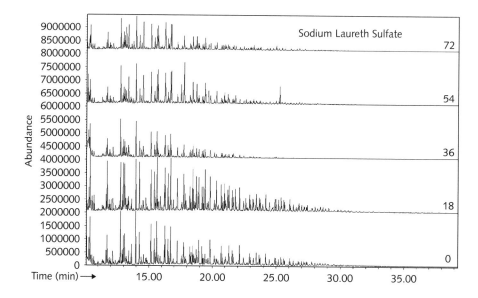

Figure 5.25

GC-MS of hydrolysis products of sodium lauryl sulfate and sodium laureth sulfate

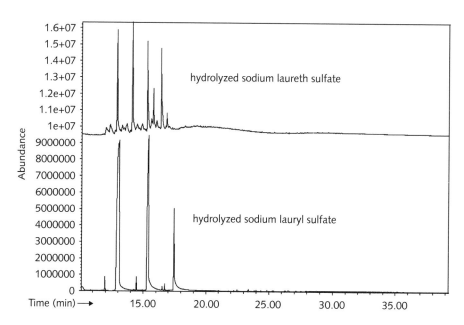

Thermal treatment at 50°C for 162 hours did not degrade either surfactant; therefore, it appears that light is necessary to trigger the degradation process.

GC-MS studies Aging of surfactant–paint surrogate samples showed the expected pattern of linseed oil degradation, with the many small volatile sodium laureth sulfate peaks decreasing over time. Solvent extracts from the aged sodium laureth sulfate–oil painting samples showed the same surfactant degradation patterns as seen in the surfactant alone and the surfactant–paint surrogate experiments.

Conclusions The presence of sodium laureth sulfate during the aging process does not appear to alter the pattern of linseed oil film, red

lead–linseed oil film, or oil painting–related peaks in the GC-MS. Sodium laureth sulfate itself is quite stable. Peaks observed on aging, either by itself or in contact with a paint surrogate, were due to the multitude of impurities in the surfactant. These materials did dissipate over time but had not entirely disappeared, even after 72 hours of aging. The possible effects of these materials on the paint surrogates or on the painting were not investigated. The question of longer-term degradation of sodium laureth sulfate to an acidic substance ($NaHSO_4$) is a concern.

Miscellaneous Studies

Capture of volatile degradation products

Because Ethomeen C/25 appears to degrade by loss of the ethylene oxide units over time, the following experiment was designed to determine the nature of some of the volatile products lost during the aging process.

A thin layer chromatography plate was used as a surrogate oil painting to simulate a surface layer of surfactant on a substrate. Ethomeen C/25 (1.6 g) in 10 mL of toluene was applied to a Whatman KGF TLC plate (20 cm × 20 cm, 250μ silica gel). The TLC plate was placed in a toluene vapor atmosphere and thoroughly wetted with toluene, then allowed to stand for four days to allow diffusion to evenly distribute the Ethomeen C/25 over the plate. The plate was then air-dried and placed in a zip-lock polyethylene bag (with air inlet and outlet ports) in the Weather-o-meter. A slow stream of humidified air was passed over the surface of the plate and vented to a stirred flask containing a solution of 2,4-dinitrophenylhydrazine while the plate was irradiated at 10 W/m² (fig. 5.26).

A crystalline precipitate was seen in the flask after 72 hours of irradiation. The solid was filtered, dissolved in ethyl acetate, shaken with a sodium bicarbonate solution, and the ethyl acetate layer separated and evaporated. The product mixture was then separated into two major components (fig. 5.27) and two minor ones by preparative TLC (eluent: methylene chloride: toluene:methanol, 50:49:1). The first major fraction was identified by GC-MS as the 2,4-dinitrophenylhydrazone (DNP) of acetaldehyde. The second was identified as the bis-2,4-DNP derivative of glyoxal. The two minor components were not identified.

Figure 5.26

Schematic diagram of volatile by-product analysis apparatus

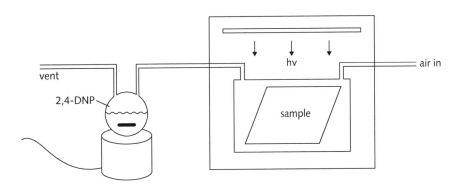

Figure 5.27

Isolated derivatives of acetaldehyde and
glyoxal

Amine N-oxides

Suggested possible oxidation products of the tertiary amine surfactants
Ethomeen C/12 and Ethomeen C/25 under aging conditions are the cor-
responding amine N-oxides (Burnstock and White 2000). To investigate
this further, authentic samples of these compounds were prepared by
established procedures for FTIR and GC-MS analysis (Cope and Ciganek
1963). The IR spectra were inconclusive, with no distinctive peaks asso-
ciated with the N-oxide. GC-MS analysis showed a very distinctive pat-
tern in which no peak in the chromatogram corresponded to any peak
observed in aging experiments with the Ethomeen surfactants, either in
the control experiments or with linseed oil or on the oil painting. The
fragmentation patterns of the observed peaks also were quite different
(fig. 5.28). It is evident from these data that the N-oxides of Ethomeen
surfactants do not seem to be significant oxidation products in the aging
studies.

Figure 5.28

GC-MS of Ethomeen C/25 N-oxide

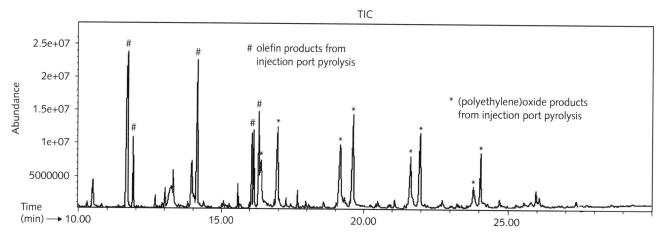

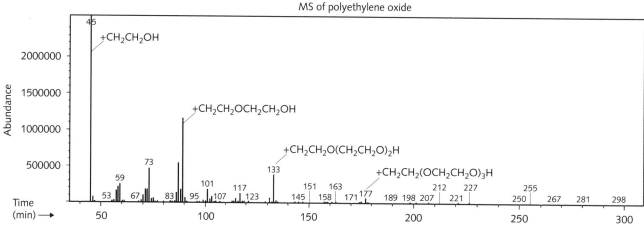

Conclusions

Aqueous cleaning gels have three major ingredients: a cleaning agent (organic solvent or solvent mixture) held in an aqueous gel of a thickening agent, such as Carbopol, and a surfactant. Concerns have been raised about whether gel cleaning formulations may leave potentially harmful residues that at some future time may result in harm to the paint film. One way to approach this question is to examine the rate at which gel components such as surfactants may degrade and disappear entirely. If this happens quickly enough, the conservator can at least be sure there are no surfactant residues left behind on the painted surface.

To this end, this study has investigated the aging characteristics of seven different surfactants singly (neat) and also in contact with several different paint-related surfaces. The surfactants chosen for investigation included several nonionic surfactants that are currently in use in gel-cleaning formulations (Ethomeen C/12, Ethomeen C/25, Triton XL-80N, and Brij 700); one, Triton X-100, that was formerly used extensively but has now been mostly discontinued because of concerns about peroxide formation as well as toxicity issues; and two traditional anionic surfactants, sodium lauryl and sodium laureth sulfates.

Each surfactant was aged artificially by itself, on a linseed oil film, on a red lead–linseed oil film, and on a hundred-year-old paint film. The degradation of the surfactant and the underlying oil or paint surfaces was examined over the aging period of 72 hours with FTIR and GC-MS in order to obtain some sense of the rate of degradation and the nature of chemical degradation products.

The method of artificial aging, exposure to a xenon arc lamp at a specified power for a specified time, does not really approximate actual modern museum lighting conditions. However, short of exposing surfactant samples on paint films in a museum for one hundred years before examining them for possible residues, there are few alternatives to conducting aging and degradation studies in real time.

This study presents an extreme case with respect to the amounts of several different surfactants in contact with a linseed oil films or oil paint surfaces during aging tests. This procedure is a common approach when trying to accelerate possible long-term effects of a material in contact with another substrate. Further, to use GC-MS or pyGC-MS analysis techniques, a higher level of surfactant application is needed as the expected levels remaining after an effective clearance procedure by experienced conservators are so low as to be undetectable by these methods.

Even at the high levels used in this study, all seven surfactants appear to degrade independently of the surface to which they are applied and to have no chemical effect on either quite new or on a late-nineteenth-century oil paint surface. Nonionic surfactants, such as Ethomeen C/12 and C/25, Triton X-100 and XL-80N, and Brij 700, degrade fairly rapidly to volatile components and disappear from the substrate. In contrast, the anionic surfactants (sodium lauryl sulfate and sodium laureth sulfate) are much more stable and can reside on the paint surface over an

extended period. Further, the breakdown products of these surfactants do leave behind a nonvolatile acidic substance, $NaHSO_4$. On the other hand, the sodium sulfate–based surfactants are among those more easily removed by aqueous clearance methods. The choice of surfactant then becomes a matter of efficacy and compatibility with the selected cleaning system.

There are two secondary conclusions from this study. The first is that the common acid–ester derivatizing reagent used for GC analysis (MethPrep II) will react with some unactivated hydroxyl groups to give methyl as well as m-trifluoromethylphenyl ethers in the gas chromatograph injection port at 300°C. The second is that the N-oxides of the Ethomeen surfactants are at least not primary aging products in their degradation. Some simple aldehydes are probably the major volatile degradation products of the Ethomeens and other surfactants containing poly(ethylene oxide).

Appendix

Interaction of MethPrep with Surfactants

Janice Carlson and W. Christian Petersen

MethPrep II reagent was used on samples of an oil painting treated with surfactants to break down and derivatize the linseed oil medium for subsequent GC-MS analysis. The surfactants were not expected to interact significantly with the reagent, as there were no carboxylic acid or ester groups present. However, evidence of methylation and phenylation of unactivated hydroxylic functions in the presence of excess of MethPrep II was found in all of the surfactants examined except for sodium lauryl sulfate.

Ethomeen C/12

Direct injection of Ethomeen C/12 in the GC-MS gave the expected peaks for the cocoamine + 2 ethylene oxide units, predominantly $n =$ 12. Following treatment with excess MethPrep II for one hour at 60°C, GC-MS showed nearly complete absence of these peaks and the presence of a new series of peaks corresponding to various degrees of methylation and phenylation of the terminal hydroxyl group of the surfactant. (See fig. 5A.1.)

A virtually identical chromatogram (GC-MS) was also seen for Ethomeen C/12 combined with excess MethPrep II and immediately injected into the inlet at 300°C. The reaction of MethPrep II with these nonacidic hydroxyls is an injection port phenomenon.

Triton X-100

Direct injection of Triton X-100 in the GC-MS gave a Gaussian distribution of peaks that were identified as the expected p-t-octylphenol poly(ethylene oxide) oligomers. The response of Triton X-100 to MethPrep II treatment was to produce a Gaussian distribution of *pairs* of peaks (fig. 5A.2), and no peaks in the two experiments matched in retention time. This distribution of double peaks was found to be actually two overlapping distributions of oligomers, one of which was o-methylated and the other o-(m-trifluoromethylphenyl) derivatives (fig. 5A.3).

Figure 5A.1

Analysis of GC peaks of Ethomeen C/12
treated with MethPrep II

Figure 5A.2

GC-MS (TIC) of Triton X-100 with and
without MethPrep II

Figure 5A.3

GC of Triton X-100 with

MS of representative peaks

Triton X-100 with MethPrep II phenylated peaks

Triton X-100 with MethPrep II methylated peaks

Triton XL-80N

Direct injection of Triton XL-80N showed a GC spectrum typical of poly(ethylene oxide) oligomers. After treatment with MethPrep II, the peaks of the directly injected sample disappeared and were replaced by twice as many peaks with different retention times. These peaks were proposed to be the corresponding methylated and phenylated derivatives.

Ethomeen C/25

Direct injection or MethPrep II treated samples produced minimal elution due to the high molecular weight of Ethomeen C/25. Aged samples that have undergone degradation to lower mass compounds eluted peaks that show poly(ethylene oxide) fragments similar to Triton XL-80N when treated with excess MethPrep II.

Brij 700

A comparison of aged Brij 700 samples with and without MethPrep II showed similar peak patterns but with differing retention times (fig. 5A.4). (Some aging was required to produce volatile material.) The mass spectra of the various peaks of the MethPrep II–treated samples showed evidence of m-trifluoromethylphenyl derivatives based on their fragmentation patterns.

Figure 5A.4

GC-MS qualitative comparison of aged Brij 700, with and without MethPrep II

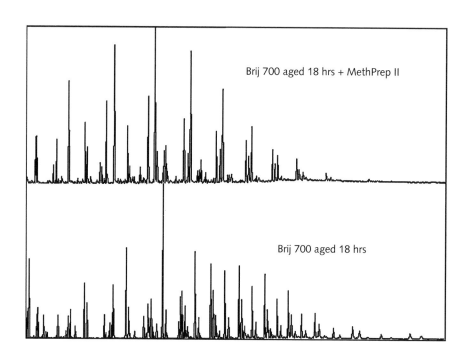

Brij 700 aged 18 hrs + MethPrep II

Brij 700 aged 18 hrs

Sodium Laureth Sulfate

Treatment of sodium laureth sulfate with MethPrep II appeared to enhance the intensity of the various volatile components (impurities) (fig. 5A.5), and it enhanced these same volatiles present in the hydrolyzed sample while showing the main components of the surfactant (four major peaks).

Figure 5A.5

GC-MS response of hydrolysis products of sodium laureth sulfate to MethPrep II

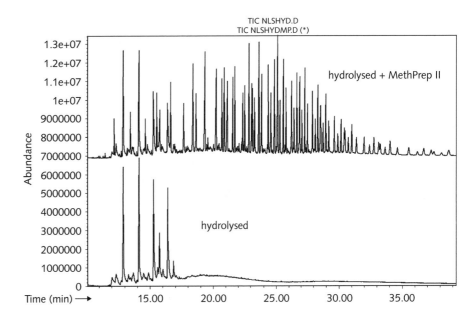

Chapter 6

Detection of Residues on the Surfaces of Museum Objects Previously Cleaned with Aqueous Gels

Narayan Khandekar

As discussed in chapter 3, a number of specific effects of residue on the surface of objects cleaned with the aqueous gel systems have been suggested. These include altering its aging characteristics, changing the solubility parameters of the cleaned surface, and generating damaging by-products as the residues degrade (Erhardt and Bischoff 1993, 1994; Burnstock and White 2000). If residues are present on museum objects that were treated with gels, there may be very real consequences.

The work described in chapter 5 showed that minimal concentrations of gel components remained on samples of a test painting after clearing in an experimental situation. But what about real objects—objects that have been cleaned using gel methods over the past fifteen or more years? What residues, if any, might remain on the surfaces? This chapter describes (1) the development of an experimental protocol to detect these residues and (2) the analysis of samples from four paintings and three objects that were cleaned with a gel system to detect aqueous gel residues.

Materials and Methods

Test painting
The test painting used to develop the analytical methodology was an unsigned and untitled early-twentieth-century varnished oil on canvas, titled *The Deposition* (artist unknown), from the GCI Study Collection (fig. 6.1). Some areas of the painting had been cleaned during the 1990 Wolbers workshop at the GCI; however, large areas of untouched varnish remained. It was these areas that were used in this experiment.

Samples and standards
Carbopol 954, 934, 940, and 941, Ethomeen C/12 and C/25, mastic, Triton X-100, and Arkon P90 were used as obtained from the manufacturer. The samples from the museum objects (see pp. 123–27) were collected using clean scalpels. They were stored in glass containers until analyzed. Appropriate care was taken to minimize cross-contamination of tools and working surfaces.

Figure 6.1

Test painting used to develop analytical methodology. Artist unknown, *The Deposition*, ca. 1900s. Varnished oil on canvas, 59.7 × 48.3 cm (23 1/2 × 19 in.). Los Angeles, Getty Conservation Institute Study Collection

Pyrolysis gas chromatography (pyGC)

Pyrolysis gas chromatography analysis was done using a Hewlett-Packard (HP) 5890 GC equipped with CDS 122 Pyroprobe injector, helium carrier gas, an HP 5MS cross-linked (5%-Phenyl)-methylpolysiloxane capillary column of 30 m × 0.25 mm with a 0.25 µm film thickness, and a flame ionization detector (300°C). The sample, placed in an open quartz pyrolysis tube on a quartz wool plug, was inserted into the injector of the GC, which was held at 300°C and pyrolyzed at 850°C for 20 seconds. The GC column was held at 40°C for 1 minute and then increased by 10°C/min. to 320°C and held for 15 minutes.

Pyrolysis mass spectrometry (pyMS)

The sample, in a closed-end pyrolysis tube, was inserted via direct insertion valve directly into an HP 5988A mass spectrometer using a CDS microextended pyroprobe connected to a CDS 122 pyroprobe. The sample was heated rapidly at a rate of 300°C/sec. to a final temperature of 900°C and held for 4 minutes. Data were collected and analyzed using HP Chemstation software.

Pyrolysis gas chromatography–mass spectrometry (pyGC-MS)

Samples were run on an HP 6890 instrument equipped with a CDS Pyroprobe 2000 valved interface injector, an HP 5MS cross-linked (5%-Phenyl)-methylpolysiloxane capillary column of 30 m × 0.25 mm with a 0.25 µm film thickness, and a mass selective detector. The sample was placed in a quartz tube on a quartz wool plug, 5µl of MethPrep II

(methylating agent) was deposited on the sample, and the quartz tube was inserted into a CDS Pyroprobe 2000 valved interface on an HP 6890 GC with 5973 mass selective detector. The injector was held at 300°C and the sample was pyrolyzed at 850°C for 20 seconds. The oven was held at 40°C for 1 minute, then increased at 6°C/min. to 310°C and held for 14 minutes. Helium was used as the carrier gas.

Detecting Residue on a Model System

Developing an analytical methodology

The gel used in this study had the same formulation as those described in chapter 3 and reported by Stulik et al. (2000, 2002):

> Carbopol 954 (2 g)
> Ethomeen C/25 (20 mL)
> isopropanol (100 mL)
> benzyl alcohol (10 mL)
> deionized water (~10 mL)

Both the Carbopol 954 and the Ethomeen C/25 standards were analyzed using pyrolysis gas chromatography, pyrolysis mass spectrometry—a process very similar to direct temperature resolved mass spectrometry (DTMS)—and pyrolysis gas chromatography–mass spectrometry to establish their analytical signature, as were the oil medium and varnish from the test painting. In anticipation of the second phase of the study, other materials used to treat the museum objects included in this study, such as Ethomeen C/12, Triton X-100, Arkon P-90, mastic, and waxes, also were analyzed.

Other researchers (Learner 1995, 1997; van den Berg, van der Horst, and Boon 1999; Sutherland 2001) have been successful in using pyrolysis injection techniques for analyzing polymers from museum objects in both GC-MS and MS applications. It appeared that these techniques would also be suitable in this study because of the high molecular weight of the Carbopol polymers and surfactants in the gel formulations.

Detection of Carbopol

Carbopol, a commercial preparation of a polyacrylic acid, is considered a relatively stable molecular species (Seymour and Carraher 1992). If detectable, it would be an ideal marker molecule for gel residues, as it would not change on the surface of the object. Since other researchers have observed that gel components are removed unevenly during clearance of the gel (e.g., Burnstock and Kieslich 1996), detection of Carbopol would not necessarily indicate the presence of other gel components. Another drawback of Carbopol as a marker is that it is left in relatively low concentrations, 3-10 $\mu g/cm^2$, as a residue (see chap. 5; see also Stulik et al. 2000).

PyGC showed that each of the Carbopols—954, 934, 940, 941— provided a distinct chromatogram, supporting the hypothesis that it

would be possible to detect Carbopol residues. It was also hoped that the specific Carbopol used in the gel could be identified (fig. 6.2). However, even with a newly developed pyrolysis valved interface for the GC-MS, attempts to measure Carbopol residues by pyGC, pyMS, and pyGC-MS were unsuccessful, but signals from other gel components, especially the surfactant, were strong in pyGC-MS. Based on this result, it was decided to consider them as alternatives to Carbopol as the marker molecule of gel residues. Other components of the gel also were examined by pyGC-MS. Because of their volatility, the solvents were not considered. The surfactant, Ethomeen C/25, proved to have a promisingly sensitive level of detection as shown by the work of Carlson and Petersen in chapter 5.

Figure 6.2

Total ion chromatograms (TIC) of Carbopol 954, 934, 940, and 941

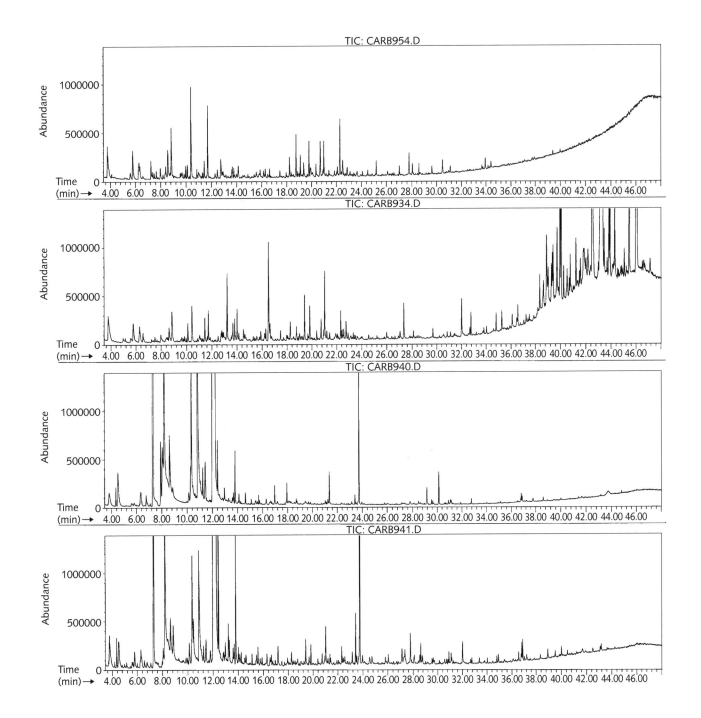

The information gained from the pyGC-MS study could be used to detect surfactants by pyMS using single ion monitoring techniques.

Detection of surfactants

Since Ethomeen C/25 was easily detected by pyGC-MS, the use of surfactants as markers of gel residues was pursued despite the knowledge that they break down over time (see chap. 5). The three molecular fragment ions found most effective for detecting Ethomeen C/25 analysis—m/z 45, 59, and 89 (fig. 6.3)—were selected as marker ions characteristic of Ethomeen C/25 to study sensitivity of the analytical methodology and to detect gel residue.

Figure 6.3

TIC of Ethomeen C/25 and single ion chromatograms (SIC) at m/z 45, 59, and 89 for Ethomeen C/25

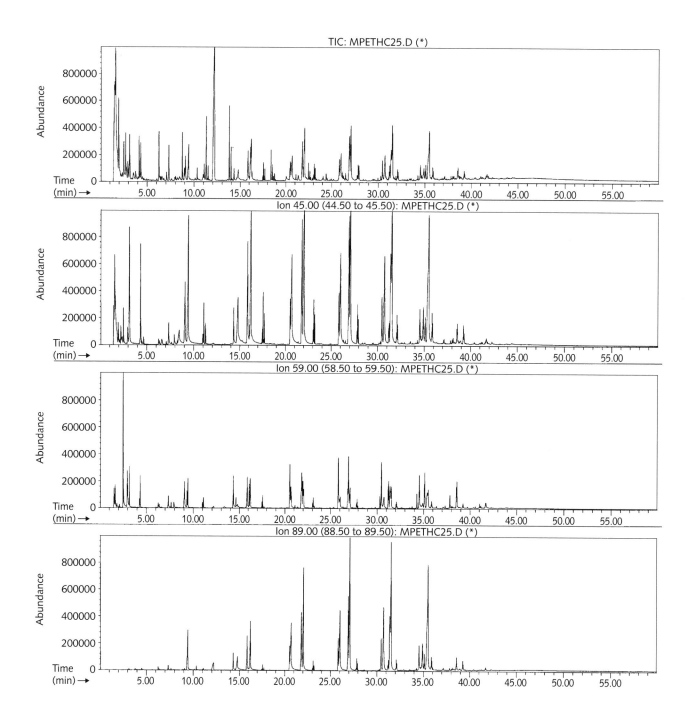

A standard solution of 0.00117 g of Ethomeen C/25 in 4 mL of water (293 ppm) was prepared. A series of 50 µl (1.4625 x 10^{-5} g of Ethomeen), 20 µl (5.85 × 10^{-6} g of Ethomeen), 10 µl (2.925 × 10^{-6} g of Ethomeen), 5 µl (1.4625 × 10^{-6} g of Ethomeen), and 1 µl (2.925 × 10^{-7} g of Ethomeen) aliquots of the standard solution were run by pyGC-MS after adding 5 µl of the methylating agent, MethPrep II (a 0.2N methanolic solution of m-trifluoromethylphenyl trimethylammonium hydroxide). MethPrep II would be needed in a later part of the study to aid in the volatilization of samples that contain polar molecules such as oil media and varnish; it was added here to assess its contribution to the chromatograms.

Analysis of a series of successive solutions of Ethomeen C/25 in water showed a level of detection of about 10^{-6} g (1 µg). The area of paint scraped for an analysis of gel residues was ~20 µm² (i.e., one-fifth of a square centimeter). In the experiment described in chapter 3, the levels of surfactant residues varied between 11 and 169 µg/cm²; therefore, each paint sample scraping should yield between 2.2 and 33.8 µg of Ethomeen C/25 residues. Even the best cleaning in the earlier experiment would leave residues of Ethomeen C/25—more than twice the detection limit.

Further, the levels of Carbopol residues, as mentioned earlier, were much lower than those of the surfactants (3–10 µg/cm² for Carbopol compared to 11–169 µg/cm² for Ethomeen). As the surfactants have also been suspected of producing damaging by-products—peroxide, in the case of Triton X-100 (Burnstock and White 1990)—and of permanently altering the solubility parameters of the paint (Erhardt and Bischoff 1993, 1994), the detection of surfactant residues also is important.

As some of the objects in the study had been cleaned with gels containing the surfactants Ethomeen C/12 and Triton X-100, the process was repeated to find other ions to detect residues of those components. Each of the surfactants analyzed has a distinctive chromatogram (fig. 6.4; see also chap. 5).

A sample of the test gel was analyzed. Ethomeen C/25 was easily detected, confirming that it is a useful marker for gel residues on paint films.

Detection of residue on the test painting

The next step was to attempt to detect residue on the test painting that had been cleaned in small areas using the gel formulation. The gel had been used to remove varnish from the surface and was cleared with a dry swab followed by a water rinse. (This method of clearance has been shown by the quantitative radioisotope study to be one of the more effective methods of removing gel residues.) A scraping from 20 mm² of the cleaned surface was analyzed by pyGC-MS, collecting the total ion chromatogram and later selecting the ions m/z 45, 59, and 89 for Ethomeen C/25 residues (fig. 6.5). Samples of paint that had been scraped free of varnish also were analyzed to ensure that there was no confusion

between the paint and the gel residues (fig. 6.6). The Ethomeen C/25 produced a distinctive series of peaks that eluted between 14 and 32 minutes. This series of peaks was reflected in the extracted ion chromatograms. Analysis of the gel-cleaned area clearly identified Ethomeen C/25 residues, which was consistent with the findings presented in chapter 5, and it confirmed the calculations that predicted the amount of Ethomeen residue would be above detection limits.

This phase of the study confirmed that if gel residues are present, then a method exists for their detection.

Figure 6.4

TIC of Triton X-100, Ethomeen C/12, and Ethomeen C/25

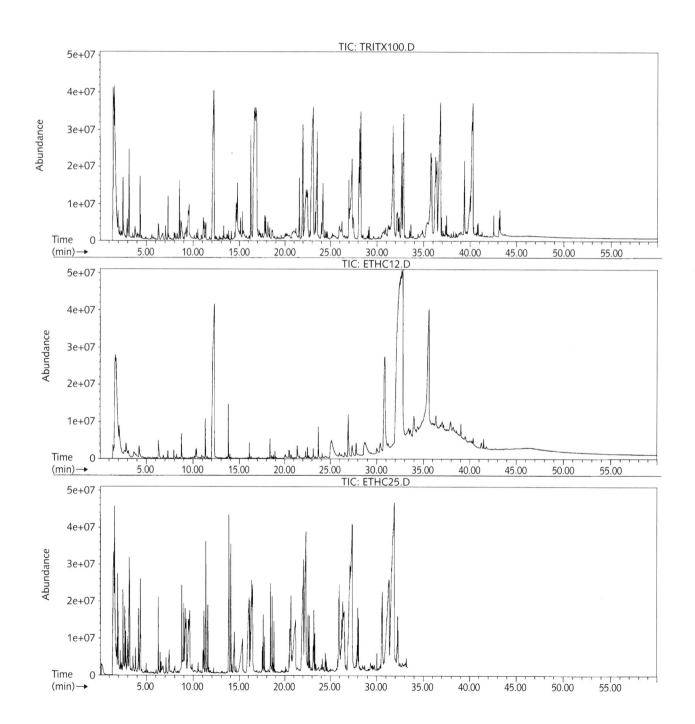

Examination of Museum Objects

Figure 6.5

SIC at m/z 89 for untreated paint from the test painting (MPPPAINT), paint from the test painting after gel cleaning (MPGELPNT), and Ethomeen C/25 (MPETHC25), showing gel and Ethomeen residues on the cleaned painting

Phase II involved analysis of samples taken from museum objects for gel residues. The objects had been cleaned with gels to clean surfaces and/or remove nonoriginal layers.

The study objects

The study included three paintings from the collection of the J. Paul Getty Museum:

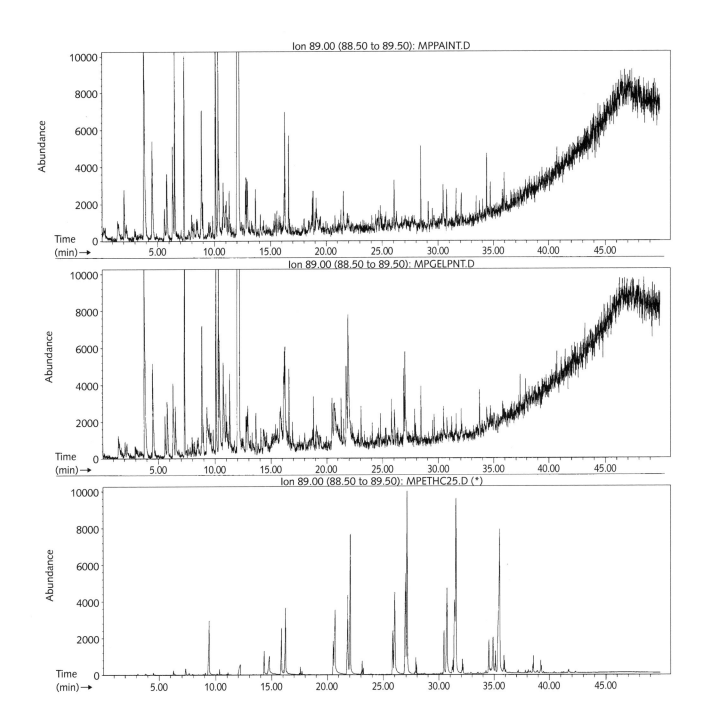

Figure 6.6

SIC at m/z 89 for untreated paint from the test painting (MPPAINT), gel formulation (MPGEL), and paint from the test painting after gel cleaning (MPGELPNT), showing the low levels of gel and Ethomeen residues on the cleaned painting

1. Jacques-Louis David's *The Farewell of Telemachus and Eucharis*, 1818. Oil on canvas, 87.2 × 103 cm (34 1/2 × 40 1/2 in.), 87.PA.27 (see fig. 1.1). The painting was cleaned in 1987 using a deoxycholic acid soap containing hydroxymethyl cellulose, benzyl alcohol, and Triton X-100, except for the Prussian blue drapery, which was cleaned with a solvent gel containing Carbopol 941, ethanol, and xylene.

2. James Ensor's *Christ's Entry into Brussels in 1889*, 1888. Oil on canvas, 252.5 × 430.5 cm (99 1/2 × 169 1/2 in.), 87.PA.96 (see Plates 1 and 8). This painting had been cleaned

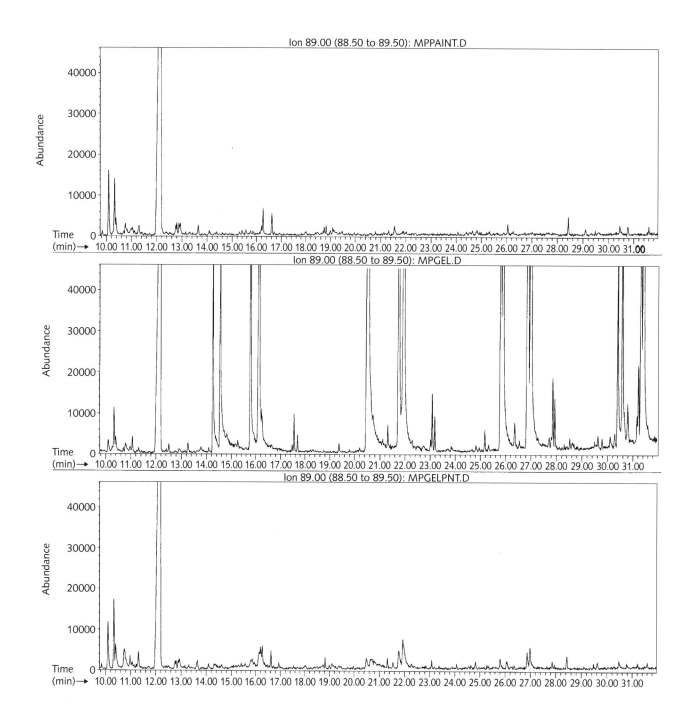

in 1987. Three samples were analyzed: one from a blue pigmented area cleaned with a xylene:Triton X-100 solvent gel; a white-pigmented area cleaned with a Carbopol:Triton X-100:Ethomeen C/25:ethanol solvent gel; and a green pigmented area cleaned with toluene (i.e., no gel).

3. Jean Raoux's *Orpheus and Eurydice*, ca. 1718–20. Oil on canvas, 205.7 × 203.2 cm (81 × 80 in.), 73.PA.153 (see fig. 6.7). Some areas were cleaned in 1999 using a solvent gel containing Carbopol 954, Ethomeen C/25, and acetone.

The study also included the following objects in the collections of the Winterthur Museum, Garden and Library:

4. James Peale's *Still Life with Yellow Blossoms*, 1828. Oil on canvas, 48.7 × 64.4 cm (19 3/16 × 25 3/8 in.), 57.0625 (see fig. 6.8). The painting was cleaned in 1989 using a Carbopol 943:Ethomeen C/25 solvent gel.

5. Tilt-top tea table, Philadelphia, Pennsylvania; ca. 1765–80. Mahogany; overall H: 71.4 cm (28 1/8 in.), diameter of table top: 87.3 cm (34 3/8 in.), 60.1061 (see fig. 1.2 and Plate 9). The polyurethane varnish applied in the 1970s was removed

Figure 6.7

Jean Raoux (French, 1677–1734), *Orpheus and Eurydice*, ca. 1718–20. Oil on canvas, 205.7 x 203.2 cm (81 x 80 in.). Los Angeles, J. Paul Getty Museum, Gift of William P. Garred, 73.PA.153

Figure 6.8

James Peale, *Still Life with Yellow Blossoms*, 1828. Oil on canvas, 48.7 × 64.4 cm (19 3/16 × 25 3/8 in.). Winterthur, Delaware, Winterthur Museum, 57.0625. Courtesy, Winterthur Museum

in 1989 using a Carbopol 943:Ethomeen C/25 solvent gel. (An enzyme/detergent solution removed residual varnish.)

6. Painted card table, Middletown, Connecticut; 1810–1835. Maple and white pine; H: 73.7 cm (29 in.), W: 96.5 cm (38 in.), D: 47 cm (18 1/2 in.), 52.0164 (see fig. 6.9). The table was cleaned in 1992 using a Carbopol 943:Ethomeen C/25 solvent gel.

7. Varnished side chair with leather upholstery, Boston, Massachusetts; 1725–1775. Maple, leather, iron and brass

Figure 6.9

Painted card table, Middletown, Connecticut; 1810–1835. Maple and white pine; H: 73.7 cm (29 in.), W: 96.5 cm (38 in.), D: 47 cm (18 1/2 in.). Winterthur, Delaware, Winterthur Museum, 52.0164. Courtesy, Winterthur Museum

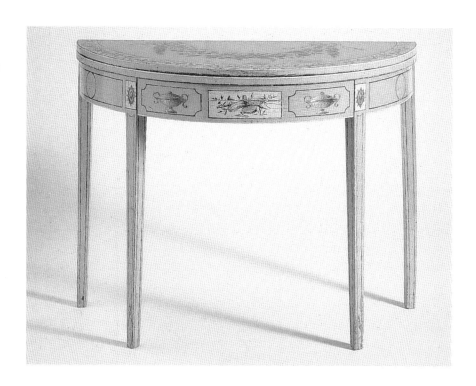

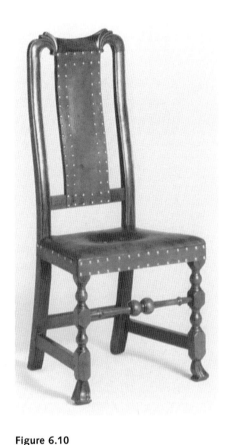

Figure 6.10

Varnished side chair with leather upholstery, Boston, Massachusetts; 1725–1775. Maple, leather, iron and brass nails; H: 112 cm (43 3/4 in.), W: 48.3 cm (19 in.), D: 37.5 cm (14 3/4 in.). Winterthur, Delaware, Winterthur Museum, 77.0568.001. Courtesy, Winterthur Museum

nails; H: 112 cm (43 3/4 in.), W: 48.3 cm (19 in.), D: 37.5 cm (14 3/4 in.), 77.0568.001 (see fig. 6.10). The chair was cleaned in 1995 using a Carbopol 943:Ethomeen C/25 solvent gel.

Analytical methodology

The samples were treated with 5 µg of MethPrep II in the quartz pyrolysis tube and then analyzed by pyGC-MS (table 6.1). The total ion chromatograms were collected and the relevant single ions selected later: Ethomeen C/12 (m/z ions 41, 86, 100), Ethomeen C/25 (m/z ions 45, 59, 89), Triton X-100 (m/z ions 45, 59, 135).

As only one surfactant was used in each gel formulation and the TIC of each surfactant was distinct, the chance of confusion as a result of overlapping ion monitoring between Triton X-100 and Ethomeen C/25 was slight. The other materials used in treatment of the objects, such as Arkon P90 and mastic, were analyzed in an identical way and subtracted from the sample chromatograms to simplify interpretation.

Results

No evidence of surfactants was detected in any of the samples (fig. 6.11).

Interpretation and Discussion

Burnstock and Kieslich (1996) did not observe any residual surfactant in their SEM analysis of gel residue, which is consistent with the findings in this study. However, they did detect nonspecified residues by GC-MS and proposed that these components were preferentially removed during clearance. There was no aging period in their experiment after gel application and before analysis; therefore, no degradation of components took place. That some Ethomeen C/25 was detected at low levels on the test painting suggests that surfactant residues can be detected immediately after gel clearance (see also chap. 3). It is possible but unlikely that the

Table 6.1

Weights of samples from museum objects used for pyGC-MS analysis

Sample	Weight of Paint Before Pyrolysis	Weight of Paint After Pyrolysis	Weight of Paint Pyrolyzed
1. J.-L. David – Brown	43 µg	—	—
1. J.-L. David – Blue	98 µg	39 µg	59 µg
2. J. Raoux	113 µg	51 µg	62 µg
3. J. Ensor – Matte green	79 µg	22 µg	57 µg
3. J. Ensor – White	243 µg	178 µg	65 µg
3. J. Ensor – Blue	76 µg	26 µg	50 µg
4. J. Peale	8 µg	6 µg	2 µg
5. Tilt-top tea table	16 µg	9 µg	7 µg
6. Card table	31 µg	21 µg	10 µg
7. Leather chair	13 µg	2 µg	11 µg

Figure 6.11

TIC and SIC at m/z 45, 59, and at no change, of a sample of white pigment from Study Object 3, the Ensor painting. This area of the painting was cleaned with a gel containing Triton X-100 and Ethomeen C/25. The chromatograms show no evidence of surfactant residues.

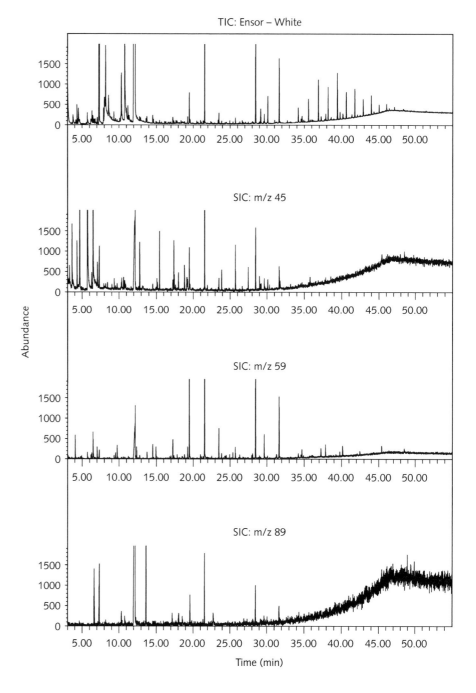

surfactant in the gels used on the museum objects in this study had been completely removed from the surfaces.

Another explanation may be that any surfactant residues on the objects had since degraded. It was shown in chapter 5 that Ethomeen C/25 degrades significantly, but not completely, after one 12-hour cycle of artificial aging (18 W/m^2, Atlas SunChex Weather-o-meter). This suggests that surfactant degradation occurs fairly quickly.

It might be expected then, that if Ethomeen C/25 had been left as part of a gel residue on the treated objects, the degradation process would begin immediately, taking the levels of surfactant to below detection limits. That surfactants were not detected, even on the most recently

Figure 6.12

TIC and SIC at m/z 56, 59, and 89 from Study Object 2, the Raoux painting. This area of the painting was cleaned with a gel containing Ethomeen C/25. The chromatograms show no evidence of surfactant residues.

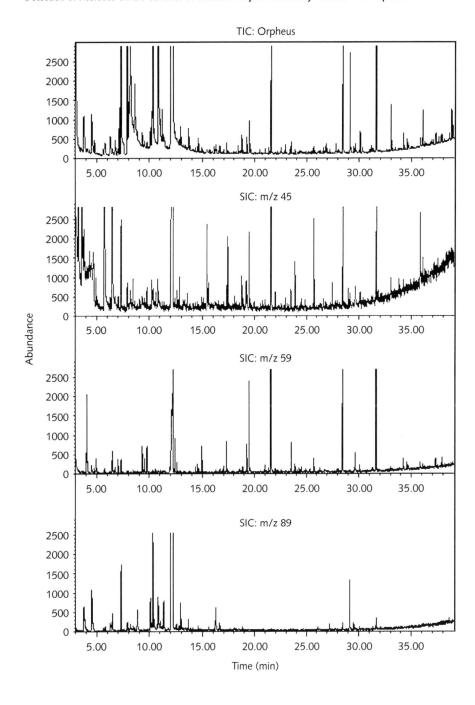

cleaned object—the Raoux painting was cleaned in 1999 and sampled shortly therafter, although analyses were conducted in early 2001—suggests that surfactant residues, if any, present on the objects were most likely low to start with and that the degradation of the surfactants occurred in the less than two years between sampling and analysis (fig. 6.12). This view is reinforced by the low levels of surfactants detected on the test painting after gel cleaning and clearing.

Conclusions

In attempting to detect residue on the surfaces of objects cleaned previously with gels, pyGC and pyMS were assessed as analytical methods of detecting Carbopol residues at low concentrations. Problems of contamination and sensitivity were encountered with pyGC; therefore, pyGC-MS was used in the study as it provides enough sensitivity and seems to be free of contamination problems. With the success of the pyGC-MS analyses, pyMS could prove to be another analytical tool for this type of investigation.

Although it had been hoped initially that we would be able to identify each component of a gel residue, Carbopol proved unsuitable as a marker because it could not easily be detected by pyGC-MS. Surfactants, however, proved suitable markers because they were detectable by pyGC-MS at microgram concentration levels on paint films and therefore were used in the study.

Low concentration levels of surfactant residues were detected on a test painting that had been cleaned with a solvent gel containing Ethomeen C/25 and subsequently cleared of the gel. However, no evidence of surfactant residues was detected on the samples from the seven museum objects that had been cleaned with the various gel systems, some as long as fifteen years ago. It seems likely that the amount of surfactant residue on the surface, if any, was below the detectable limits of this analytical methodology. It is also possible that the surfactants had begun to degrade, taking the amount of surfactant residue to levels below detection limits (1 µg of surfactant).

The initial aim of this work was to detect possible residues of aqueous cleaning gels. Surfactants were used as markers; no surfactant residues were found. It cannot be concluded that there is no gel residue of any kind, however, as some were found on the model system. But the most likely explanation is that the surfactants had degraded. More work remains to be done on gel residues, including investigation of other components found in gel formulations, such as triethanolamine, and detection of molecules like the Carbopols. The fact that surfactants were not detected can be reassuring, although it remains to be seen if the oil paint has been altered by the degradation of the surfactants.

Chapter 7
Project Outcome, Spin-offs, and Future Research Needs

Dusan Stulik and Richard Wolbers

The introduction of aqueous cleaning systems, including gels, was applauded as a major advancement in conservation practice, and application of the new cleaning methodology spread quickly to conservation laboratories and private studios around the world. Practicing conservators appreciated the many benefits of these gel systems that allowed them to deal with difficult cleaning tasks and reduced their exposure to highly concentrated organic solvent vapors.

As stated in chapter 2, introduction of the gel systems raised a number of questions related to the cleaning-clearing mechanisms and to the unknown chemical and physical interaction of any gel residues and residue decomposition products with the surfaces cleaned using any of these gel formulations. The problem of gel residues became the hot topic in conservation circles, but a constructive discussion of the problem was hampered by the lack of hard data on the following:

- a quantitative evaluation of gel residues and gel components, that is, whether residues remain after the cleaning-clearing process, and if so, what is their chemical composition;
- the aging process of any gel residues, that is, the potential for degradation of the paint surface caused by chemical interaction of gel components, degradation products, and the cleaned surfaces; and/or whether there are harmful changes in the physical properties of the cleaned surface that can be traced to the presence of gel residues; and
- a critical evaluation of cleaning treatments using the gels systems since their introduction the early 1980s.

The goal of the collaborative Surface Cleaning–Gels Research Project was to provide experimental data and to stimulate and advance discussion of gel cleaning issues.

Chapters 1 and 2 provide a historical background of surface cleaning and its role in conservation and restoration practice, a summary of published information on various aspects of gel cleaning, and existing research on gel residues. Chapters 3, 5, and 6 describe the three primary research components of the project: research into gel residues, aging characterization of surfactants, and detection of residues on the

surfaces of objects previously treated with gels. During the course of the project, some important information emerged through a comparison of cleaning with free solvents and solvent gel cleaning. This is presented in chapter 4.

Project Results

Gel residues

The experimental results show that some gel residues always remain on the cleaned surface of various materials, particularly those that do not have an ideal smooth, nonporous, and nonabsorbing surface. It would have been unrealistic to experiment with the entire range of gel formulations. We therefore chose a typical formulation that would work well on the test material—painting fragments—available for the experimental work. The selected gel formulation included a gel-forming polymer (Carbopol), a surfactant (Ethomeen C/25), an organic solvent mixture (isopropanol and benzyl alcohol), and water. We felt that although this gel was essentially only a single formulation, it would reasonably represent a related range of formulations. The results of these studies would then be a very useful guide to evaluating a typical gel-cleaning situation encountered in conservation practice.

The amounts of gel residues detected on surfaces is a function of surface chemistry, topography, and porosity. Our cleaning experiments with "ideal" (inert, smooth, nonporous, nonabsorbing) surfaces conducted during the development phase of the methodology showed that it is possible to achieve ~100% clearance of the gel.

Any increase in gel–surface interaction—whether chemical or physical—and surface porosity and topography increases the amount of residues that cannot be removed using standard clearing procedures. The amounts of gel residues on very porous surfaces (in our experiments, terracotta and plaster) can be five to ten times higher than those detected on the relatively smooth and nonporous surface of an oil painting. The amounts detected on the test oil painting samples showed that actual amounts of gel residues are a function of local topography of the painting and the cleaning and clearing technique of the conservator. The autoradiography experiments showed that a cleaning gel can "hide" in fine brushstrokes and any damage on the surface of the painting. Comparison of the results of the cleaning experiments by eight highly experienced conservators showed that the amount of residues could differ by up to a factor of 10 between individual clearing experiments. (We must be careful not to overinterpret these results because local variations in surface topography can also play an important role.) Results also showed that the amount of residues depends on the clearing strategy (e.g., the appropriate use of a combination of "dry" and "wet" clearing steps).

The average amount of gel residues detected on cleaned surfaces of the test painting was about 60 $\mu g/cm^{-2}$, but actual amounts varied from about 15 to 200 $\mu g/cm^{-2}$, depending mainly on local topography

and surface damage. It is very difficult, even for an experienced scientist, to get a good "feel" for how large or small the amount of $60 \mu g/cm^{-2}$ really is. To help conceptualize such a small number, it is useful to mention here that the amount of residues detected on the cleaned and cleared surface of the test painting approximates the amount of matter transferred to the painting surface by touching it six times with a bare finger.

It is also possible to relate the amount of gel residues and their components to the mass of the paint layer. One square centimeter of the paint layer (including a ground layer) weighed, on average, 0.064 g (or 64,000 µg). Using the worst case scenario, data on gel residue quantities left on the surface of the cleaned painting, that is, the highest average µg/cm^2 value of all results from our painting experiments, the gel residues represent 0.35% of the weight of the entire paint layer. For individual residue components, this relationship is as follows: isopropanol, 0.003% (2 µg); benzyl alcohol, 0.08% (49 µg); Ethomeen C/25, 0.26% (169 µg); and Carbopol, 0.01% (10 µg). Each is given as a mass percentage of the entire one-square-centimeter paint layer.

On average, 99.90% of applied cleaning gel was successfully removed from the surface of the test painting during the cleaning and clearing process. The low molecular weight solvent (isopropanol) evaporated relatively quickly, leaving behind gel residues composed of Ethomeen C/25, benzyl alcohol, and Carbopol. Quantitative measurements of individual gel components and these same components in the residues show that a clearing solvent mixture (isopropanol:Shellsol mixture 1:2) slightly alters the weight proportion of the major components in the gel (10:5:1 Ethomeen:benzyl alcohol:Carbopol). The major components of the final composition of the gel residues were 8.5:3.5:1, Ethomeen:benzyl alcohol:Carbopol. This means that the clearing solvent selectively removed some components of the gel residues.

The following important conclusions can be stated based on the experiments in this part of our research project:

- The average amount of gel residues is ~60 µg/cm^{-2}, with local variation based on microtopography and porosity of the cleaned surface.
- The average amount of gel residues on the cleaned surface might differ by up to a factor of 10, depending on the cleaning and clearing strategy used by the conservator.
- The gel residues are composed of Ethomeen, Carbopol, and benzyl alcohol.
- The proportion of components in gel residues differs slightly from the original formulation due to selective removal of its components. The final weight ratio of gel residue components is 8.5:3.5:1 Ethomeen:benzyl alcohol:Carbopol (in unaged gel residues).

It is not sufficient to know the amounts and composition of gel residues that can be expected on the cleaned surface to evaluate whether

these amounts might have any detrimental effect on the material. Because all of the gel formulation components are too inert to damage the cleaned surface, the only way gel residues might damage the cleaned object would be if some components of the gel formulation decomposed during aging and formed harmful decomposition products. This damage could be chemical or physical, or a combination of both.

One example of a harmful chemical process that might occur as a result of degradation of gel components during aging (including light exposure) is the formation of highly reactive decomposition products. These could irreversibly change the surface (e.g., color change, corrosion, decomposition, etc.). One harmful physical effect would be that a residual or decomposition product of a gel component caused irreversible mechanical changes to the surface layer of the cleaned object (e.g., cracking, swelling, delamination, increased solubility, etc.). To predict the possibility of such residue–material interaction, it is necessary to study the composition of the gel residues and to evaluate the aging characteristics of all the residue components.

The gel residues from our experiments are composed of Ethomeen C/25, Carbopol, and some benzyl alcohol (the water and isopropanol are sufficiently volatile to be considered directly removed by evaporation).

Gel components

Benzyl alcohol

Benzyl alcohol (C_7H_8O; MW 108.14; boiling point 205°C) has a vapor pressure high enough that it can be expected to evaporate over an extended aging process.

Although benzyl alcohol may remain on a surface as residual material, it is likely to be a very stable compound. We can predict that after a long period of time, the concentration of benzyl alcohol in the gel residues will probably reach a low, steady-state concentration or amount that will be a fraction of its concentration directly after the cleaning process. However, there is no information available on how low this concentration might be. To evaluate a possible effect of benzyl alcohol on a paint layer or any cleaned material, it would be necessary to evaluate the kinetics of benzyl alcohol evaporation from gel residues, the concentration of benzyl alcohol in well-aged residues, its possible diffusion to the cleaned surface, and a threshold concentration above which it can modify physical properties of the cleaned material.

Two other components, Ethomeen and Carbopol, are high molecular weight compounds with low vapor pressure.

There has been a great deal of research devoted to the natural and artificial aging process of polyacrylic acid polymers (many industrial polymers and modern acrylic paints are based on polyacrylic ester polymers). This research has shown that the polyacrylic chain is quite stable and that with exposure to UV light, we can expect internal crosslinking and thus a decrease in solubility. This allows us to predict that the

Carbopol portion of the gel residues will be rather stable and will not produce any harmful components.

Ethomeen C/25

Ethomeen C/25 (ethoxylated (15) cocoalkylamine) (MW 860, boiling point 268°C at 760 mm Hg) is the least understood component of gel residues. It also does not come in a very pure form. It serves as a surfactant, but its aging characteristics and those of other important surfactants currently in use or which could be used in different gel formulations were not known at the outset of this study. This fact motivated us to study the aging characteristics of both surfactants alone and surfactants deposited on the oil paint substrate, as discussed in chapter 5.

Aging characteristics of individual gel components

Selected surfactants were artificially aged and analyzed using FTIR and GC-MS. The surfactants were aged alone to identify decomposition products and decomposition kinetics. And they were deposited on dried films of linseed oil, red lead in linseed oil paint, and on the approximately hundred-year-old test oil painting to evaluate whether the decomposition pattern changed under the influence of the products of simultaneously degrading linseed oil and oil paint. The results of our studies showed that nonionic surfactants degrade rather rapidly to form highly volatile components, to the point that no traces of surfactants can be detected using current highly sensitive analytical technology, GC-MS.

On the other hand, the ionic surfactants (e.g., sodium lauryl sulfate and sodium laureth sulfate) are more stable. If these surfactants decompose, they tend to form sodium hydrogen sulfate and may alter the pH of the surfaces. The studies seem to show, however, that surfactants and linseed oil and selected oil paint age independently. The decomposition patterns of surfactants and binding materials such as drying oils seem to be independent of each other even when they are physically mixed or in contact with one another during exposure in normal conditions.

The surfactant used in our cleaning experiments—Ethomeen C/25—was studied in more detail and was found not to produce N-oxides on aging, as has been reported elsewhere (Burnstock and White 2000). Rather it forms decomposition products that evaporate from the surfactant or the test material containing surfactant and drying oil. Two of these products were identified as acetaldehyde and glyoxal.

The observation that the Ethomeen surfactants seem to rapidly decompose to form volatile decomposition products, together with previously obtained data on the stability of other components of the cleaning gel residues in our study, allows us to predict the behavior of the gel during the cleaning and clearing process and during long-term natural aging of gel residues:

- During cleaning, the highly volatile components of the gel formulation (e.g., isopropanol and water) are slowly depleted.

- During the clearing procedure, isopropanol continues to evaporate, and some of the organic solvent soluble components of the gel (benzyl alcohol and some Ethomeen C/25) can be extracted from the residues.
- The gel residues are not homogeneously distributed across the cleaned surface. Smooth and nonporous areas are expected to contain less residues than areas showing pronounced surface microtopography, surface damage, or porosity.
- When left uncovered (i.e., no varnish is applied), gel residues lose benzyl alcohol by evaporation; Ethomeen degrades to acetaldehyde and glyoxal by UV-initiated decomposition, and these then evaporate.
- After a long natural aging, it can be expected that the concentrations of benzyl alcohol and Ethomeen will significantly diminish as the residues decompose; a lightly cross-linked layer of stable and nonreactive poly-acrylates (Carbopol) will eventually be the only residual material.

This scenario assumes that gel residues are not covered subsequently by a varnish or other protective coating. If a varnish layer is applied, all the aging processes described above would slow down, and residues would be embedded between the object surface (the paint layer) and the varnish layer(s). At present, we cannot predict whether gel residues would affect future removal or stability of subsequent varnish layer(s); or whether any future gel cleaning of the same surface might increase the amount of gel residues or alter their characteristics.

Detection of residues on surfaces cleaned with aqueous gels

A large number of art objects have been cleaned using both aqueous and solvent gel formulations. Some of these treatments were carried out more than fifteen years ago—enough time to see some signs of damage. To test the validity of the above predictions and to gain more information about the likely fate of gel residue materials, samples were taken from the surfaces of some of these paintings and objects. We hoped to answer two questions: Is there a way to detect the presence of any gel residues on cleaned paintings and furniture (representing both painted surfaces and three-dimensional art objects); and is it possible to detect any signs of surface changes or damage that, even theoretically, might be attributed to the presence of gel residues?

A methodology to detect and quantitatively evaluate the presence of gel residues was developed and tested. This method and the GC-MS method discussed in chapter 5 used surfactants as markers to detect gel residues. The detection limit of Ethomeen C/25 is ~5 $\mu g/cm^{-2}$, which allows the presence of Ethomeen to be detected on relatively smooth and nonabsorbing areas of oil paintings, even at relatively low gel residue concentrations. Samples from three paintings in the J. Paul Getty Museum collection cleaned with gel systems between 1987 and 1999 and three pieces of furniture and one painting in the Winthertur Museum col-

lection cleaned with gels between 1989 and 1995 were analyzed for the presence of surface residues. The results showed that:

- concentrations of the Ethomeen component were below the detection limit of the analytical methodology (i.e., 5 µg/cm^{-2} of Ethomeen C/25); and
- some gel residues were still present in the form of very low concentrations of polyacrylic acid (Carbopol).

Cleaning using solvents and solvent mixtures

At the beginning of our project, evaluation of *free* solvent cleaning methods in a comparative sense was not included in the overall experimental design. But a cleaning experiment with a selection of radioactively labeled solvents conducted on the sections of the same test painting provided some valuable information during the course of the present study. In addition, an evaporation experiment was conducted to study any residues of these solvents. Both studies provided some unexpected insights into cleaning with free (i.e., nongelled) solvents.

In our experiments, and as reported in previous studies (Feller, Stolow, and Jones 1959), relatively long residency times could be observed, even with free or nongelled solvents in the test painting structure. These findings were especially surprising and may have two direct impacts on cleaning system choices:

1. Solvent residue concentrations on the painting surface after solvent cleaning can actually *exceed* concentrations of gel residues in a comparable cleaning situation. This applies for solvents with higher boiling points (Shellsol and higher molecular weight hydrocarbons, benzyl alcohol, etc.).
2. One ramification of a long free solvent residency in a paint film may be that the usual interval of several days between solvent cleaning and revarnishing (if applied) may not be sufficient time to allow solvents to evaporate from the cleaned surface.

In conclusion, we feel we accomplished all the major objectives of the research project and answered a number of important questions related to gel cleaning. Based on our experimental results, we are convinced that the gel cleaning methodology will continue as a very useful tool of modern conservation practice. As originally intended, and presented by Wolbers, it is only an addition to the several tools now available for cleaning fine-art and object surfaces. The conservator will adopt a cleaning methodology that will answer the challenge of a particular cleaning task and minimize the potential of any damage to the object.

One important result of our research was that our free solvent and solvent mixture studies show significantly higher residues from some solvents commonly used in cleaning and clearing procedures than from the solvent gel. While much concern has focused on potential degradation effects from residues left by the solvent gel cleaning systems, as dis-

cussed in chapter 4 and above, our results suggest that a great deal more research is required on the use of free solvents and solvent mixtures as surface cleaning agents.

New Research Methodologies Resulting from the Project

Four important analytical methodologies were developed, tested, and applied in the course of the project that have potential for future application to conservation research. They are as follows:

- The methodology for assessing the presence of surface residues using a combination of radiolabeled compounds and scintillation counting techniques developed by Wolbers (1990) was advanced to allow the study of the composition of gel residues, the concentration of the individual components of the gel formulations, and the dynamics of cleaning and clearing processes.
- A methodology for studying surface and/or spatial distribution of gel across the surface of the test object using radioactively labeled gel components in combination with two-dimensional autoradiography was developed. This was tested in conjunction with surface profilometry study of surface microtopography and damage.
- A methodology was developed to analyze residues on cleaned surfaces using the pyGC and pyMS techniques. The sensitivity of the methodology allowed us to detect 5 $\mu g/cm^{-2}$ of Ethomeen C/25, and this could be used to trace the presence of Ethomeen-based gels on the cleaned surfaces.
- A methodology was developed to study aging characteristics of surfactants in cleaning gel formulations, using artificial aging in combination with FTIR and GC-MS analysis.

Suggestions for Further Research into Aqueous Gel Systems and Surface Cleaning

The Surface Cleaning–Gels Research Project answered many important questions related to gel cleaning systems and their application in conservation practice. As usual, during the project, we identified a number of other research topics that should be investigated but which we could not pursue given the objectives of our project. We hope that others will use this research as a starting point to investigate some of the outstanding issues listed below.

Optimization of gel formulations

The specific amounts (i.e., ratio) of Ethomeen and Carbopol, for instance, tend to dramatically affect gel strength and viscosity. For the

cleaning experiment, we chose an arbitrary amount of Ethomeen C/25 and Carbopol that would produce a gel of between 20K and 30K cps. As a *practical tool* and to further reduce the potential for the deposit of gel residues, it may be possible to produce a gel of sufficient viscosity to be easily applied and removed from a given surface by substantially reducing the amount of Carbopol and/or Ethomeens.

Some of the more practical parameters involved in formulating gels need to be further explored. For instance, the amount of water is critical for creating a link—"a complex salt"—between Carbopol and Ethomeen in the current protocols for making these types of gels. But how much is sufficient to do so? Would additional or excess amounts of water interfere with the gel formation? Would excess water exist as a separate or emulsified phase in some solvent systems? Are micro-emulsions forming with solubilization properties different from those of simple or uniphase gelled solvent systems? How can different gel-forming compounds, surfactants, and other gel cleaning components be used in a similar manner?

Optimization of the solvent cleaning process

The same scientific methodology used to study concentration and changes of concentration of different radiolabeled components during gel cleaning experiments can be used to study and optimize the clearing of gel residues from the cleaned object. Our study showed that the quality of surface clearing differed between individual conservators by up to a factor of 10, based on the actual range of application and clearing methodologies (swab size, pressure on the surface, rolling or rubbing, etc.) used by a group of experienced conservators. How might varying clearing solvent or rinsing solutions affect this? What solubility parameters *are* sufficient to clear a gel made with Ethomeen C/25 or C/12? Are some solvent mixtures more, or less, effective at partitioning the adsorbed or residual amounts of Carbopol and Ethomeen on treated surfaces (e.g., oil paint films)?

Cleaning mechanism and the role of individual gel components

The same scientific methodology can be used to provide more details on gel cleaning mechanisms and to identify the exact role of each component of the gel formulation. For example, the Ethomeens have nominally low aggregation numbers; this may be what allows them to still function as surfactants while being bound to a polymer "backbone" material such as Carbopol. What ethoxylate chain length and degree of substitution is sufficient for micelle formation still to occur? Does ethoxylate chain length affect adsorption or clearance of the Ethomeens from certain surfaces? There is a need to explore via experimentation the notion that viscous gel formulations allow more localized treatment and limit capillary transport or diffusion of organic solvents into the paint layers. What is the relationship between viscosity and diffusion rate and between viscosity and porosity of substrate materials?

Potential effects of gel residues on future conservation treatments

The fate of gel residues during and following application of subsequent materials (e.g., varnishes, restoration materials) is an open question. What is the likely effect on current and future restoration? How will previous gel treatments affect future varnish removal and recleaning using the same or different gel systems?

Questions related to long-term effects of gel residues on painted surfaces

There is a need to prepare a large test set of varied materials that are frequently or likely to be cleaned using gel formulations, cleaning them with different gel formulations, and exposing them to museum display or storage environmental conditions. Detailed, long-term monitoring of any changes to these materials may yield important long-term properties or characteristics that cannot be anticipated in any other manner; that is, do residual gel materials contribute to increased soiling or soil retention on treated surfaces? From a slightly different approach, it would be interesting to use custom radiolabeled binding media to create radioactively labeled mock paintings to artificially age them and then study the leaching of paint components into cold unlabeled gels and solvents and solvent mixtures.

More sensitive analytical methodologies for detecting residues

Analytical methodologies are needed to monitor the presence and changes of trace or very small amounts of materials on artifact surfaces, including small concentrations of gel forming components.

Comparison of solvent gel cleaning with other cleaning methods

Experimental comparison or connection of other traditional or novel cleaning processes (i.e., "solvent only" methods) with those involving gel systems is needed to further explore and describe the chemical and physical changes that occur in art materials during cleaning. This also should provide a quantitative comparison of various methods to better understand or define their appropriate and reasonable use under specific conditions or situations. It is reasonable to think that the same research methodologies (e.g., radioisotopic methods) used in our study could be used to study residence time, transport, diffusion, capillary flow, and residual materials of free solvents that are applied to artifact surfaces.

Quick tests to evaluate cleaning problems

A series of simple field tests is needed to allow the conservator to quickly assess the solubility parameter requirements of a given material. For example, polarity-sensitive dyes might yield more important and useful information about a likely solvent or solvent gel for a particular situation than would lengthy empirical or trial-and-error methods of testing numerous solvents in order to find the appropriate one.

A Decision Tree as a Methodological Approach to Preparing Solvent Gels for Surface Cleaning Tasks

One of the underlying advantages of designing and making *tailored* cleaning systems in the conservation laboratory or studio is that a better match often can be made between the aesthetic and physical needs of the object and the tools that will eventually be used to achieve an appropriate and satisfying treatment result. To be useful, any tool must feel *comfortable* in the practitioner's hands, but it also must be *appropriate* to the specific task, and while time and familiarity are essential to using any tool to its best advantage, we need to be clear about what it can and cannot do.

Another great advantage of using the gel cleaning system may be that there are a virtually infinite number of different formulations and permutations of possible formulations that can be specifically designed for nearly any cleaning problem. The difficulty lies in making sense of them all. How can endless possible combinations be narrowed to a few potential choices for a situation at hand? To be truly *comfortable* in the context of our project cleaning experiments, we sought a rationale for choosing a particular gel for a "model" test painting and to experimentally test one gel, its components, and their interaction with a particular object.

In a theoretical sense, to take full advantage of the flexibility of the gel cleaning systems requires in-depth knowledge of the chemistry of the systems, the role of each component of a gel, the synergy between the different components, and an understanding of each cleaning situation almost at a molecular level. Considerable practical experience in solving surface cleaning problems also helps.

It is our understanding, based on visits to many conservation laboratories around the world and on discussions with many practicing conservators that the infinite flexibility of the gel cleaning systems can be rather intimidating. And it became clear that conservators would welcome a methodology or decision-making tool that would simplify the process of developing an efficient cleaning strategy for a given cleaning problem and reduce the number of tests needed to arrive at an optimum gel formulation. Development of such a decision tool was not included in our current research project objectives; however, we felt that designing and testing a general "decision tree" for surface cleaning would be a logical and very important topic of future research. An ideal decision tree would help the conservator to:

- think about material and chemical issues of a given cleaning task;
- collect important background data;
- perform a minimum number of analytical tests critical to understanding the chemistry and physical properties of the object to be cleaned and necessary for developing a cleaning strategy; and

- limit the number of cleaning tests on the object to identify the least invasive yet efficient cleaning agent, mixture, or gel formulation.

There are several optimum parameters in designing such a decision tree:

a) The system should have general applicability to most surface cleaning situations.
b) The decision tree should start with the simplest and least invasive method.
c) Based on experience or on knowledge of the cleaning problem, the conservator should be able to skip certain parts of the decision tree, or advance faster, in order to arrive at a cleaning strategy and cleaning agent or formulation.

Our research team discussed various theoretical and experimental approaches that might lead to development of a methodology in the form of a decision tree for the organic solvent gel systems. The idea for a format originated with a previous GCI project that involved the identification of binding media. In that research, a decision tree approach based on a series of simple separation procedures and chemical tests was used to identify individual binding media and binding media mixtures in paint samples (Stulik and Florsheim 1992).

This general idea was used to develop the first version of a decision tree for surface cleaning by Dusan Stulik and Richard Wolbers during a meeting at the Winterthur Museum in 1999. The early version of the decision tree started with an outline of the possible logical steps in determining the materials or methods that might be used to remove soil from an oil paint surface: simple physical means of removing dirt (dusting, erasers, etc.) were proposed as a first step, for instance. If these methods did not achieve the desired result, the decision tree suggested getting more information and branching out by conducting a series of simple chemical tests to provide crucial information on the composition of the surface to be cleaned and on the chemical character of a dirt and or paint layer(s) to be removed. The next step was to test-clean using deionized water; if water removed at least some of the dirt layer without any deleterious effect, the next steps might target increasing and fine-tuning water-based cleaning by the systematic addition of other chemical agents—pH modifiers and buffers, surfactants, chelating agents, and gel formers—to safely lift, disperse, and remove the dirt. If water did not show promise in removing the soiling materials (or if other complicating conditions or materials were involved), the decision tree shifted to organic solvents and solvent gel systems. Using simple organic solvents of different strengths, solvent mixtures, and complex solvent gel formulations, surfactants, and gel-forming material, the conservator could optimize a cleaning agent for the specific situation.

It became clear, however, in this initial attempt at describing a decision tree for even a "simple" problem such as trying to design—at

least on paper—a cleaning system to remove dirt from an oil film was a daunting task. The decision-making process for arriving at a specific cleaning formula from myriad initial possibilities was so complex as to make codification into a single tree document impossible. The decision to clean or not to clean, and how to gauge the success or failure of cleaning at any one step or branching point, is difficult at best.

Wolbers later modified this decision tree concept into a more detailed system that included a set of prepared "test kit" solutions, to arrive at an optimum cleaning strategy and cleaning mixture or gel (fig. 7.1). This revised system included a series of solutions prepared in the GCI laboratories and was given a trial by paintings conservator Chris Stavroudis (who participated in the 1998 cleaning test described in chap. 5). In the process, Stavroudis proposed additional modifications to the system and also proposed development of a computer-based decision tree database. A pilot testing of the decision tree and the test kit, together with an experimental database program developed by Stavroudis, was carried out by conservators and interns in the Paintings Conservation Laboratory of the J. Paul Getty Museum in April 2002 (fig. 7.2).

Our early attempts to define decision trees and test kits showed that it is not easy to design a methodology for describing problem solving of this sort. Stavroudis and Wolbers, however, are continuing this

Figure 7.1

Schematic for the methodological approach to selecting a cleaning agent

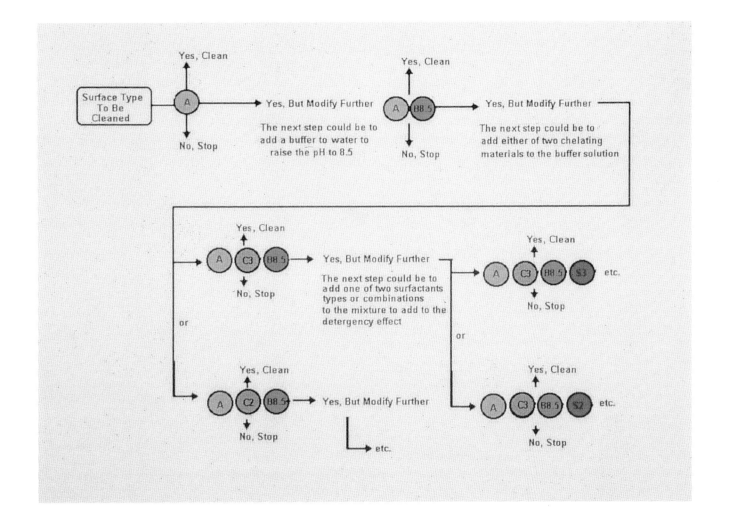

Figure 7.2

Trial application of the decision tree and test kit in the Getty Museum's Paintings Conservation Laboratory

work through the development of large, easily accessible databases using software to present choices and materials and to help the conservator formulate test solutions with more accuracy. Once fully developed and rigorously tested, these kinds of approaches using computer and software development to address a general decision-making problem have great potential as new and helpful conservation tools for advancing cleaning methods.

References

Bischoff, J. J.
1995. Correspondence. To the Editors. *Studies in Conservation* 40(3): 207–12.

Boissonnas, P., and W. Percival-Prescott.
1987. Removal of varnish and glue from painted surfaces using micro friction. In *8th Triennial Meeting, Sydney, Australia, 6–11 September 1987: Preprints*, ed. K. Grimstad, 137–44. Paris: ICOM–Committee for Conservation.

Buck, S. L.
1993. Three case studies in the treatment of painted furniture. In *Papers Presented at the Wooden Artifacts Group Specialty Session, 21st A.I.C. Annual Meeting, Denver, May 31–June 6, 1993*. Washington, D.C.: American Institute for Conservation.

Burnstock, A., and T. Kieslich.
1996. A study of the clearance of solvent gels used for varnish removal from paintings. In *11th Triennial Meeting, Edinburgh, 1–6 September 1996: Preprints*, ed. J. Bridgland, 253–62. ICOM–Committee for Conservation. London: James and James.

Burnstock, A., and T. Learner.
1992. Changes in the surface characteristics of artificially aged mastic varnishes after cleaning using alkaline reagents. *Studies in Conservation* 37(3): 165–84.

Burnstock, A., and R. White.
1990. The effects of selected solvents and soaps on a simulated canvas painting. In *Cleaning, Retouching and Coatings: Technology and Practice for Easel Paintings and Polychrome Sculpture: Preprints of the Contributions to the Brussels Congress, 3–7 September 1990*, ed. J. S. Mills and P. Smith, 111–18. London: International Institute for Conservation of Historic and Artistic Works.

1993. Cleaning gels: Further studies. In *Conservation Science in the U.K.: Preprints of the Meeting Held in Glasgow, May 1993*, ed. N. H. Tennent, 36–39. London: James and James.

2000. A preliminary assessment of the aging/degradation of Ethomeen C-12 residues from solvent gel formulations and their potential for inducing changes in resinous paint media. In *Tradition and Innovation: Advances in Conservation: Contributions to the Melbourne Congress, 10–14 October 2000*, 34–38. London: International Institute for Conservation of Historic and Artistic Works.

Carlson, J., C. Stavroudis, and S. Blank.
1990. Letters. Comprising a letter to the editor from Jean Carlson, and a reply from Chris Stavroudis and Sharon Blank. *WAAC Newsletter* 12(2): 31–32.

Cope, A. C., and E. Ciganek.
1963. Methylcyclohexane and N,N-dimethylhydroxylamine hydrochloride. *Organic Syntheses Collective.* Vol. 4. New York: Wiley.

Dimond, J.
1990. Resin soap experiments. *Conservation News* 41: 8–10.

Dauchot-Dehon, M.
1973–74. Les effets des solvants sur les couches picturales. 1. Alcools et acétone. *Bulletin Institut Royal du Patrimoine Artistique* 13: 89–104.

Ehmann, W. D., and D. E. Vance.
1991. *Radiochemistry and Nuclear Methods of Analysis.* New York: Wiley.

Erhardt, D.
Correspondence. To the Editors. *Studies in Conservation* 40(3): 210–11.

Erhardt, D., and J. J. Bischoff.
1993. Resin soaps and solvents in the cleaning of paintings: Similarities and difference. In *10th Triennial Meeting, Washington, D.C., USA, 22–27 August 1993: Preprints*, ed. J. Bridgland, 141–46. Paris: ICOM–Committee for Conservation.

1994. The roles of various components of resin soaps, bile acid soaps and gels and their effects on oil paint films. *Studies in Conservation* 39(1): 3–27.

1994. Correspondence. To the Editors. *Studies in Conservation* 39(4): 285–86.

Erhardt, D., and J.-S.Tsang.
1990. The extractable components of oil paint films. In *Cleaning, Retouching and Coatings: Technology and Practice for Easel Paintings and Polychrome Sculpture: Preprints of the Contributions to the Brussels Congress, 3–7 September 1990*, ed. J. S. Mills and P. Smith, 93–97. London: International Institute for Conservation of Historic and Artistic Works.

Feller, R. L.
1994. *Accelerated Aging: Photochemical and Thermal Aspects.* Los Angeles: Getty Conservation Institute.

Feller, R., N. Stolow, and E. Jones.
1959. *On Picture Varnishes and Their Solvents.* Oberlin: Intermuseum Conservation Association.

Fronek, J.
1987. Technical Exchange. LACMA experiments with cleaning systems. *WAAC Newsletter* 9(1): 9–10.

Goldberg, L.
1989. A fresh face for Samuel Gompers: Methyl cellulose poultice cleaning. *Journal of the American Institute for Conservation* 28: 19–29.

Gridley, M.
1991. A survey of contemporary material and methods for varnish removal. Final year project in conservation. Courtauld Institute of Art, London.

Grissom, C., T. Power, and S. West.
1988. Methyl cellulose poultice cleaning of a large marble sculpture. In *VIth International Congress on Deterioration and Conservation of Stone 1988*, 551–62. Torún: Nicholas Copernicus University.

Hedley, G.
1993. Recent developments in cleaning. In *Measured Opinions: Collected Papers on the Conservation of Paintings,* ed. C. Villers, 135–56. London: United Kingdom Institute for Conservation.

Hedley, G., M. Odlyha, A. Burnstock, J. Tillinghast, and C. Husband.
1990. A study of the mechanical and surface properties of oil paint films treated with organic solvents and water. In *Cleaning, Retouching and Coatings: Technology and Practice for Easel Paintings and Polychrome Sculpture: Preprints of the Contributions to the Brussels Congress, 3–7 September 1990,* ed. J. S. Mills and P. Smith, 98–105. London: International Institute for Conservation of Historic and Artistic Works. [Also published as A study of the mechanical and surface properties of oil paint films treated with organic solvents and water. In *Measured Opinions: Collected Papers on the Conservation of Paintings,* ed. C. Villers, 103–11. London: United Kingdom Institute for Conservation.]

Heydenreich, G.
1994. Removal of a wax-resin lining and colour changes: A case study. *Conservator* 18: 23–27.

Johnson, M., and E. Packard.
1971. Methods used for the identification of binding media in Italian paintings of the fifteenth and sixteenth centuries. *Studies in Conservation* 16(4): 145–64.

Khandekar, N.
2000. A survey of the conservation literature relating to the development of aqueous gel cleaning on painted and varnished surfaces. *Reviews in Conservation* 1: 10–20.

Khandekar, N., V. Dorge, H. Khanjian, D. Stulik, and A. de Tagle.
2002. Detection of residues on the surfaces of objects previously treated with aqueous gels. In *13th Triennial Meeting, Rio de Janeiro, 22–27 September 2002, Preprints,* ed. J. Bridgland, 352–59. ICOM–Committee for Conservation. London: James and James.

Koller, J.
1990. Cleaning of a nineteenth-century painting with deoxycholate soap: Mechanism and residue studies. In *Cleaning, Retouching and Coatings: Technology and Practice for Easel Paintings and Polychrome Sculpture: Preprints of the Contributions to the Brussels Congress, 3–7 September 1990,* ed. J. S. Mills and P. Smith, 106–10. London: International Institute for Conservation of Historic and Artistic Works.

LACONA II.
1997. Presentations at the 2nd International Conference on Lasers in the Conservation of Artworks, The Conservation Centre, Liverpool, 23–25 April 1997.

LACONA III.
2000. Proceedings of the International Conference on Lasers in the Conservation of Artworks III, Lacona III, Florence, Italy, 26–29 April 1999. *Journal of Cultural Heritage* 1, Supplement 1 (August 2000).

LACONA IV.
2003. Proceedings of the International Conference on Lasers in the Conservation of Artworks IV, Lacona IV, Paris, France, 11–14 September 2001. *Journal of Cultural Heritage* 4, Supplement 1 (2003).

Landrey, G.
1990. The use of fluorescent microscopy in furniture conservation. In *9th Triennial Meeting, Dresden, German Democratic Republic, 26–31 August 1990: Preprints*, 835–39. Los Angeles: ICOM–Committee for Conservation.

1993. Fluorescence microscopy. In *Papers Presented at the Wooden Artifacts Group Specialty Session, 21st A.I.C. Annual Meeting, Denver, 31 May–6 June 1993*. Washington, D.C.: American Institute for Conservation.

Landrey, G. J., N. Reinhold, and R. C. Wolbers.
1988. Surface treatment of a Philadelphia pillar-and-claw snap-top table. In *Papers Presented at the Wooden Artifacts Group Specialty Session, 16th A.I.C. Annual Meeting, New Orleans, Louisiana, 1–5 June 1988*. Washington, D.C.: American Institute for Conservation.

Lang, S.
1998. A review of literature published in response to Wolbers' resin soap, bile soaps and solvent gels. Final year research project. Royal College of Art and Victoria and Albert Museum Joint Conservation Course (furniture conservation).

Laurie, A. P.
1935. Restrainers and solvents used in cleaning old varnish from pictures. *Technical Studies in the Field of the Fine Arts* 4(1): 34–35.

Learner, T. J. S.
1995. The analysis of synthetic resins found in twentieth-century paint media. In *Resins Ancient and Modern*, ed. M. M. Wright and J. Townsend, 76–84. Edinburgh: Scottish Society for Conservation and Restoration.

1997. The characterization of acrylic painting materials and implications for their use, conservation and stability. Ph.D. dissertation, Birkbeck College, University of London.

Marijnissen, R. H.
1967. *Dégradation, conservation et restauration de l'oeuvre d'art*. Brussels: Éditions Arcade, 66–72.

Martin, E.
1977. Some improvements in techniques of analysis of paint media. *Studies in Conservation* 22(2): 63–67.

Masschelein-Kleiner, L., and J. Deneyer.
1981. Contributions à l'étude des solvants utilisés en conservation. In *Preprints ICOM Committee for Conservation 6th Triennial Meeting, Ottawa, 21–25 September 1981*. Los Angeles: ICOM—Committee for Conservation, 81/20/2.

Michalski, S.
1990. A physical model of the cleaning of oil paint. In *Cleaning, Retouching and Coatings: Technology and Practice for Easel Paintings and Polychrome Sculpture:*

Preprints of the Contributions to the Brussels Congress, 3–7 September 1990, ed. J. S. Mills and P. Smith, 85–92. London: International Institute for Conservation of Historic and Artistic Works.

Miller, A.
1998. Aging characteristics of surfactants. Paper submitted for course ARTC-673, Winterthur/University of Delaware Program in Art Conservation. Unpublished.

Newman, D. J., and C. J. Nunn.
1975. Solvent retention in organic coatings. *Progress in Organic Coatings* 3: 221–43.

Phenix, A.
1993. Application of new cleaning methods. *Conservation News* 52: 42–43.

1995. Correspondence. To the Editors. *Studies in Conservation* 40(3): 207–8.

1998a. The effects of organic solvents on paint and varnish. Proceedings of colloquium Beobachtungen zur Gemäldeoberfläche und Möglichkeiten ihrer Behandlung, Schule für Gestaltung, Bern, Switzerland, 13–14 March 1998. Unpublished.

1998b. Organic solvents and the cleaning of paintings: An introduction. Proceedings of colloquium Beobachtungen zur Gemäldeoberfläche und Möglichkeiten ihrer Behandlung, Schule für Gestaltung, Bern, Switzerland, 13–14 March 1998. Unpublished.

1998c. The science and technology of the cleaning of pictures: Past, present and future. In *25 Years School of Conservation: The Jubilee Symposium, Preprints, 18–20 May 1998*, ed. K. Burchersen, 109–19. Copenhagen: Konservatorskolen det Kongelige Danske Kunstakademi.

1998d. Solvent-induced swelling of paint films: Some preliminary results. *WAAC Newsletter* 20(3): 15–20.

1998e. Solubility parameters and the cleaning of paintings: An update and review. *Zeitschrift für Kunsttechnologie und Konservierung* 12(2): 387–409.

Phenix, A., and K. Sutherland.
2001. The cleaning of paintings: Effects of organic solvents on oil paint films. *Reviews in Conservation* 2: 47–60.

Rabin, B.
1978. Personal communication from Bernard Rabin to Joyce Hill Stoner. August 1978.

Rees-Jones, S.
1962. Science and the art of picture cleaning. *Burlington Magazine* 104(707): 60–62.

Ruhemann, H.
1968. *The Cleaning of Paintings: Problems and Potentialities*. London: Faber and Faber.

Scott, D. A.
2002. *Copper and Bronze in Art: Corrosion, Colorants, Conservation*. Los Angeles: Getty Conservation Institute.

Seymour, R. B., and C. E. Carraher Jr.
1992. *Polymer Chemistry: An Introduction.* 3d ed. rev. and expanded. New York: Marcel Dekker.

Society of Automotive Engineers, Inc.
1989. Accelerated exposure of automotive exterior materials using a controlled irradiance water-cooled xenon arc apparatus. Report issued June 1989, as SAE J1960.

Southall, A.
1988. New approach to cleaning painted surfaces. *Conservation News* 37: 43–44.

1989a. Wolbers' cleaning methods. *Conservation News* 38: 12–13.

1989b. Wolbers' corner. *Conservation News* 39: 11–12.

1990a. Detergents, soaps, surfactants. In *Dirt and Pictures Separated, Papers Given at a Conference Held Jointly by UKIC and the Tate Gallery, January 1990,* ed. S. Hackney, J. Townsend, N. Eastaugh, and V. Todd, 29–34. London: United Kingdom Institute of Conservation.

1990b. Detergents, their use on paintings. Presentation and handout at Dirt and Pictures Separated, a conference held jointly by UKIC and the Tate Gallery, January 1990.

Stavroudis, C.
1992. Untitled. *The CM Times* (product catalog). Reno: Conservation Materials.

1995. Correspondence. To the Editors. *Studies in Conservation* 40(3): 208–9.

Stavroudis, C., and S. Blank.
1989. Solvents and sensibility, pts. I–III. *WAAC Newsletter* 11(2): 2–10.

Stolow, N.
1956. Some investigations of the action of solvents on drying oil films. Ph.D. dissertation, University College, London, Institute of Archaeology.

1963. Application of science to cleaning methods: Solvent action studies on pigmented and unpigmented linseed oil films. In *Recent Advances in Conservation: Contributions to the IIC Rome Conference, 1961,* 84–88. London: Butterworths.

1985. Part II. Solvent action. In R. Feller, N. Stolow, and E. Jones, *On Picture Varnishes and Their Solvents,* 45–116. Washington, D.C.: National Gallery of Art.

Stringari, C.
1990. Vincent van Gogh's triptych of trees in blossom, Arles (1888). Part I. Examination and treatment of the altered surface coating. In *Cleaning, Retouching and Coatings: Technology and Practice for Easel Paintings and Polychrome Sculpture: Preprints of the Contributions to the Brussels Congress, 3–7 September 1990,* ed. J. S. Mills and P. Smith, 126–30. London: International Institute for Conservation of Historic and Artistic Works.

Stulik, D., V. Dorge, H. Khanjian, N. Khandekar, A. de Tagle, D. Miller, R. Wolbers, and J. Carlson.
2000. Surface cleaning: Quantitative study of gel residue on cleaned paint surfaces. In *Tradition and Innovation: Advances in Conservation. Contributions to the Melbourne*

Congress, 10–14 October 2000, 188–94. London: International Institute for the Conservation of Historic and Artistic Works.

Stulik, D., and H. Florsheim.
1992. Binding media identification in painted ethnographic objects. *Journal of the American Institute for Conservation* 31(3): 275–88.

Stulik, D., H. Khanjian, V. Dorge, A. de Tagle, J. Maish, B. Considine, D. Miller, and N. Khandekar.
2002. Scientific investigation of surface cleaning processes: Quantitative study of gel residue on porous and topographically complex surfaces. In *13th Triennial Meeting, Rio de Janeiro, 22–27 September 2002, Preprints*, ed. R. Vontobel, 245–51. ICOM–Committee for Conservation. London: James and James.

Sumira, S.
1990. Conservation treatment of globe surfaces. In *Cleaning, Retouching and Coatings: Technology and Practice for Easel Paintings and Polychrome Sculpture: Preprints of the Contributions to the Brussels Congress, 3–7 September 1990*, 56–58. London: International Institute for the Conservation of Historic and Artistic Works.

Sutherland, K. R.
2001. Solvent extractable components of oil paint films. Ph.D. dissertation, University of Amsterdam, FOM Institute for Atomic and Molecular Physics.

Thomson, G.
1967. Annual exposures to light within museums. *Studies in Conservation* 12(1): 26–36.

Tsang, J., and D. Erhardt.
1992. Current research on the effects of solvents and gelled and aqueous cleaning systems on oil paint films. *Journal of the American Institute for Conservation* 31: 87–94.

Tumosa, C. S., J. Millard, D. Erhardt, M. F. Mecklenburg.
1999. Effects of solvents on the physical properties of paint films. In *12th Triennial Meeting, Lyon, 29 August–3 September 1999: Preprints*, ed. J. Bridgland, 347–52. ICOM–Committee for Conservation. London: James and James.

van den Berg, K. J., J. van der Horst, and J. J. Boon.
1999. Recognition of copals in aged resin/oil paints and varnishes. In *12th Triennial Meeting, Lyon, 29 August–3 September 1999: Preprints*, ed. J. Bridgland, 855–67. ICOM–Committee for Conservation. London: James and James.

van der Doelen, G. A.
1999. *Molecular Studies of Fresh and Aged Triterpenoid Varnishes*. Amsterdam: University of Amsterdam.

Wolbers, R. C.
1988. Aspects of the examination and cleaning of two portraits by Richard and William Jennys. In *Preprints of Papers Presented at the 16th Annual Meeting of the American Institute for Conservation of Historic and Artistic Works, New Orleans, Louisiana, 1–5 June, 1988*, 245–60. Washington, D.C.: American Institute for Conservation.

1989. *Notes for Workshop on New Methods in the Cleaning of Paintings*. Marina del Rey, Calif.: Getty Conservation Institute.

1990. A radio-isotopic assay for the direct measurement of residual cleaning materials on a paint film. In *Cleaning, Retouching and Coatings: Technology and Practice for Easel Paintings and Polychrome Sculpture: Preprints of the Contributions to the Brussels Congress, 3–7 September 1990*, ed. J. S. Mills and P. Smith, 119–25. London: International Institute for Conservation of Historic and Artistic Works.

1992. Recent developments in the use of gel formulations for the cleaning of paintings. In *Restoration '92 Conservation, Training, Materials and Techniques: Latest Developments, Preprints of the Conference Held at the RAI International Exhibition and Congress Centre, Amsterdam, 20–22 October 1992*, ed. V. Todd, J. Marsden, M. K. Talley Jr., J. Lodewijks, and K. W. Sluyterman van Loo, 74–75. London: United Kingdom Institute for Conservation.

1994. Correspondence. To the Editors. *Studies in Conservation* 39(4): 284–85.

2000. *Cleaning Painted Surfaces: Aqueous Methods*. London: Archtype.

Wolbers, R. C., and G. Landrey.
1987. The use of direct reactive fluorescent dyes for the characterization of binding media in cross-sectional examination. In *Preprints of Papers Presented at the Fifteenth Annual Meeting of the American Institute for Conservation of Historic and Artistic Works, Vancouver, British Columbia, Canada, 20–24 May 1987*, 168–202. Washington, D.C.: American Institute for Conservation.

Wolbers, R. C., with N. Sterman and C. Stavroudis.
1990. *Notes for Workshop on New Methods in the Cleaning of Paintings*. Marina del Rey, Calif.: Getty Conservation Institute.

Yoshida, T.
1972. Solvent evaporation from paint films. *Progress in Organic Coatings* 1: 73–90.

Materials

Tritium (3H) custom-labeled Ethomeen C/25 and Carbopol 954
"off-the-shelf" radiocarbon-labeled benzyl alcohol and isopropanol.
Moravek Biochemical
577 Mercury Lane, Brea, CA 92821, USA
Tel: (800) 447-0100; Fax: (714) 990-2018
E-mail: moravek@worldnet.att.net
Web: www.moravek.com

Radiocarbon-labeled glycine (used as a standard)
ICN Biomedical, Inc.
3300 Hyland Ave, Costa Mesa, CA 92626, USA
Tel: (714) 545-0113; Fax: (714) 641-7216
Web: www.icnbiomed.com

Benzyl alcohol, Triton X-100, Triton XL-80N,
Brij 700, sodium lauryl sulfate
Sigma-Aldrich
P.O. Box 14508, St. Louis, MO 63178, USA
Tel: (800) 325 3010; Fax: (800) 962-9591
E-mail: custserv@sial.com
Web: www.sigma-aldrich.com

Isopropanol
Fisher Scientific
2170 Martin Avenue, Santa Clara, CA 95050, USA
Tel: (800) 766-7000; Fax: (800) 826-1166
Web: www.fishersci.com

Ethomeen C/12, mineral spirits
Conservation Support Systems
924 West Pedregosa Street
Santa Barbara, CA 93101, USA
Tel: (800) 482-6299; Fax: (805) 682-2064
E-mail: css@silcom.com
Web: www.silcom.com

Ethomeen C/25
Conservator's Emporium
100 Standing Rock Circle, Reno, NV 89511, USA
Tel: (775) 852-0404; Fax: (702) 852-3737
E-mail: ConsEmp@consemp.com
Web: www.consemp.com

Carbopol® 954
Noveon, Inc. (formerly B.F. Goodrich Specialty Chemicals)
9911 Brecksville Road, Cleveland, OH 44141-23244, USA
Tel: (216) 447-5000; Fax: (216) 447-6315
Web: www.noveoninc.com

1801 and LS 6500 liquid scintillation counters
Ready Solv HP liquid scintillation cocktail
Beckman Coulter, Inc.
P.O. Box 890789, Dallas, TX 75389-0789, USA
Tel: (714) 773-6715; Fax (800) 643-4366
E-mail: krider@salessupport.com
Web: www.beckmancoulter.com

Glass scintillation vials
Research Products International
410 N. Business Center Drive, Mt. Prospect, IL 60056, USA
Tel: (800) 323-9814; Fax: (847) 635-1177
E-mail: service@rpicorp.com
Web: www.rpicorp.com

Acrylics, red lead oxide pigment
Golden Artists Colors
188 Bell Road, New Berlin, NY 13411-9527, USA
Tel: (607) 847-6154; Fax: (607) 847-6767
E-mail: sales@goldenpaints.com
Web: www.goldenpaints.com

Sodium laureth sulfate
The Chemistry Store
520 NE 26th Court, Pompano Beach, FL 33064, USA
Tel: (800) 224-1430; Fax: (954) 946-2711
E-mail: sales@chemistrystore.com
Web: www.chemistrystore.com

MethPrep II (m-trifluoromethylphenyltrimethyl-ammonium hydroxide)
Alltech Associates, Inc.
2051 Waukegan Road, Deerfield, IL 60015-1899, USA
Tel: (800) 225-8324; Fax: (847) 948-1078
E-mail: alltech@alltechemail.com
Web: www.alltechweb.com

Phenyl methyl siloxane
Agilent Technologies (formerly Hewlett-Packard)
P.O. Box 945575, Atlanta, GA 30394-5575, USA
Tel: (800) 227-9770; Fax: (302) 633-8901
E-mail: cag_sales-na@agilent.com
Web: www.agilent.com/chem

Silica gel
Analtech
Bodman Industries
P.O. Box 2421, Aston, PA 19014, USA
Tel: (800) 241-8774; Fax: (610) 459-8036
E-mail: service@bodman.com
Web: www.bodman.com

Arkon P-90 (C$_9$ hydrogenated hydrocarbon resin)
Arakawa Chemical (USA) Inc.
625 N. Michigan Avenue, Suite 1700, Chicago, IL 60611, USA
Tel: (312) 642-1750; Fax: (312) 642-0089
E-mail: arakawa@arakawa-usa.com
Web: www.arakawa-usa.com

Index

Note: Page numbers followed by the letters *f* and *t* indicate figures and tables, respectively.

About the Authors

Janice Carlson was formerly Senior Scientist in the Scientific Research and Analysis Laboratory of the Conservation Division of Winterthur Museum, Garden and Library and Adjunct Associate Professor in the Winterthur/University of Delaware Program in Art Conservation. She holds B.A. and M.S. degrees in analytical chemistry. Address: Conservation Department, Winterthur Museum, Winterthur, DE 19735, USA.

Valerie Dorge was formerly Project Specialist in the GCI Field Projects group. Before joining the GCI as a training coordinator, she was a conservator at the Canadian Conservation Institute. She has a B.A. in material culture studies and is a Fellow of the IIC. Address: 30 Bayley Street, Pittsworth, Queensland 4356, Australia.

Narayan Khandekar is Senior Conservation Scientist at the Fogg Art Museum. He previously was Associate Scientist in the Museum Research Laboratory of the Getty Conservation Institute. He has a Ph.D. in organic chemistry and a postgraduate diploma in the conservation of easel paintings. Address: Fogg Art Museum, 32 Quincy Street, Cambridge, MA 02138, USA.

Herant Khanjian is Assistant Scientist in the Scientific Group of the Getty Conservation Institute. He has a B.A. in chemistry from California State University, Northridge. Address: The Getty Conservation Institute, 1200 Getty Center Drive, Los Angeles, CA 90049-1684, USA.

David Miller is Professor in the Department of Chemistry at California State University, Northridge. He has a Ph.D. in radiochemistry. Address: Department of Chemistry, California State University, Northridge, 18111 Nordhoff Street, Northridge, CA 91330-8262, USA.

W. Christian Petersen is a volunteer in the Scientific Research and Analysis Laboratory of the Conservation Division of Winterthur Museum, Garden and Library. He is a retired research scientist from the DuPont Company in Wilmington, Delaware. He has a B.A. and a Ph.D. in organic chemistry. Address: Conservation Department, Winterthur Museum, Winterthur, DE 19735, USA.

Dusan Stulik is Senior Scientist in the Museum Research Laboratory of the Getty Conservation Institute. He has a B.S. and an M.S. in chemistry and a Ph.D. in physics. Address: The Getty Conservation Institute, 1200 Getty Center Drive, Los Angeles, CA 90049-1684, USA.

Richard Wolbers is Associate Professor in the Winterthur/University of Delaware Program in Art Conservation. He was previously Conservator of Paintings at the Winterthur Museum. He has an M.S. in paintings conservation, an M.F.A. in painting, and a B.S. in biochemistry. Address: Art Conservation Program, University of Delaware, 303 Old College, Newark, DE 19716, USA.